NEGATING THE IMAGE

Negating the Image

Case Studies in Iconoclasm

Edited by Anne McClanan and Jeff Johnson

ASHGATE

Published by
Ashgate Publishing Limited
Gower House
Croft Road
Aldershot
Hants GU11 3HR
England

Ashgate Publishing Company
131 Main Street
Burlington, VT 05401–5600 USA

Ashgate website: http://www.ashgate.com

British Library Cataloguing in Publication Data
Negating the image : case studies in iconoclasm
 1. Iconoclasm 2. Symbolism in art
 I. McClanan, Anne L., 1966– II. Johnson, Jeffrey
 246.5'3'09

Library of Congress Cataloging-in-Publication Data
Negating the image : case studies in iconoclasm / edited by Anne McClanan and Jeffrey Johnson.
 p. cm.
 Includes index.
 ISBN 0-7546-0854-9 (alk. paper)
 1. Aesthetics--Case studies. 2. Image (Philosophy)--Case studies. 3. Iconoclasm--Case studies. I. McClanan, Anne L., 1966- II. Johnson, Jeffrey.

BH301.I52N44 2005
701'.03--dc22

 2005050019

ISBN 0 7546 0854 9

Typeset by Bournemouth Colour Press, Parkstone, Poole and printed in Great Britain by Biddles Ltd, King's Lynn.

Contents

Erratum

Captions for the following figures were transposed in the original printing

4.3 Stuttgarter Psalter, *c.* AD 820, 'Et effuderunt […] sanguinem filiorum suorum et filiarum suarum, quas sacrificaverunt sculptilibus Chanaan' [page 92]

4.4 Stuttgarter Psalter, *c.* AD 820, 'Similes illis fiant qui faciunt ea et omnes qui confidunt in eis' [page 93]

4.5 Bern, Prudentius, *Psychomachia*, verses 30-35 [page 94]

List of Figures

filiorum suorum et filiarum suarum, quas sacrificaverunt sculptilibus Chanaan' (And shed innocent blood, even the blood of their sons and of their daughters, whom they sacrificed unto the idols of Canaan: and the land was polluted with blood)

4.4 Stuttgarter Psalter, *c.* AD 820, Bibl. fol. 23, fol. 150v, Ps. 135:18, Württembergische Landesbibliothek Stuttgart. 'Similes illis fiant qui faciunt ea et omnes qui confidunt in eis' (They that make them are like unto them: so is every one that trusteth in them)

4.5 Prudentius, Cod. 264, fol. 69r, Burgerbibliothek Bern, *Psychomachia*, verses 30-35, 'But she, rising higher, smites her foe's head down, with its fillet-decked brows, lays in the dust that mouth that was sated with the blood of beasts, and tramples the eyes under foot, squeezing them out in death. The throat is choked and the scant breath confined by the stopping of its passage, and long gasps make a hard and agonising death'

4.6 Reliquary statue of Ste Foy, after AD 886, Conques

6 Naming names and shifting identities in ancient Egyptian iconoclasm

6.1 The god Horus Behedety from the inside of the Enclosure Wall in the Temple of Edfu. The falcon head of the god has been effaced and a Coptic cross carved into the god's kilt (photo: P. Wilson)

6. 2 King Amenhotep III from the Temple of Luxor. The rings (cartouches) containing the king's names are in front of his face and the 'Amenhotep' name looks untidy because it had the original name of 'Amen' effaced by Atenists and then the name of 'Amen' was restored later (photo: P. Wilson)

6. 3 a) Hieroglyphs for the name of the god 'Amen'

b) Two variant vulture hieroglyphs used to write the name of the goddess 'Mut' and thus with the phonetic value 'm-u-t'

c) The hieroglyphs used to write the plural word for 'gods'

d) The word for 'to die' 'm-n-i', composed of the same hieroglyphs used for the name of 'Amen' except for the last sign. This word was carefully removed in the tomb of Amenemhet (Davies, 1915, pl. X left, centre panels of text)

7 Supplanting the devotional image after Netherlandish iconoclasm

7.1 Master of the Magdalena Legend, *Holy Family, c.* 1515–25 (Courtesy of the Koninklijk Museum voor Schone Kunsten, Antwerp, Belgium)

7.2 Willem Kruyper, *Ten Commandments*, 1602 (Courtesy of the Hervormde Stichting voor de Grote of St. Stevenskerk te Nijmegen, Nijmegen, The Netherlands)

7.3 Interior of St Peter's Church, Leiden, with Anonymous, *Ten Commandments*, seventeenth century (Courtesy of the Gemeentearchief Leiden, The Netherlands)

7.4 Anonymous, *Ten Commandments*, *c.*1590–1610 (Courtesy of the Kerkgemeente Edam, Edam, The Netherlands)

7.5 Pieter Jansz. Saenredam, *Choir and Southern Choir Ambulatory Seen from the Christmas Chapel in the St. Bavo Church, Haarlem*, 1636 (Courtesy of the Coll. Frits Lugt, Institut Néerlandais, Paris)

8 Preservation and destruction, oblivion and memory

8.1 François Perrier, frontispiece of *Segmenta nobilium et statuarii*, 23.6 x 15.5 cm, engraving, 1638, Paris, Bibliothèque

List of Contributors

ADRIAN A. BANTJES is Associate Professor of Latin American history at the University of Wyoming. He is the author of *As If Jesus Walked on Earth: Cardenismo, Sonora, and the Mexican Revolution* (Wilmington, Del., 1998) and has written extensively on the cultural, religious, political and social history of the Mexican Revolution. He is currently finishing a study of iconoclasm and popular religion in revolutionary Mexico.

FINBARR B. FLOOD is Assistant Professor in the Department of Fine Arts, New York University. His research interests include cross-cultural aspects of medieval Islamic art and architecture and the representation of medieval Isamic culture in Euro-American scholarship. He has published on these topics in *Ars Orientalis, Art Bulletin, Iran* and *Muqarnas*, and in a book-length study of early Islamic mosque architecture (*The Great Mosque of Damascus: Studies on the Making of an Umayyad Visual Culture*, Leiden, 2001). He is currently working on his second book, which deals with gifting, looting and the reuse of cultural artifacts in the Ghurid sultanate.

BEATE FRICKE is an assistant professor at the University of Zurich. She is an Art History graduate of the University of Karlsruhe, where she recently completed her Ph.D. on 'Idolatry, imagery and gift exchange in view of the Statue of Sainte Foy at Conques: considerations upon a genealogy of sculpture' (Götzendienst, Bildkultur und Gabentausch anbetracht der Statue der Hl. Fides in Conques – Überlegungen zur Genealogie der Skulptur). She was a research fellow in the Graduiertenkolleg 'Bild. Körper. Medium – Eine anthropologische Perspektive', led by Hans Belting and Beat Wyss at the Hochschule für Gestaltung, Karlsruhe. A research grant from the Gerda-Henkel Foundation allowed her to complete the studies for this project in Paris, Rome and southern France.

DARIO GAMBONI is Professor of Art History at the University of Geneva. He is the author of *Un iconoclasme moderne. Théorie et pratiques contemporaines du vandalisme artistique* (Lausanne and Zurich, 1983) and *The Destruction of Art: Iconoclasm and Vandalism since the French Revolution* (New Haven and London, 1997), as well as numerous books and articles on nineteenth- and twentieth-century art.

LIZ JAMES is Reader in Art History, Department of Art History, University of Sussex. She is an Associate Director of the AHRB Centre for Byzantine Cultural History based in Belfast, Newcastle and Sussex. Her publications include work on light and colour in Byzantine art and on Byzantine empresses. The essay in this volume relates to her interest in the perception and nature of art in Byzantium and questions of vision and visuality.

JEFF JOHNSON earned his Ph.D. in English and American Literature from Harvard University. Currently he is Assistant Professor of English at the University of Central Arkansas. His book on feud narratives is forthcoming from the University Press of Virginia. His next project is a comparative study of the idea of regionalism and its expressions in nations of the western hemisphere, focusing on the US South and the Brazilian North-east. He is interested in the cultural roles of images and their relation to other forms of representation.

ANNE MCCLANAN is an Associate Professor of Art History at Portland State University. Her prior books are *Representations of Early Byzantine Empresses: Image and Empire* (New York, 2002) and a co-edited volume of essays, *The Material Culture of Sex, Procreation, and Marriage in Premodern Europe* (New York, 2001). Her work on Byzantine iconoclasm led her to this transhistorical study of the phenomenon. She studied at Harvard University, The Johns Hopkins University and Columbia University.

MIA M. MOCHIZUKI is a Visiting Scholar in the Department of Art History and Archaeology at Columbia University. Her research interests include the impact of verbal culture on the visual arts in the seventeenth-century Netherlands and the export of style in the early modern world. She is currently completing a book on the Dutch Reformed Church after iconoclasm.

PENELOPE WILSON is an Egyptology graduate of the University of Liverpool, where she also studied aspects of lexicography in the Edfu Temple texts for a Ph.D., now published as *A Ptolemaic Lexikon* (Leuven, 1997). She worked for seven years as Assistant Keeper in the Department of Antiquities in the

Fitzwilliam Museum, Cambridge (England) and is now a Lecturer in Egyptology in the Department of Archaeology, University of Durham. She is active in the Egypt Exploration Society's Delta Survey project and is the Field Director of the joint EES/University of Durham Saïs project in Egypt.

Acknowledgements

Writing a book requires a network of people providing support and inspiration, and that is never more true than in the case of an anthology. This project began in a 1997 College Art Association panel co-chaired by Anne McClanan with Madeline Caviness. The early discussions with scholars such as Jerry Silk, Joseph Koerner, Eleanor Heartney, Lee Palmer Wandel, Hanns Hubach, Eric Varner, Christine Göttler, Gridley McKim-Smith and Marcia Welles helped define our aims and gave us the energy to make it past initial setbacks.

At Ashgate, Patricia Edwardes, as the commissioning editor, and then Lucinda Lax shepherded us through the editorial process with judicious advice, and Melissa Riley-Jones deftly coordinated all of the logistics of production.

Moreover we feel particularly grateful to have had such a stimulating and professional group of contributors; their good humor and patience throughout the process of collaboration has been much appreciated.

From A.M.:
The co-editing of this book arose from a graduate school friendship. In that spirit I'd like to dedicate my work on this book to the dear friends who have sustained my studies.

Introduction: 'O for a muse of fire …'

Anne McClanan and Jeff Johnson

The word 'iconoclasm' emerged from the theological debates in eighth- and ninth-century Byzantium, when earlier Christian doubts about the admissibility of religious images crystallized into imperial policy. It derives from the Greek term, εἰκονοχλάστης, meaning the person who destroys sacred likenesses – 'icons'.[1] The two root words were both charged with spiritual significance, for 'icon' denoted ritual images ranging from Christian paintings to pagan statuary and '–klastes' is cognate with the word used to describe a range of acts involving 'breaking', such as the Eucharistic breaking of bread. The medieval writers who devised this term were all staunch defenders of the orthodoxy of icons in Christian devotional practice, denouncing the errors of their 'iconoclastic' opponents. The earliest located appearances of 'iconoclast' in English from 1596 through the mid-seventeenth century were specific references to the Byzantine controversies, but by 1654, in the Civil War atmosphere of radical Protestant attacks on church ceremonial, Anglican clergyman Jeremy Taylor could use the word as a generic term for those objecting to Christian images.[2] Though the use of 'iconoclasm', 'iconoclast' and their derivatives to refer to *any* attacks on traditional cultural authority is attested in English only since the 1860s, this extension of the term is the meaning most familiar to contemporary readers of this and other languages, who may know nothing of its medieval Greek roots. Since the nineteenth century 'iconoclastic' has often been a compliment instead of an insult to political radicals or avant-garde artists praised for assaulting the existent to make way for the better. 'Iconoclasm' is now rarely encountered as an accusation, having lost the pejorative force of its Byzantine origins and of its early appearances in English. In common usage the public destruction of objects is reproached with a word like 'vandalism', which has an overlapping but different semantic range.

When 'iconoclasm' is applied to attacks on artworks, though, it retains

much of its original force and its negative connotations. That is historically appropriate, since the targets of the Byzantine Iconoclasts were objects that now claim more widespread interest and sympathy as artworks than as religious artifacts, even when they retain a cult significance. The objects targeted for destruction in the essays that follow this introduction, ranging in time and space from Pharaonic Egypt to medieval India to twentieth-century Mexico, qualify as 'art' by contemporary metropolitan standards, whether or not their makers thought of them as other or greater than 'art'. Concern about iconoclasm now more often centres on imperiled aesthetic or historical value than on religious potency. The international dismay at the Taliban's demolition of the Bamiyan Buddhas in Afghanistan was expressed as regret for the loss of cultural heritage, not as outraged Buddhist piety (Figure 1.1). Art and the Nation and Civilization have joined (or supplanted) the Deity and the Ruler as matters calling forth zealous defence against barbaric attacks on icons. The term, 'iconoclasm' remains useful in such different circumstances because beliefs and practices collected under that term and the scandalized responses 'iconoclasm', evokes appear together in diverse historical contexts. The common features and differences of the range of iconoclasms may offer as much insight into cultural attitudes towards visual representation and the objects in which it is embodied as the study of the creation of objects, but they have been far less studied.

The essays in *Negating the Image* are a contribution to the comparative exploration of iconoclasms. They display some of the enormous variety in historical attacks on images and image-making: variety in the objects assailed, in the sponsors of iconoclasm and the defenders of images, in the arguments advanced on all sides, in the severity of iconoclastic episodes.[3] The essays are linked by their concern with acts that initially seem to be aimed only at removal, negation or obliteration. However, a surprising common thread is the ultimate productivity of objects and images often stimulated by iconoclasm: its capacity to renovate existing cultural forms and materials or to inspire new projects. In 2002 an exhibition in Karlsruhe and its accompanying catalogue brought to the fore the notion of 'iconoclash'. As defined by the chief curator, Bruno Latour, iconoclash is an act of destruction in which the destructive act is clouded by a fog of ambiguity about whether the annihilation is destructive or constructive (Latour and Weibel, 2002, p. 14). Latour posits in contrast clear meanings and motivations to iconoclasm, an idea that several of this anthology's contributors dispute strongly.[4]

The treatment of 'icon' in the essays implicitly presupposes a shared basic definition that each modifies to fit its specific context and concerns. The icon discussed in this anthology is a concrete object incorporating a visual sign or signs. The *immediate* target of an iconoclastic act must be material, not solely conceptual. Representational images of animate entities (supernatural

figures, persons, animals) are the most common icons and seem to arouse the most iconoclastic vehemence. Images appear to offer closer access for attacks on what they represent, or graver insults to what they represent, by their distance from the exalted interpretant. However, more abstract figures like the Christian cross or national flags may also serve and be repudiated as icons. While linguistic signs alone are not usually iconic, inscriptions in their *materiality* may be regarded and attacked as icons.

Within the society that employs the icons, the referents of the icons' signs possess great power that transcends the objects, though power also may be seen as immanent within the objects themselves. The power embodied in or represented by the icon may be a deity, a social collective or a concept. If the icon does not qualify as 'religious' by current usage, it still represents something that claims a sacral aura. The power of the icon's referent and the icon's connection to the referent are publicly recognized, even though either or both the referent or the connection may be contested. Each icon may be one of many representations of its referent (the Virgin Mary, Śiva, the Buddha), but each icon is felt to have unique properties not possessed by copies or reproductions of the particular icon – unless those reproductions are in turn granted the individual status and concomitant properties of icons. Workshop copies of famous images of the Virgin in rural churches or mass-produced figures of Śiva in home shrines may function as icons, but photoreproductions of such images on postcards rarely do – unless those postcards in turn are incorporated into shrines.⁵ The individual object itself, not just what it represents, must possess a certain gravity in order for its destruction to be deplored or celebrated as iconoclastic. Societies' beliefs and actions bestow that weight on objects, making distinctions that would appear trivial out of context. For example, the emotional impact of flag burning in the United States is linked to the treatment of iconographically identical official flags as unique items to be individually destroyed only with due ceremony; baseball caps and bumper stickers sporting images of the American flag aren't granted the same status and their casual destruction arouses no passion.

Iconoclasm is a principled attack on specific objects aimed primarily at the objects' referents or at their connection to the power they represent. Iconoclastic acts require not just the intent to remove or destroy objects but the intent to attack their relation to that power. The iconoclast thus possesses some theory, however thin and indefinite, of how that relation works. The most common manifestation of iconoclasm assaults the icon's referent through the icon's physical being, because the referent is either beyond reach or is especially vulnerable through the icon. Iconoclasm can be a tangible denial of the represented power's very existence, as in the Christian smashing of pagan idols discussed by Beate Fricke or the campaign against

Christian images in post-Revolutionary Mexico described by Adrian Bantjes.

Iconoclasm may also be a rebuke or punishment to the human or supernatural figure represented by the icon. Obliterating images of anathematized persons is a key step in *damnatio memoriae*, the effort of authorities to banish those censured from a society's collective memory. Though the Latin phrase may postdate the fall of Rome, ancient Mediterranean civilizations like that of the Egyptians treated by Penelope Wilson's essay already knew the practice.[6] The intended sanctions can be partly supernatural, as they apparently were in Egypt, or avowedly secular, as in the erasure of Trotsky from the visual archive of the Revolution in Stalin's Soviet Union. On the other hand, the weak may punish offences of a human or extrahuman power beyond their reach through its available icons. The recent exhibition in Bern, 'Bildersturm: Wahnsinn oder Gottes Wille?' included destructive acts motivated by frustration and disappointment at unrealized prayers as a subtheme in the largely Reformation iconoclasm that it considered (Dupeux et al., 2000).

The very use of icons may be attacked as a practice unworthy of the transcendent splendour that the icons claim to signify. Representational images have been banned in various strains of Jewish, Christian, Muslim and Buddhist thought as misleading or degrading misconstruals of the sacred. Polemics that originated the term in Byzantium drew upon centuries of preceding Christian and pre-Christian debate on the appropriate use and meaning of visual representation. This exclusion of visual representation of divinity is in itself better labelled 'aniconic' than iconoclastic, but it has sometimes produced iconoclastic theories and practices that violently repudiate a previous regime of image-making superseded by conversion or conquest. Even then, the treatment of pre-existing images and structures is often more complex than their simple abolition. During Byzantine iconoclasm itself, many rulers assumed a more passive rather than active role – they preferred to remove, not destroy icons.[7]

The essays in this anthology by Finbarr Flood on Islamic India and Beate Fricke on early Christian Europe demonstrate the creation of new objects and iconographic programmes incorporating – often literally – the remains of monuments destroyed in accordance with the new creeds. Aniconic traditions may evolve their own non-representational sacred art to fill the very spaces elsewhere occupied by the banned images. The Peoples of the Book have often turned to decorative renditions of their sacred texts. To the familiar example of Qur'anic calligraphy in Islamic art and architecture, Mia Mochizuki's essay adds the highly elaborated inscription of religious messages on the recently bared walls of Dutch Protestant churches during the Reformation.

These varying manifestations of iconoclasm are at least conceptually

distinct from vandalism. The divergence is registered in everyday language by the pairing of 'vandalism' with adjectives like 'random', 'crude', 'aimless' and 'simple'. Like iconoclasm, vandalism is primarily a public act directed at the widest possible audience, but the intention of the vandal seems to be focused on the act itself, the pleasure in exercising the power to mark or destroy or in the shock it will deliver to others. Whether acts of vandalism are anonymous defiances or open assertions of self, public symbols of authority make the most satisfying targets. When images and objects we classify as 'art' are defaced more for their notoriety or their general association with status and authority than for their specific capacity for representation, we tend to call it vandalism. According to several classical sources, the 356 BC burning of the Temple of Artemis in Ephesus by Herostratus in order to secure his place in history would be vandalism rather than iconoclasm as we have distinguished the terms.[8] But the useful distinctions made in these ideal-typical definitions blur when we investigate the mixed motives and varying interpretations ascribed to destructive acts like Herostratus'. Vandalism and iconoclasm are similarly loaded and contentious terms; vandalism, like iconoclasm, is in the eye of the beholder.[9] 'Vandalism' may be a label applied to attacks on public symbols in order to deny or suppress principles that the attacks were intended to convey. Those who welcome on aesthetic or religious grounds the new site produced by a destructive act may reject either negative label. What a government or community calls vandalism, a graffiti writer may call art or a zealot may call an act of faith.

Iconoclasm is rarely invoked when objects are not deliberately attacked but suffer time's attrition through human neglect until recycled for their materials or simply removed as impediments to new purposes. Such destruction is preceded by the state that Dario Gamboni calls 'oblivion', in which an object is no longer noticed and its meaning is no longer present or important to the society that contains it. Gamboni's essay in this volume, however, suggests that even oblivion bears a close relation in the modern era to the active and purposeful destruction we usually call iconoclasm.

The range of examples found in this anthology suggests we need to define 'iconoclasm' flexibly enough to identify the common features in disparate historical incidents, which will in turn allow us to see their significant differences, and sharply enough to distinguish 'iconoclasm' from affiliated practices and beliefs without denying their connections. If the term is to be applied at all beyond its Byzantine origins, it cannot circumscribe a single phenomenon with a single continuous history, not even when 'iconoclasm' appears within a purportedly unified religious or political tradition. From this historical variety, the anthology can only sample a set of episodes spanning four continents and three millennia. The diversity of our contributors (five art historians with different regional and chronological

interests, a historian and an archaeologist) is reflected in the methodologies they employ and the questions they pose to their material. The variety of practices they discuss leads several authors to question the extension of the term 'iconoclasm': to extend its application, or to ask whether it fits the acts and ideas they analyse. The essays accordingly have been ordered to emphasize parallels and contrasts between situations and questions that recur among them rather than chronologically or geographically.

An essay by Dario Gamboni concludes the anthology by framing issues in the study of iconoclasm that recur in the specific historical case studies of the preceding essays. Gamboni's earlier work, including *The Destruction of Art: Iconoclasm and Vandalism since the French Revolution* (1997) and many shorter essays, underlies much recent discussion. Gamboni suggests that iconoclasm may produce new objects from the ruins of old ones, or stimulate their production to replace those destroyed – even, or especially, if the new producers want to proclaim their differences from their predecessors.

Gamboni's view of iconoclasm as a stage in the re-making of art is referenced explicitly in the essay by Finbarr Flood, but it winds through the rest of the anthology as well. Flood and Adrian Bantjes focus directly on the fate of objects during apparently classic episodes of iconoclastic destruction, showing that the struggle to redefine the roles of old artifacts in new visual cultures has involved more than demolition. In the next two essays, treating early medieval Western Europe, the centre of interest shifts to representation: Beate Fricke discusses the textual representation of iconoclasm itself, while Liz James finds a complex relation between words and images in western reception of Byzantium's Iconoclasm controversy. Penelope Wilson touches on all these concerns in differentiating the wide spectrum of ancient Egyptian practices that have been labelled iconoclasm. Mia Mochizuki returns specifically to the question of representation, arguing that after iconoclasm swept over Dutch Protestant churches, word replaced image as visual representation.

Finbarr Flood's essay on the Muslim reappropriation of Hindu sacred architecture in medieval India complicates the received view of 'Islamic iconoclasm'. An essential Islamic hostility to images rooted in Qur'anic proscription has often passed as conventional wisdom that warrants no exploration. The recent demolition of the Bamiyan Buddhas has melded with the destruction of the World Trade Center to feed stereotypes of Islamic religion and society in the western (especially American) popular media as xenophobic destroyers of monuments (Flood, 2002). Flood, in contrast, teases out a variety of phenomena obscured under the label 'Islamic iconoclasm', as well as the potential for productive innovation that the label disguises. His reassessment of four Ghurid mosques shows how a previous series of scholarly assumptions styled their late twelfth- and early thirteenth-century

reuse of materials from Indian temples in absolutist terms drawn from the Protestant Reformation's rejection of 'Catholic' imagery. He argues that these buildings have been egregiously misconstrued in order to subsume their actual construction within a pre-existing idea of Islamic iconoclasm. The reuse in the mosque of earlier temple elements produced new meanings, rather than negating meaning entirely; this iconoclasm generated from existing materials a significance more appropriate to their new religious contexts.

While iconoclasm in medieval India followed the transference of royal sanction from one set of religious institutions to another, in post-Revolutionary Mexico of the 1920s–1930s it was part of an aggressively secular attack sponsored by the new regime on the religious underpinnings of its predecessor. The Catholic Church was denounced for purveying superstition that furthered the oppression of the masses, especially for disseminating rituals, images and texts encouraging popular religion. Taking on the term 'semioclasm' to include a broader range of practices than physical attacks on particular icons, Bantjes foregrounds the new visual and verbal languages fashioned to replace the symbolism of pre-Revolutionary Mexico abhorred by the Revolutionary authorities. This semiomorphosis sometimes backfired among the people it was supposed to enlighten, and officially promoted iconoclasm sometimes strengthened religious devotion to images. The rural Cristero rebels of 1926–29 violently rejected the new state instead. Meanwhile, the cult of Revolutionary heroes and martyrs absorbed from the old regime forms intended to create reverence for the new that depended on the very principles the Revolution was supposed to have undermined.

Beate Fricke's contribution treats an earlier attempt to develop a new iconographic programme that depended on its understanding of the tradition it displaced. Attacks on classical sculptures in early medieval Western Europe were intrinsic to the centuries-long process of Christian conversion, for the ancient rites could only be refuted and finally replaced by disabling the idols that embodied their persistence. Physical attacks in earlier centuries gave way to their literary rehearsal as remaining idols disappeared but idol-smashing became a topos in the writing of saints' lives. Detailed descriptions of newly disempowered, but still whole, idols yielded to the perfunctory recounting of destroyed images as paganism as an active opponent faded into memory. But Christian material culture absorbed the pagan past within new forms like the cult statues of saints, sometimes literally, as in the case of the ninth-century statue of Ste Foy at Conques with its recycled head of a Roman emperor. Fricke argues that a specifically western Christian conception of permissible religious images was articulated through explicit and implicit arguments for the falsity of idols that are

registered in representations of anti-pagan iconoclasm. Those representations incidentally trace the emergence of models for monumental Christian art out of the pagan ruins.

The anthology's next four essays, beginning with Fricke's, revolve around concepts of representation and the relation between word and image exposed in pursuing or combating iconoclasm. The eighth-century Carolingian *Libri Carolini*, a text drawn on by Fricke, articulates a Western European response to Byzantine Iconoclasm in which Liz James finds early medieval perceptions of image and text at variance with their modern separation into different realms. Byzantine iconophile authors such as John of Damascus articulated the concept that images were integral to spiritual contemplation, for these visual representations were necessary bonds between the believer and the icon. In the minute dissection of the function and status of a representation, which was at the heart of the theological wrangling of Byzantine Iconoclasm and the errant riposte in the *Libri Carolini*, the 'transparency' of the relation of the image to its signification was put in question. This complexity was not limited to images. James argues that the written word might be not just the vehicle of sacred meaning but, in largely illiterate medieval society, could possess spiritual power in its own right that might complicate or even overshadow its ostensible messages. In spite of its differences, the *Libri Carolini*'s argument aligns with the concerns of the Iconoclasts in the weight of influence.

Penelope Wilson questions the extension of the term 'iconoclasm' as she surveys destructive acts aimed at both text and image in Ancient Egypt spanning more than two thousand years. Egyptian visual culture made iconoclasm in the strict sense an attractive manner of punishment and protest, since Egyptian beliefs left mortal authority vulnerable to defacement of its symbols, and the mutilation of funerary images was an extreme threat to the afterlife of the dead. However, surviving evidence of ancient alterations to monuments often implies less belligerent motives. Wilson tries to untangle some of the complexities in looking at the actions centring on the heterodox pharaoh Akhenaten (fourteenth century BC), who tried to supplant traditional representations with a new iconography to match his religious innovations and whose successors reacted by trying to erase traces of Akhenaten himself from the public record. But if that pharaoh's presence and innovations were fiercely suppressed, the motivation for other erasures appears more ambiguous. After one of Akhenaten's secondary queens, Kiya, was supplanted by Meritaten, her name and image were removed from most sites where they had been found. Is this iconoclasm, or might it be viewed more justly as a benign transfer of property duly noted? Wilson also notes Egypt's ancient tradition of recycling images and materials without deliberate prejudice to their original

purposes. Iconoclasm may finally be too negatively charged a word to cover the intent of many Egyptian practices.

Mia Mochizuki's essay examines in turn the extension of the term 'icon' in describing what came after a moment of iconoclasm. Rather than detailing a case study of the actual destruction or suppression of images, the essay focuses on the new decorative programme that succeeded the removed images in a body of Dutch churches stripped during the Protestant Reformation. Not all Dutch church interiors took on the empty whiteness seen in Saenredam's church paintings. Some were redecorated with religious texts in elaborate designs, which Mochizuki feels took on the status of pictorial representations in their own right (Figure 1.2). Against the claim that these texts were presented only to be read, she argues that these altered spaces presented an embodied version of the holy text, in which the word assumes the status of pictorial representation.

Dario Gamboni's essay closes by demonstrating through examples spanning seventeenth- to twenty-first-century western art his concept of 'oblivion', the peaceful senescence of an object's significance due to changing practices of viewing objects. Introducing oblivion into the debates on iconoclasm tests the boundaries of 'iconoclasm'. Oblivion or reappropriation for other purposes can alter the meaning of objects and their place in a cultural landscape more than their simple rejection can, negating more thoroughly their prior meanings. This leads Gamboni to ponder whether direct assault on art objects, which we now take as the primary manifestation of iconoclasm, so entirely erases its targets.

Our survey of the anthology's contents has emphasized the transformative over the purely destructive energies unleashed in and by iconoclasm. We must also acknowledge the difficulty of erasing prevalent iconographic programmes and their material expressions even when erasure is supported by state power and mass conversion. Existing artifacts are deliberately reused (as described by Gamboni, Flood and Wilson), survive through inertia, and may be preserved as unintended models in the very discourse that attacks them (as seen in the essays by Bantjes and Fricke). Dario Gamboni's work has touched on this survival of iconoclasm by artifacts, which deserves more comparative exploration than this collection of essays can offer.

While the essays here share these perhaps surprising commonalities, their sequence moves (approximately) from acts of iconoclasm to the concepts that underpin it, with a corresponding shift in emphasis from material objects towards texts. The focus of our collection remains more often on the what and why of destruction than on the specific nature of the connection between the icon and referent, upon which its meanings depend.

We hope that the work collected here will also stimulate investigations of

the thinking about images that makes iconoclasm conceivable as well as the thinking that prompts iconoclastic acts. Do the various manifestations of iconoclasm trace to a common psychic structure, or are iconoclastic practices too culturally diverse to admit more than heuristic comparison? The former would require the possibility of a philosophical anthropology, not just ethnographies, of the structure and function of images.[10] Is iconoclasm culturally or psychically rooted in hostility to images as such, or to visual pleasure, or in the denigration of visual experience in favour of more austere or more immediate experiences (conceptual, aural, tangible)? What relation do aniconic traditions – which predate the prohibitions of images in the Abrahamic religions – bear to iconoclastic impulses?[11] How are iconoclasm and its interpretation gendered, if and when they are?[12] These questions are implicated in debates about the status of images classed in categories from art to advertising in contemporary US society, while contemporary ambivalence and hostility towards images find historical parallels and antecedents in iconoclastic debates and actions. This anthology has been forced to omit both the current American dimensions of 'iconoclasm' and a host of other examples. The contributions of the essays included here, though, do suggest that more comparative study of iconoclasm will further illuminate the destruction (and creation) of images across the diversity of human societies.

Notes

1 Early usages of the term εἰχονοχλάστης appear in eighth-century authors such as Germanus I of Constantinople, John of Damascus and Basilius Ancyanus Alius.

2 See the entries for 'iconoclasm' and 'iconoclast' in the *Oxford English Dictionary*, 2nd edn (New York: Oxford University Press, 1989).

3 Even the sources from the classic Byzantine iconoclastic episodes of the eighth and ninth centuries suggest different motivations and characteristics, depending on the point of view of the medieval writer. Charles Barber's recent study (2002) does a masterful job of bringing this complexity to light.

4 Further spin-offs from that seminal exhibition have already appeared, for Joseph Koerner's study of 'Reformation art' (2004) surely derives from his participation in that collaboration.

5 Recent studies such as the work of David Morgan (1996) offer examples of how mass-produced imagery can approach iconic status, even within American Protestant contexts.

6 The actual phrase *damnatio memoriae* is relatively modern (Stewart, 1999, p. 161).

7 The existence of the singular cache of early Byzantine icons within the Monastery of Saint Catherine at Mount Sinai does imply, though, the amount of material destroyed during the reigns of more aggressively iconoclastic rulers such as Constantine Copronymous (an appellation perpetuated by hostile iconophile sources that means Dung-maker in Greek).

8 Mentions of the deliberate burning of the Temple of Artemis include Cicero, *De Natura Deorum* ii.27; Strabo, *Geography* 14.I.22; Plutarch, *Life of Alexander* 3.

9 A recent criminological survey of vandalism yielded perhaps unsurprising results. Whereas the art historical literature has focused on sensational attacks on celebrated artworks, most vandalism in the British art galleries reporting consisted of rather banal injuries, such as scribbling on the walls (Cordess and Turcan, 1993).

10 David Freedberg's *The Power of Images* (1989), which informs many of the discussions about iconoclasm in the general literature, posits a fear of images as a psychological or cognitive common feature in the (mis)recognition, repression and destruction of images. Freedberg concentrates on arguing for the existence of this fear through cross-cultural comparisons rather than assigning it specific origins or structures. Key reviews of this influential work include those by Malcolm Bull (1991), Arthur C. Danto (1990) and Crispin Sartwell (1991).

11 Joseph Gutmann, for example, edited an anthology of comparative examples of iconoclasm entitled *The Image and the Word* (1977). It has often been noted as well that the theology of the Protestant Reformation's iconoclasm was heavily dependent on the argumentation formulated during the Byzantine controversy.

12 The gender of iconoclasts and their actions' interpreters has so far received limited attention. While most iconoclasts seem to be men, that is hardly surprising given the historical milieu of the available case studies. Julie Spraggon remarks this in *Puritan Iconoclasm during the English Civil War* (2003, p. xii). The status of women in the phenomenon of Byzantine iconoclasm and its rejection has received lively scholarly attention. Numerous primary texts suggest a particularly deep commitment by Byzantine women to the use of icons in worship and in the protection of icons during Iconoclasm, which is being reappraised. Marie-France Auzépy (1990) had shown that, not only was the howling mob of female iconodules a convenient ninth-century fiction, but the Chalke icon did not exist at that time for any variety of mob to destroy. Different sides of the debate on the role of women in Byzantine Iconoclasm can be seen in Cormack as opposed to the arguments in Herrin (2002).

References

Auzépy, Marie-France (1990), 'La destruction de l'icône du Christ de la Chalcé par Léon III: Propagande or réalité?', *Byzantion* **60**, 445–92.

Barber, Charles (2002), *On the Limits of Representation in Byzantine Iconoclasm*, Princeton and Oxford: Princeton University Press.

Bull, Malcolm (1991), review of Freedberg, *The Power of Images*, *Burlington Magazine*, **133**, 125–6.

Cordess, Christopher and Turcan, Maja (1993), 'Art vandalism', *British Journal of Criminology* **33**, 95–102.

Cormack, Robin (1997), 'Women and icons, and women in icons', in James, Liz (ed.), *Women, Men, and Eunuchs: Gender in Byzantium*, New York and London: Routledge, pp. 24–51.

Danto, Arthur C. (1990), review of Freedberg, *The Power of Images*, *Art Bulletin* **72**, 341–2.

Dupeux, Cécile, Jezler, Peter and Wirth, Jean (2000), *Bildersturm: Wahnsinn oder Gottes Wille?*, exh. cat., Munich: Fink.

Flood, Finbarr Barry (2002), 'Beyond cult and culture: Bamiyan, Islamic iconoclasm, and the museum', *Art Bulletin* **84**, 641–59.

Freedberg, David (1989), *The Power of Images: Studies in the History and Structure of Response*, Chicago: University of Chicago Press.

Gamboni, Dario (1997), *The Destruction of Art: Iconoclasm and Vandalism since the French Revolution*, New Haven: Yale University Press.

Gutmann, Joseph (ed.) (1977), *The Image and the Word: Confrontations in Judaism, Christianity, and Islam*, Missoula, Mont.: Scholars Press for the American Academy of Religion.

Herrin, Judith (2002), *Women in Purple*, Princeton: Princeton University Press.

Koerner, Joseph Leo (2004), *The Reformation of the Image*, Chicago: University of Chicago Press.

Latour, Bruno and Weibel, Peter (eds) (2002), *Iconoclash: Beyond the Image Wars in Science, Religion and Art*, exh. cat. (Zentrum für Kunst und Medientechnologie, Karlsruhe), Cambridge, Mass. and London: MIT Press.

Morgan, David (1996), 'Would Jesus have sat for a portrait?' Morgan David (ed.), in *Icons of American Protestantism: The Art of Warner Sallman*, New Haven: Yale University Press, pp. 181-206.

Sartwell, Crispin (1991), review of Freedberg, *The Power of Images*, *Journal of Aesthetics and Art Criticism* **49**, 85–6.

Spraggon, Julie (2003), *Puritan Iconoclasm during the English Civil War*, Rochester, NY: Boydell.

Stewart, Peter (1999), 'The destruction of statues in Late Antiquity', in Miles, Richard (ed.), *Constructing Identities in Late Antiquity*, London: Routledge, pp. 159-89.

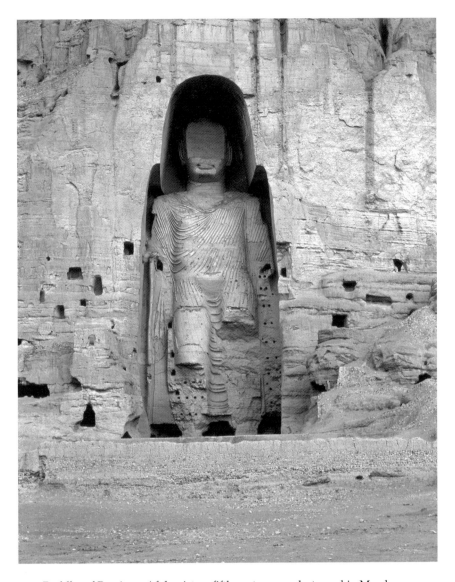

1.1　Buddha of Bamiyan, Afghanistan, fifth century AD, destroyed in March 2001.

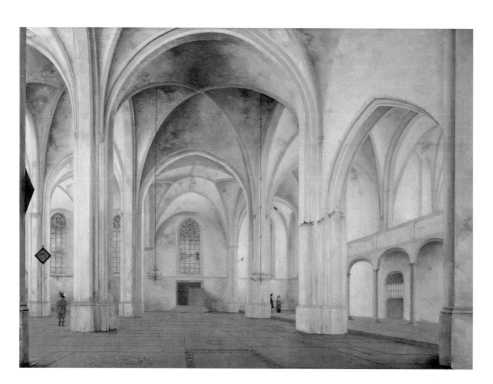

1.2 Pieter Jansz. Saenredam, *Interior of the church of Saint Cunera in Rhenan, Netherlands*, 50 x 68.8 cm, oil, 1655

Refiguring iconoclasm in the early Indian mosque[1]

Finbarr B. Flood

Most accounts of the recent destruction of the Bamiyan Buddhas took it for granted that their demise could be situated within a long culturally determined tradition of image destruction referred to as 'Islamic iconoclasm' (Flood, 2002a). In traditional usage, 'Islamic iconoclasm' refers to a quasi-pathological aversion to figuration that is assumed to be an essential and enduring characteristic of Islamic cultures, directed towards the religious images of the non-Muslim 'Other' in particular. Acts of iconoclasm committed by Muslims are held to be the product of a religious compulsion underwritten by a timeless theology of images, and only secondarily motivated by economic or political factors, if at all. The naturalization of iconoclastic acts negates the role of Muslim iconoclasts as historical agents (Ernst, 2000, p. 116), obscures the specific socio-political circumstances in which image destruction occurs, and elides regional and historical differences in attitudes to figuration. Those who represented the fate of the Buddhas as the inevitable product of a cultural fixation with images, for example, ignored the fact that they had been celebrated as wonders by Muslim writers for almost a millennium before their destruction. In doing so, they obviated the need to explain what specific changes in the culture and politics of the region (and beyond) had led to the events of March 2001.

The dominance of an essentialist paradigm is reflected in the striking dearth of any detailed regional or synchronic studies of what Muslims who objected to images (whether created by Muslims or others) actually did to them. Although this essay focuses on a particular region of the Islamic world (northern India) at a specific point in time (the late twelfth century), in attempting to challenge established notions about Islamic iconoclasm, it seeks to demonstrate the need for further empirical research on the subject and a re-evaluation of the conceptual framework within which it has been articulated.

Islamic iconoclasm

The opposition to figuration in Islam is based not on any Qur'anic injunction, but on various Traditions of the Prophet, the Hadith (Paret, 1960 and 1968; van Reenen, 1990), whose proscriptions are reinforced by historical accounts of idol-destruction after the conversion of pagan sanctuaries in Arabia for Muslim use (Flood, 2002a). The two principal objections to figuration in the proscriptive texts are a concern with usurping divine creative powers (Paret, 1960, pp. 43–4; Wensinck[-Fahd] 1997, p. 889), and fear of *shirk*, polytheism and idolatry (Hawting, 1999, pp. 22, 49). There is a general consensus in the Traditions forbidding all representations that have shadows (whose defacement is obligatory), and some schools of thought go so far as to liken artists to polytheists (Wensinck-[Fahd], 1997, pp. 889–90). Proscriptions like these were undoubtedly a factor in promoting aniconism, or the avoidance of figural imagery (Grabar, 1977, p. 51), but their impact varied widely in time and place. Attitudes towards figuration could change over time, or with the advent of new political regimes and consequent shifts in cultural values. Changes in attitudes or a lingering unease with figuration could inspire acts of iconoclasm by pious individuals or, more rarely, by agents of the state, acts that might target either the symbols of the 'Other' and/or the art produced during the reigns of Muslim predecessors.[2] The uneven and sometimes inconsistent ways in which such iconoclastic initiatives were undertaken, and the fact that figuration was contested even between Muslims attests the lack of a homogenous or monolithic attitude towards figural art in the medieval Islamic world.

The practical strategies for dealing with pre-existing images prescribed in the Hadith offer two basic alternatives that fall far short of obliteration. Images could, for example, be recontextualized in a manner that made clear that they were in no way venerated (by reusing figural textiles as floor cushions, for example). Alternatively, they might be decapitated, so that they became inanimate, that is, devoid of a soul, *rūḥ* (Paret, 1960, pp. 46–7; Paret, 1976–77, pp. 158, 176; van Reenen, 1990, pp. 33, 54). To judge from both textual evidence and surviving objects, these strategies were frequently employed by medieval iconoclasts in the Islamic world (Flood, 2002a). In many cases defacement (or the mutilation of the affective parts of the face such as the eyes and nose) often substituted for decapitation, a practice that finds precedent in early accounts of the Prophet Muhammad's iconoclastic activities (Faris, 1952, p. 27). Particularly in manuscript painting, a line was sometimes drawn across the throat in a symbolic decapitation (Petrosyan et al., 1995, pp. 144–55).

In terms of their practices, Muslim iconoclasts are often indistinguishable from other types of iconoclasts, for the same focus on the head, face and eyes

characterizes the work of late antique, medieval and early modern iconoclasts in Europe (Freedberg, 1989, p. 415). This attention to the affective features of the representation may have been intended to neutralize images in a manner determined by Prophetic precedent, but it also accords with the way in which shame, transgression or a lack of fidelity was inscribed on the body of contemporary living beings (Flood, forthcoming a). In certain cases religious images were publicly destroyed in places otherwise used for public executions and the punishment of criminals in the Islamic world (Rashid and Mokhdoomi, 1949, p. 23), a practice that finds parallels in other cultures (Nylander, 1980; Stewart, 1999).

While the prescribed methods were frequently employed against images, iconoclastic praxis could also range from the total obliteration of objectionable images to their ritual defilement by bringing them into contact with impure substances (Flood, 2002 a). As Dario Gamboni notes in his recent book on European iconoclasm, 'a work may be "damaged" rather than "destroyed" in order to make it a token of the violence it was subjected to and of the infamy of anything with which it is associated' (1997, p. 9). The Hadith dealing with images suggest and certain iconoclastic practices imply that this was often less an attempt to negate the image than to neutralize it. The continued existence of ritually 'destroyed' images suggests that the dichotomy between creation and destruction that underlies much writing on Islamic iconoclasm offers too reductive a reading of iconoclastic practice.

Islamic iconoclasm and the early Indian mosque

There are few areas of the Islamic world where the issue of Islamic iconoclasm has proved as contentious as it has in South Asia. In traditional South Asian historiography of the colonial and post-colonial periods, the invasions of predominantly Hindu northern India by the armies of Muslim sultans based in Afghanistan during the eleventh and twelfth centuries are characterized as pitting a monolithic indigenous iconophilia against an equally homogeneous Islamic iconophobia, resulting in the destruction of temples and the looting and desecration of religious icons.

Curiously, discussions of Islamic iconoclasm in South Asia have tended to focus on its least tangible aspect, the now vanished portable images, whose histories are known primarily through medieval texts (Davis, 1997, pp. 88–113). This focus on the intangible reflects a larger historical problem in the study of medieval South Asian cultures, namely the pre-eminence afforded texts, which frequently provide the lens through which even material remains of the medieval period are viewed (Patel, 2000, pp. 325–58; Kumar, 2001, p. 172). Thus, the much more quantifiable evidence for iconoclasm

offered by the transformation of images that appeared on architectural elements from Hindu temples reused in certain medieval Indian mosques has escaped detailed examination. Nevertheless, in a regional variant of the essentialist view of Muslim responses to the image discussed above,[3] these have generally been taken as corroborating textual accounts of a virulent iconoclasm, with devastating consequences in the present.

The destruction of the sixteenth-century Babri Mosque at Ayodhya in 1992, which sparked violent inter-communal rioting, was rationalized by the belief that a temple that once stood on the site had been destroyed by Muslim iconoclasts to make way for the mosque (Guha-Thakurta, 1997). Those seeking to provide a rationale for this act of contemporary iconoclasm, and to prepare the ground for future destruction, have drawn directly on colonial and post-colonial scholarship on Indo-Islamic monuments (Goel, 1993). Within such scholarship the very presence of 'Hindu' material in mosques is frequently assumed (often erroneously – see Flood, 2001, p. 155) to corroborate the generic references to temple destruction that pepper medieval Arabic and Persian textual histories, with little further investigation (Asher, 2000, p. 122; Patel, 2000, pp. 311–22; Kumar, 2001, p. 175).[4] However unwitting, the recent complicity of scholarship on early Indo-Islamic architecture in the current wave of anti-Muslim iconoclasm is directly proportional to its continuing willingness to embrace the essentialist paradigm of Islamic iconoclasm discussed in the preceding section.

This paradigm is particularly evident in published discussions of the mosques built in the later twelfth and early thirteenth centuries (roughly between 1190 and 1205), after much of northern India was brought under the control of an eastern Iranian dynasty of Muslim rulers from Ghur in what today is central Afghanistan. This radical change in the political configuration of South Asia has usually been seen as bringing about a profound rupture in the cultural fabric of the region, the product of a clash between two mutually opposed and incommensurate cultural traditions. Articulated within discussions of mosques built after the conquest, discussions often strongly coloured by issues of colonialism, nationalism, religious fundamentalism and race (Kumar, 2001; Flood, 2004), the question of responses to the image, and to religious imagery in particular, has served as a touchstone for this division.

At least four mosques built in the wake of the conquest survive. Two of these, the Qutb (or 'Quwwat al-Islam') mosque in Delhi and the Arhai-din-ka Jhompra Mosque in Ajmir, Rajasthan, bear foundation inscriptions giving respective dates of 587/1192 and 596/1199 (Horovitz, 1911–12, pp. 13, 15; Hillenbrand, 1988). The inscriptions of the Delhi mosque inform us that it was built by the Turkish commander Qutb al-Din Aybak on the orders of the Ghurid sultan, Muhammad ibn Sam [d. 1206] (Horovitz, 1911–12, p. 14; Page,

1926, p. 29). A third mosque, the Shahi-Masjid at Khatu in Rajasthan, is provided with a mihrab (prayer-niche) of virtually identical form to that in the Ajmir mosque, and can be confidently dated to the turn of the twelfth century (Shokoohy and Shokoohy, 1993, p. 107). Finally, the Chaurasi Khamba mosque at Kaman, in the Bayana region of Rajasthan can be ascribed to the patronage of another Turkish commander of the Ghurids, Baha al-Din Tughrul, some time between 1195 and 1210, when he ruled as governor (Shokoohy and Shokoohy, 1987).

The basic form of these stone monuments is similar in each case, with a monumental projecting entrance (often elevated) leading to a central courtyard with a multi-bayed prayer hall at its western end and, at Delhi and Kaman, a narrow arcade or *riwāq* surrounding the remaining three sides. The interior spaces are covered by means of corbelled domes and flat slabs supported on trabeate beams borne by pillars composed of discrete sections set vertically on end to achieve the required height (Figure 2.1). Many (but not all) of these elements have been reused from earlier pre-conquest monuments.

Based on a number of common features, including the use of spolia and their location on what are believed to be the sites of former temples, it has been suggested that such mosques constitute a distinct type, recently dubbed the 'conquest mosque', which are associated with the expansion of the frontiers of Islamic South Asia (Wagoner and Rice, 2001, pp. 89–90). By contrast, the stone mosques built by (mainly Hindu) craftsmen for communities of Muslims living in Sind and Gujarat in the eleventh and twelfth centuries, before the Ghurid conquest, make no use of spolia (Shokoohy, 1988). Such craftsmen were surely available in major urban centres such as Ajmir and Delhi after the conquest and, as we will see, may even have been involved in the construction of Ghurid mosques from reused materials. The use of spolia even when alternatives were available thus seems to represent a conscious choice. The fact that the same pattern is repeated later after expansion into different Indian regions by the Delhi sultans in the thirteenth and fourteenth centuries suggests a relationship between the construction of such mosques from spolia and successful campaigns of conquest (Wagoner and Rice, 2001, pp. 90–105).

As Dale Kinney has noted of spolia in another context, 'how the *spolia* were acquired must have been a principal determinant of how they were originally perceived' (1995, p. 57). In published discussions of the Indo-Ghurid mosques the reused material is either assumed to come from desecrated temples, or the contentious issue of source is side-stepped by attributing the use of spolia rather generically and vaguely to a pragmatism deriving from their abundance (Patel, 2000, p. 270). It seems probable that the truth lies somewhere in between. As the range of styles represented in the

material indicates, not all the material reused in Indo-Ghurid mosques is of the same date: in fact, some of the material pre-dates the Ghurid conquest by several centuries (Meister, 1993, p. 448). Although not strictly orthodox, the reuse of earlier architectural material was known in north Indian temples (Wink, 1997, p. 322; Dhaky, 1998, p. 127). The reuse of material does not of itself offer evidence for temple desecration, therefore, since some of this material may have been available from ruined structures including (but not restricted to) temples. Other of the spolia reused in the Indo-Ghurid mosques come from more recent structures, however, and their abundance seems to reflect a policy of selective desecration during periods of conquest and military expansion.

Although the phenomenon of iconoclasm in pre-conquest South Asia is usually considered a cultural anomaly, and has therefore never been systematically studied, both image destruction and temple desecration was practised by 'Hindu' kings before the advent of the Ghurids. Just as divergent attitudes to images existed within Islam, Buddhist, Hindu and Jain images were also contested between different sects and faiths in South Asia, sometimes leading to the desecration and destruction of portable icons, or the erasure and mutilation of images in temples and shrines (Golzio, 1990; Thapar, 1994, pp. 16–18; Wink, 1997, pp. 310–11; Flood, forthcoming a). Other instances of pre-conquest iconoclasm occurred at times of military conquest or political change, and may be seen as reflecting the close inter-relationships between centres of political and religious authority in medieval South Asia. In addition to image destruction, medieval South Asian rulers also desecrated the temples of those that they defeated far more frequently than one might imagine from published discussions of the early Indian mosque (Eaton, 2000, p. 256; Flood, forthcoming a).

In a recent study of those instances of temple desecration by invading Muslim armies that can be reliably documented, Richard Eaton concludes that 'temples had been the natural sites for the contestation of kingly authority well before the coming of the Muslim Turks to India,' therefore, 'by targeting for desecration those temples that were associated with defeated kings, conquering Turks, when they made their own bid for sovereign domain in India, were subscribing to, even while they were exploiting, indigenous notions of royal legitimacy' (2000, pp. 256, 270). In many cases these were not random acts of destruction, but represented a targeted desecration of temples associated with ruling dynasties, whose tutelary images were often carried off for display in the victor's capital (Davis, 1997, pp. 51–87; Eaton, 2000, p. 256). Eaton's analysis suggests that periods of military and political expansion were characterized by a selective desecration of shrines identified as the power bases of defeated rivals: as an instrument of state policy this practice finds parallels in the practices of pre-conquest

Indian rulers. Along with the looting and destruction of religious images, temple desecration therefore appears to have been a phenomenon of the expanding frontier in pre-Ghurid South Asia. It thus seems likely that the employment of spolia in the early mosques derives from a complex interweaving of political and economic pragmatism: depriving a rival of the source of his political power, while profiting from the resulting availability of architectural materials. A similar intention can be detected behind the looting of temple elements by pre-conquest Indian kings, who carried the materials off to be incorporated into their own dynastic shrines (Dayalan, 1985, p. 136). To highlight continuities in royal practice is not to deny important differences in the nuances and political consequences of iconoclastic acts in northern India before and after the Ghurid conquest (Kumar, 2001, pp. 159, 161), although even here cultural difference has frequently been overemphasized (Flood, 2002a, pp. 650–51; Flood, forthcoming a). It is, however, important to emphasize that the principle of image destruction, temple desecration and the reuse of architectural elements in the context of military conquest was by no means as alien to South Asia before the twelfth century as is often assumed.

Iconoclasm and the aesthetics of early Indo-Islamic mosques

Perhaps because of its implied associations with conquest and victory, the reuse of architectural members in Indo-Ghurid mosques has been read as a derogation of Indic tradition, a negative response to the aesthetics of the temple and its emphasis on figuration. In one of the earliest reports on the 'Quwwat al-Islam' Mosque, the Ghurid Friday mosque of Delhi (1192 onwards [Figure 2.1]), the antiquarian Alexander Cunningham noted in 1863 that:

The general effect of these large rows of made-up columns is certainly rich and pleasing; but this effect is due to the kindly hand of time, which has almost entirely removed the coating of plaster with which the whole of these beautifully sculptured pillars were once barbarously covered by the idol-hating Musalmâns.

(1871, p. 177)

What is particularly interesting about Cunningham's appraisal is the way in which the question of aesthetic value was inversely linked to the iconoclastic impulse in scholarly discourse on this key monument from its inception. This linkage is related to a much broader art historical tendency to privilege originary works over those created from their components (Kinney, 1995, p. 55; Patel, 2000, p. 236). In terms of the Indo-Ghurid mosque, that originary work is doubled, consisting of both the assumed material source, the

despoliated temple from which components are drawn, and the conceptual source, the eastern Iranian mosque to which the early Indian mosques are often assumed to be crude (and aesthetically alien) approximations (Welch, 1993, p. 314). In what follows, I want to suggest ways of looking at the Indo-Ghurid mosque that transcend the tendency to privilege some implied original (whether material temple or conceptual mosque), considering the Indo-Ghurid monuments not as random collections of mutilated fragments, but as *Gesamtkunstwerks*, total artworks, and examining the role of iconoclasm in their creation.

Let us turn to the first two of Cunningham's propositions: that the images carved on the reused pillars were covered, hence no aesthetic value was placed on the pillars. The iconoclastic practices envisioned by Cunningham – a spree of image mutilation followed by a swift dose of whitewash – not only have a distinctly Protestant feel to them, but are based on a number of erroneous assumptions. In fact, somewhat ironically, any desire to obscure the decoration of the reused pillars seems to have been subordinated to aesthetic considerations, for the 'pleasing effect' that Cunningham noted in the rows of reused pillars was deliberately orchestrated by those responsible for the mosque's construction. At key points in the mosque – around entrances for example – the grey, yellow and red stones from which the mosque was constructed are arranged so that these colours alternate in vertical bands. This is not a random effect, for similar aesthetic considerations governed the reuse of architectural material in the Ghurid Friday Mosque at Ajmir, and in the mosque at Kaman also in Rajasthan, where one also finds alternating courses of richly carved grey, yellow and red stone. Some of this material may have come from temples targeted as symbols of the *ancien régime*, but the majority of it was re-deployed in a manner congruent with pre-conquest practice; similar arrangements of structural stones to form horizontal bands of colour are sometimes found in the pre-conquest temple architecture of north India. Lithic polychromy is thus among a number of features common to both temple and mosque, despite the reconfiguration of visual idioms in the latter (Meister, 1993, p. 449). This continuity of tradition suggests that craftsmen trained to build temples were later involved in the construction of Ghurid mosques from their components. Even if these components were plastered in the *post*-Ghurid period, the care taken to achieve such effects only makes sense if the pillars were seen and *not* obscured beneath a coat of plaster when the mosques were built in the twelfth century.[5]

The assertion that the images on the structural members of the Delhi mosque were obscured is thus contradicted by the most cursory examination of the monument, and would appear to be based solely on the belief that images must have been so offensive to the patrons of the mosque that they

could not possibly have remained visible. A variant on this idea holds that the figures depicted on reused material were mutilated in 'a rather feeble and crude attempt to render the human form unrecognizable' (Grover, 1981, p. 6). Just how feeble, may be seen from the fact that clearly recognizable human figures are to be found throughout the mosque. Nevertheless, changes have been made to many of the anthropomorphic representations. In the majority of cases these alterations are restricted to the most anthropomorphic features, predominantly facial features such as eyes and noses (Figure 2.2), thereby conforming to iconoclastic practice in other areas of the medieval Islamic world (Flood, 2002a).

Assuming that the majority of the alterations to the images in the Delhi mosque were made at the time that the pillars were reused in the late twelfth century (and broad parallels with the patterns of alteration found in other Indo-Ghurid mosques would seem to support this[6]), we are dealing with something much more than a visceral response to the image. The scale of the undertaking suggests a considerable investment of time and labour: one might even speak of an economics of iconoclasm. Other case studies indicate that the iconoclastic process can be bureaucratic, calculated and protracted (Bahrani, 1995, p. 367): in the case of the materials reused in Delhi and elsewhere it must have extended over a certain time frame, days at least. We are not dealing therefore with an immediate emotional reaction, but with what appears to have been an orchestrated programme of alteration directly related to that which governed the collection and re-assembly of existing architectural materials.

As already noted, it is probable that craftsmen trained in a temple tradition were responsible for the construction of many, if not all, Indo-Ghurid mosques. It is therefore conceivable, if not provable, that these same craftsmen were responsible for altering the figures on reused pillars at the behest of their Ghurid or Turkic patrons. Many instances of 'Islamic iconoclasm' appear to be the product of a negotiation between iconoclasts and iconophiles, with the latter modifying existing images either for financial remuneration or to prevent more extensive alterations by those opposed to figuration (Schick, 1995, pp. 218–19; Flood, forthcoming a). Physical damage to religious icons was considered to preclude their veneration (Davis, 1992, p. 52), a fact noted in medieval Arabic references to Indian iconolatry (Said, 1989, p. 78). The alteration of the relatively minor deities found on the elements reused in Indo-Ghurid mosques may therefore have functioned as a mode of de-consecration desirable to both Muslim patrons and Hindu craftsmen for different reasons. The range of ways in which images are altered (from the uncommon total erasure to the ubiquitous gouging of the face [Figures 2.2 and 2.3]) suggests that while the impetus for neutralizing the images came from the patrons of these monuments, the specific ways in which it was to be effected were left to the individual craftsman.

Once again, such investment of resources in the alterations to figural imagery only makes sense if those images were originally visible in their altered state and not obscured beneath a layer of stucco. One therefore gets the impression that the alteration of anthropomorphic images was less a product of a desire to obscure them, than of a need to neutralize them in a manner which accorded with both textual prescriptions and established iconoclastic practice. This need was contingent upon the decision to reuse pre-carved elements bearing figural ornament in the construction of a mosque. This being so, it might be useful to distinguish here between *instrumental* iconoclasm, in which a particular action is executed in order to achieve a greater goal, and *expressive* iconoclasm, in which the desire to express one's beliefs or give vent to one's feelings is achieved by the act itself (Gregory, 1994, p. 89). While these are by no means mutually exclusive categories, the use of decapitation and defacement in the early Indian mosques represents a type of instrumental iconoclasm, for it permitted the licit survival of pre-existing images in the prescribed way (albeit in altered form) as part of a larger whole. Although the product of changes in attitudes *within* a religious community, an analogous phenomenon may underlie the erasure of images in the late antique synagogues of Palestine, which one scholar has ascribed to 'the desire to keep using a mosaic or appurtenance after the communal aesthetic changed from one of tolerance for images to one of lessened tolerance or even hostility toward them' (Fine, 2000, p. 190).

There is little sense that the reuse of temple elements in Indo-Ghurid mosques represents a derogation of the Indic traditions that they are assumed to instantiate, although this has been frequently asserted. On the contrary, established conventions continued to govern the reuse of pre-existing elements, which conforms to the architectural grammar of the Indian temple (Meister, 1993, p. 448). Even elements featuring figural ornament were used right side up in prominent contexts (above exterior window openings, for example [Page, 1926, pl. 9c; Dikshit, 1944]), while iconoclastic alterations to such figural scenes were relatively restrictive in nature, and did not involve all figures equally, as we shall see shortly. In Ajmir, Delhi and Khatu reused elements appeared alongside those carved ex novo, with the style of the spolia determining that of the newly carved members (Meister, 1972, p. 57; Patel, 2000, p. 235). A recent study of reuse in these early mosques concludes that 'the continued development of the style of the despoliated fragments seems to indicate more of a positive response than the traditional scholarly interpretation of a violent extinguishing of a despised tradition' (Patel, 2000, p. 322). The positive aesthetic value placed on architectural materials reused in Indo-Ghurid mosques needs to be seen in a wider cultural and geographic context. Similar continuity of tradition is attested by contemporary funerary monuments built for Ghurid patrons in the Indus Valley, which make no use

of stone or spolia, but are instead constructed from brick, the established building material in the region. The style of these monuments is closely related to that of the temples of the region, and they appear to represent collaboration between local artisans and those from Ghurid centres in Afghanistan and indigenous Indus Valley craftsmen (Flood, 2001, pp. 144–8, 157).

Even more remarkable is the evidence for Ghurid architectural tastes and aesthetic values from Afghanistan itself. While Indic elements, may be found in the art of the region from the eleventh century (Flood, 2002b, p. 111, pls 10.5–10.6), along with decorative and structural techniques that hint at the presence of Indian craftsmen (Fischer, 1966, p. 29; Pinder-Wilson, 2001, p. 157), it is precisely at the height of the Indian conquest at the end of the twelfth century that a vogue for Indic ornament manifests itself most strongly in the Ghurid homeland. The most remarkable testimony to this vogue is the Masjid-i sangi at Larvand in central Afghanistan, a small stone mosque built entirely in an Indic idiom, whether by migrant craftsmen or with materials taken to Afghanistan from India is not clear (Scarcia and Taddei, 1973; Ball, 1990). Writ large in the construction of the Masjid-i sangi, the phenomenon is also evidenced in a number of other fragmentary late twelfth-century Ghurid monuments that make use of standard decorative elements of Indic architecture, among them vase-and-foliage capitals, lotus scrolls and half-lotus friezes (Flood, 2001, pp. 153–4, figs 42 and 43). Taken with the evidence of the Indian monuments themselves, such Afghan survivals offer further indications that the material reused in Indo-Ghurid mosques was invested with a positive aesthetic value.

The third and final of Cunningham's assumptions concerns not the specifics of the Indian mosque, but the more general assumption that a virulent iconophobia determined an aggressively negative attitude towards all figural imagery on the part of medieval Muslims. This idea, first promulgated in colonial era reports on the early Indian mosques, is of course premised on the essentialist discourse discussed above. It continues to have currency in qualified forms: in a recent revised edition of the most influential survey book on Islamic art and architecture, the iconoclastic transformations witnessed in the Delhi mosque are ascribed to the 'fanatic iconoclasts who formed the backbone of the conquering armies' (Ettinghausen et al., 2001, pp. 163–4). Similarly, the notion of Ghurid armies as comprised of violent iconoclasts seems to underlie continued assertions that the images on the reused stones were originally covered (Welch, 1993, p. 311), despite the evidence to the contrary within and without the mosque. Seldom is it noted, for example, that, in their Indian coin issues, the Ghurid sultans continued pre-existing types featuring Hindu deities such as Lakshmi and Nandi (Sastri, 1937, p. 495; Flood, forthcoming a). While it by no means proves that

the issue of the image was unproblematic, the minting of such coins certainly reveals a more complex and ambivalent response to figural imagery (even religious imagery) on the part of the Ghurid sultans than one would suspect from reading contemporary chronicles. The glimpse into this liminal space between textual rhetoric and cultural practice provided by the numismatic evidence may be broadened by reference to the specific treatment of the images that appeared contemporaneously on the richly carved stone elements reused in Indo-Ghurid mosques. On closer examination, many of the mosques that are assumed to embody a visceral loathing of the image in fact offer evidence that undermines the idea of a monolithic Islamic iconoclasm.

By the late twelfth century there was, as we have seen, a long-established aversion to the use of figural imagery in the decoration of a mosque, and the figural representations that appeared on reused material in Indo-Ghurid mosques were indeed considered problematic. Steps were therefore taken to alter some of the existing figural decoration. The alteration of figural sculpture on elements valued for their aesthetic properties is by no means exclusive to India: the same phenomenon is manifest contemporaneously in Ayyubid treatment of Crusader sculpture reused in the Islamic monuments of Jerusalem after its recapture in 1187 (Jacoby, 1992, p. 21; Flood, forthcoming b). Moreover, the alterations to figural imagery on the material reused in Indo-Ghurid mosques are far from evidencing a monolithic iconoclasm. On the contrary, they are closely correlated to the nature of the imaged; the economics of iconoclasm evidently dictated that only those images considered most problematic were altered.

The defacement of anthropomorphic imagery is the closest one gets to a monolithic iconoclasm, and considerable resources appear to have been expended in neutralizing such imagery. In only a few cases are the alterations so drastic that they amount to the total elimination of the form so that it is no longer recognizable or visible only in shadow outline (Figure 2.3). In most cases the alteration is restricted to the mutilation of the face or head (Figure 2.2). Much less energy was expended on dealing with animal imagery, which is only occasionally altered (as noted by Shokoohy and Shokoohy, 1993, p. 109 and 1996, p. 335). Certain types of representational imagery, including figural imagery, were thus left untouched in Indo-Ghurid mosques, with elephants, birds and mythological creatures such as *maqaras* appearing alongside headless torsos and noseless faces. This is particularly evident in the northern porch of the Kaman mosque, richly embellished with reused figural sculpture which has been selectively altered and in the mosque at Delhi, where images of mythological creatures are intact, while anthropomorphizing images are defaced (Figure 2.4).

Most remarkable of all, and perhaps by virtue of its perceived apotropaïc

properties, the image of the radiant horned lion, the *kīrtimukha*, was not only left unaltered, but became as ubiquitous a figure as it had been in pre-Ghurid Buddhist stupas and Hindu temples (Flood, forthcoming a). In the Qutbi mosque of Delhi alone, the image of the *kīrtimukha* appears more than thirty times on the trabeate lintels that still remain in place (roughly 50 per cent of the original number), and innumerable more times on the reused columns that support them. Even in the mosques at Ajmir and Khatu, where the iconoclastic alterations are most extensive, numerous manifestations of the beast are still intact. In fact, it seems to have been considered such an integral part of the contemporary mosque that it is found on elements that appear to have been carved ex novo for Ghurid mosques in India (at Khatu for example), and on the entrance and interior beams of the Masjid-i sangi in central Afghanistan, where it features alongside friezes of ducks or geese similar to those found in Indo-Ghurid mosques and Hindu temples (Scarcia and Taddei, 1973, p. 98, figs 3 and 4). The latter serves as a cogent reminder that even figuration was no bar to the assimilation of Indic elements in monuments erected for Ghurid patrons, within or without India.

As the case of the *kīrtimukha* demonstrates, it was not figuration per se that was the problem, nor even figuration in the context of mosque decoration, but the nature of what was represented in such a context. Paradoxically, despite a supposed quasi-pathological aversion to figural imagery, a surprisingly liberal attitude to figuration seems to have prevailed in the first mosques built after the Ghurid conquest.

Refiguring Indo-Islamic iconoclasm

Part of the problem with the way in which Indo-Ghurid mosques have been conceptualized from the nineteenth century onwards lies in a disciplinary tendency to privilege the creation of a work (be it painting, sculpture or monument) over its reception. The consequences of what might be called a synchronic fixation are abundantly clear in Cunningham's characterization of the reuse of temple materials in Ghurid mosques as a barbarous anti-aesthetic gesture. If, however, we approach the work diachronically, not as a static creation frozen at the moment of birth, but as dynamic and constantly shifting in terms of form, content and meaning, then we can begin to conceive of reuse and the role of iconoclasm in the early Indian mosque in a less reductive manner.

In his work on iconoclasm during the French Revolution, Richard Wrigley has noted that 'in practice, we find that acts of iconoclasm are commonly exercises in compromise, usually resulting in hybridized or synthetic results' that represent a dialectical synthesis between different traditions (1993,

p. 185). As Wrigley notes, the product of such a compromise may be intended to convey a quite different message than the original work, but its original meanings are never entirely obliterated, but are present under erasure, obscured yet still visible and in dialogue with the superimposed marks of effacement. Such mutilated images index their own history of transformation, which is integral to the production of what is in effect a new work; the act of iconoclasm may thus be seen as an attempt to re-code meaning according to new iconographic and aesthetic conventions. Developing this idea, the various responses to figural imagery witnessed in the Indo-Ghurid mosque might be seen as a compromise necessitated by a preference for the (at least partial) reuse of stone elements in the construction of new mosques, and therefore rooted in a tension between continuity and discontinuity. Indeed, as an architectural creation with multiple aesthetic affinities, the Indo-Ghurid mosque itself is the product of such a compromise.

Rather than see the consequent process of transformation in terms of hybridization or syncretism with its implied 'condition of uneasy union' (Stewart and Ernst, forthcoming), the physical and conceptual displacements that it entails might be best conceptualized as a type of visual 'translation'.[7] The concept of translation that it implies is not the traditional one of equivalence or fidelity to an original, however, but one closer to Derrida's notion of textual translation as 'a regulated transformation of one language by another, of one text by another' (1981, p. 20). Homi Bhabha has developed this idea in arguing that the process of translation gives rise not to secondary (and implicitly inferior) versions of original texts, but to new works that contain traces of the earlier meanings that they transcend (Bhabha, 1990; Evans, 1994, p. 32). Although developed in relation to texts, this concept of translation as a transformative process that gives rise to new works has much to recommend it as a model for understanding iconoclastic transformations of existing artworks.

The idea of iconoclastic intervention as transformative process has a long pedigree in twentieth-century Euro-American art, notably in Duchamp's *LHOOQ* (Gamboni, 1997, p. 262) and Rauschenberg's *Erased de Kooning* (Gamboni, 1997, p. 268). In a recent posthumous publication, the anthropologist Alfred Gell argued that as the product of a type of 'artistic agency', iconoclastic alterations follow the same conceptual structure as the act of creation, giving rise to a new work, related to, but distinct from the original (Gell, 1998, pp. 62–5). Over the past decades, a similar case has been made by several iconoclasts, who justified their interventions on well-known artworks as exercises in creative transformation (Kastner, 1997, p. 154). Such claims raise important questions about the nature of modern artistic agency and authorship, but it is worth noting that authors of the works targeted in these creative outbursts have sometimes accepted, either implicitly, or

explicitly that radical alterations to the original works constituted an extension of the creative process (Hirst, 1997).

However, unlike the self-publicizing iconoclastic gestures of contemporary artists, the acts of iconoclasm to which Indo-Ghurid mosques bear witness were not the driving force in the production of a work that might be entitled 'The Indo-Ghurid Mosque'. They were instead *contingent* upon a decision to reuse pre-existing architectural materials. Despite this contingency, conceiving of iconoclastic transformation as a process of visual translation enables us to escape the bind into which we are placed by our tendency to privilege the originary work (whether Persian mosque or Indian temple) as more authentic than any subsequent work created from its elements. Transcending the synchronic fixation inherent in colonial and later receptions of the Indo-Ghurid mosques, we can see the physical and conceptual translations to which they bear witness not as barbarous attacks upon (or crude approximations of) an originary aesthetic tradition, but as part of a process of transmutation that gave rise to the Indo-Ghurid mosque, a new work with its own distinctive aesthetic. While contingent upon a decision to reuse existing architectural elements, the alteration of figural imagery was integral to the creation of that work. A widespread and long established aversion to the use of figural imagery in the decoration of a mosque led to steps being taken to neutralize anthropomorphic images on the reused architectural elements in ways that conformed to orthodox prescriptions and established practice. The process provides evidence for the creative function of iconoclastic transformation at both the micro and the macro level: in the transformation of illicit anthropomorphic figures into qualitatively new images, and in the contribution that this makes to the creation of what was in effect a Ghurid *Gesamtkunstwerk*. The contemporary appearance of the *kīrtimukha* and other Indic elements in the art and architecture of Afghanistan serves as a reminder that, like any translation, the reception upon which this transmutation was premised altered the receiving (or target) culture in its turn.

However anachronistic the idea of iconoclasm as a type of creative process, a 'regulated transformation' of one visual language by another, appears, it finds some support among the Hadith discussed at the outset, which prescribe a transformative practice not so far removed from that which Derrida or Gell envisages. Among a group of Traditions that deal with the angel Gabriel's refusal to enter the house of the Prophet Muhammad is one which attributes his hesitancy to the presence of images on a curtain and another unspecified object. The remedy for the curtain is to transform it into pillows that will be thrown on the ground and trodden upon, while the Prophet is ordered to decapitate the remaining images, so that they become like trees by virtue of their inanimate status (Ibn Ḥanbal, 1313/1895, vol. 2,

pp. 305, 308, 390; van Reenen, 1990, p. 33). The positive iconographic value of such flora is seen from an early date in the mosaics of the Great Mosque of Damascus (AD 705–15) where, as Oleg Grabar has pointed out, monumental trees take the place of the saintly figures that one would expect in an equivalent Byzantine church mosaic (1987, pp. 88–9). Given the emphasis on tree-like images in the early Hadith dealing with figuration, and the fact that later iconoclasts sometimes replaced figural scenes with images of trees and gardens (Goswamy, 1986, p. 133), this comparison may be more germane than anyone has suspected.

Formal or iconographic transformation is a relatively common response to iconoclastic concerns (witnessed, for example, in the transmutation of the Virgin into Liberty in Revolutionary France), but the nature of the transformation envisaged in the Hadith entails a radical ontological metamorphosis. The resemblance between tree and headless image clearly lies in the fact that both are perceived to lack a spirit (rūḥ) and with it, the potential for animation (van Reenen, 1990, pp. 33, 54). Decapitation is evidently judged to result in the production of what are in fact images of an entirely different class, inanimate and licit in place of the animate and illicit originals. The acts of alteration and creation thus appear closely intertwined, the simultaneity of their products destabilizing the boundaries between abstraction and figuration that is integral to much art historical thinking.[8]

This blurring of the boundaries is particularly marked in the iconoclastic reworking of figural material in the Ghurid mosque at Ajmir. Although the phenomenon has not been noted previously, at several points the columns in the upper levels of the southern end of the prayer hall have had their figures removed in such a way as to leave only a rhomboid outline (Figure 2.5), which perfectly replicates the form of the rhomboids or ratnas of similar size that have been carved ex novo on the lower shafts of the same columns. The latter replace the figural imagery normally found in this position in temple architecture (Patel, 2000, p. 233). Both newly carved members and those that have undergone iconoclastic transformations are thus structurally and aesthetically integrated. At least in the case of the Delhi mosque, we have an unusual abundance of descriptions from the century and a half following its construction (Flood, forthcoming a). The fact that none of these thirteenth- and fourteenth-century descriptions mention either the reuse of temple elements or the associated iconoclastic alterations strongly supports the idea that the mosque was perceived as a unitary structure by at least the literate among those who used it. The view of the early Indian mosques as fragmentary reflections of greater wholes thus seems to say more about the methodologies and priorities of modern observers than about their conception and reception by medieval builders, patrons and worshippers.

The close relationship (in both theory and practice) between acts of

iconoclasm and artistic creation indicates that even when rationalized within the rhetorical frame of religious orthodoxy, iconoclasm in the medieval Islamic world was not the product of an essential pathology. Rather, it often reflected a series of choices governed by a complex nexus of aesthetic, cultural, economic and political factors. The view of early Indian mosques as lithic testaments to the iconoclastic zeal of invading Muslim armies fails to acknowledge the exigencies of particular cultural or historical conditions on prescriptive scenarios, or the ways in which the dialectic between local cultural forms and the universal norms of Islam shaped artistic practice, a phenomenon that is particularly evident in South Asia. The absurd result is that in both scholarly and popular representations, some of the most image-rich mosques in the medieval Islamic world have become paradigms of an essential and undifferentiated iconophobia.

Notes

1 This essay is largely the product of very congenial and stimulating reading group on iconoclasm that took place at the Center for Advanced Study in the Visual Arts at the National Gallery in Washington, DC, during the academic year 2000–2001. It is based on a talk presented to the symposium *Exploring the Frontiers of Islamic Art* at MIT in May 2001, and was submitted for publication early in 2002. An extended discussion of the issues raised here will appear in chapter 6 of my forthcoming book on the Ghurids, and in *Altered Images: Islam, Iconoclasm and the Mutability of Meaning*, a general history of iconoclastic practice to be published by Reaktion Books.

2 An example of the first type is the edict against images issued by the caliph Yazid in 721, although the effectiveness of this, and even its historical veracity, is open to question (Vasiliev, 1956). An iconoclastic moment primarily directed against the art produced by earlier Muslims (although it included the destruction of Hindu icons) occurred in Delhi in the fourteenth century during the reign of sultan Firuz Shah Tughluq (r. 1351–88). By order of the sultan existing figural ornament on courtly objects and monuments were effaced, the latter being replaced with depictions of gardens and trees, in accordance with the proscriptions on figuration (Rashid and Mokhdoomi, 1949, 14).

3 A good example is André Wink's analysis of Islamic iconoclasm, in which he cites the destruction of (unnamed) religious monuments in modern Bangladesh and Pakistan as exemplifying the phenomenon seen in twelfth-century India (Wink, 1997, p. 323). There is no discussion of the very different cultural and historical circumstances in which these acts occurred (partition or the rise of the nation state, for example), and questions of motive and agency are obscured by the assertion of a timeless, theologically motivated cultural compulsion. For a critique of the same phenomenon in relation to Bamiyan, see Flood (2002 a).

4 There are some notable exceptions to this general tendency: see, for example, Lehmann (1978).

5 There are in fact many examples of Indian mosques in which richly carved reused elements that were originally exposed were later plastered over (Shokoohy and Shokoohy, 2000, p. 62, figs 10–11). This might have occurred as part of the iconoclastic programme of Firuz Shah Tughluq (see note 2). Even if whitewashed later, the images were not necessarily obscured: both temples and mosques could be whitewashed annually in India without obscuring (or without any intention to obscure) their decoration.

6 The mosques at Ajmir and Khatu, which are closely related in terms of their decoration, also represent the most radical expression of both an aniconic and iconoclastic impulse that is much more muted in Delhi and Kaman.

7 In an important and innovative article Tony Stewart (2000) has explored the implications of different translation theories for conceptualizing inter-communal textual production in early modern Bengal. While acknowledging the value of translation theory for conceptualizing various modes of cultural production across cultural, linguistic or religious boundaries in pre-colonial South Asia, my own theoretical perspective is more indebted to recent work located at the intersection between post-structuralist and post-colonial theories of translation (Niranjana, 1992) than to formal linguistic theories.

8 An interesting corollary exists in a number of twelfth- and thirteenth-century inscriptions from

eastern Iran (Ghurid inscriptions among them), where the inanimate script is anthropomorphized by the provision of faces, and even limbs (Grohmann, 1955–56).

References

Asher, Catherine B. (2000), 'Mapping Hindu-Muslim identities through the architecture of Shahjahanabad and Jaipur', in Gilmartin, David and Lawrence, Bruce B. (eds), *Beyond Turk and Hindu: Rethinking Religious Identity in Islamicate South Asia*, Gainesville: University Press of Florida, pp. 121–48.

Bahrani, Zainab (1995), 'Assault and abduction: the fate of the royal image in the ancient Near East', *Art History* **18** (3), September, 363–82.

Ball, Warwick (1990), 'Some notes on the Masjid-i Sangi at Larwand in Central Afghanistan', *South Asian Studies* **6**, 105–10.

Bhabha, Homi (1990), 'The Third Space', in Rutherford, Jonathan (ed.), *Identity: Community, Culture, Difference*, London: Lawrence and Wishart.

Cunningham, Alexander (1871), *Four Reports Made during the Years 1862–63–64–65*, Archaeological Survey of India Reports, vol. 2 (repr. Delhi and Varanasi: Indological Book House, 1972).

Davis, Richard H. (1992), 'Loss and recovery of ritual self among Hindu images', *Journal of Ritual Studies* **6** (1), Winter, 43–61.

Davis, Richard H. (1997), *Lives of Indian Images*, Princeton: Princeton University Press.

Dayalan, D. (1985), 'The role of war-trophies in cultural contact', *Tamil Civilization* **3** (2–3), 133–7.

Derrida, Jacques (1981), *Positions*, trans. A. Bass, Chicago: University of Chicago Press.

Dhaky, M. A. (1998), *Encyclopaedia of Indian Temple Architecture, North India Beginnings of Medieval Idiom c. AD 900–1000*, New Delhi: American Institute of Indian Studies.

Dikshit, R. B. K. N. (1944), 'A panel showing the birth of Lord Krishna from the Qutb Mosque', *Journal of the United Provinces Historical Society* **17** (1), 84–6.

Eaton, Richard M. (2000), 'Temple desecration and Indo-Muslim States', in Gilmartin, David and Lawrence, Bruce B. (eds), *Beyond Turk and Hindu: Rethinking Religious Identity in Islamicate South Asia*, Gainesville: University Press of Florida, pp. 246–81.

Ernst, Carl W. (2000), 'Admiring the works of the ancients: the Ellora temples as viewed by Indo-Muslim authors', in Gilmartin, David and Lawrence, Bruce B. (eds), *Beyond Turk and Hindu: Rethinking Religious Identity in Islamicate South Asia*, Gainesville: University Press of Florida, pp. 98–120.

Ettinghausen, Richard, Grabar, Oleg and Jenkins-Madina, Marilyn (2001), *Islamic Art and Architecture 650–1250*, New Haven and London: Yale University Press.

Evans, Ruth (1994), 'Translating past cultures?', *The Medieval Translator* **4**, 20–45.

Faris, Nabih Amin (1952), *The Book of Idols*, Princeton: Princeton University Press.

Fine, Steven (2000), 'Iconoclasm and the art of the late-ancient Palestinian synagogues', in Levine, Lee I. and Weiss, Zeev (eds), *From Dura to Sepphoris: Studies in Jewish Art and Society in Late Antiquity*, *Journal of Roman Archaeology*, Supplementary Series 40, Portsmouth, Rhode Island.

Fischer, Klaus (1966), 'Indo-Iranian contacts as revealed by mud-brick architecture from Afghanistan', *Oriental Art* **12**, Spring, 25–9.

Flood, Finbarr Barry (2001), 'Ghūrid architecture in the Indus Valley: the Tomb of Shaykh Sādan Shahīd', *Ars Orientalis* **31**, 129–66.

Flood, Finbarr Barry (2002a), 'Between cult and culture: Bamiyan, Islamic iconoclasm and the museum', *Art Bulletin* **84**, December, 641–59.

Flood, Finbarr Barry (2002b), 'Between Ghazna and Delhi: Lahore and its lost *manāra*', in Ball, Warwick and Harrow, Leonard (eds), *Cairo to Kabul: Afghan and Islamic Studies Presented to Ralph Pinder-Wilson*, London: Melisende, pp. 102–12.

Flood, Finbarr, Barry (2004), 'Signs of violence: colonial ethnographies and Indo-Islamic monuments', *Australia and New Zealand Journal of Art* **5**, December, 20–51.

Flood, Finbarr Barry (forthcoming a), *Circulating Cultures: Artifacts, Elites and Medieval Hindu-Muslim Encounters*.

Flood, Finbarr, Barry (forthcoming b), 'An ambiguous aesthetic: Crusader spolia in Ayyubid Jerusalem', in Auld, Sylvia and Hillenbrand, Robert (eds), *Ayyubid Jerusalem*, London: World of Islam Festival Trust.

Freedberg, David (1989), *The Power of Images: Studies in the History and Theory of Response*, Chicago and London: University of Chicago Press.

Gamboni, Dario (1997), *The Destruction of Art: Iconoclasm and Vandalism since the French Revolution*, New Haven: Yale University Press.

Gell, Alfred (1998), *Art and Agency: An Anthropological Theory*, Oxford: Clarendon Press.

Goel, Sita Ram (1993), *Hindu Temples: What Happened to Them? The Islamic Evidence*, vol. 2, 2nd enlarged edn, New Delhi: Voice of India.

Golzio, Karl-Heinz (1990), 'Das Problem von Toleranz in Indischen Relgionen anhand epigraphischer Quellen', in Eimer, Helmut (ed.), *Frank-Richard Hamm Memorial Volume, October 8, 1990*, Bonn: Indica et Tibetica, pp. 89–102.

Goswamy, B. N. (1986), 'In the sultan's shadow: pre-Mughal painting in and around Delhi', in Frykenberg, R. E. (ed.), *Delhi Through the Ages: Essays in Urban History, Culture and Society*, Delhi: Oxford University Press, pp. 129–42.

Grabar, Oleg (1977), 'Islam and iconoclasm', in Bryer, Anthony and Herrin, Judith (eds), *Iconoclasm. Papers given at the Ninth Spring Symposium of Byzantine Studies, University of Birmingham, March 1975*, Birmingham: Centre for Byzantine Studies, University of Birmingham, pp. 45–52.

Grabar, Oleg (1987), *The Formation of Islamic Art*, New Haven: Yale University Press.

Gregory, Andrew P. (1994), '"Powerful Image": responses to portraits and the political uses of images in Rome', *Journal of Roman Archaeology* **7**, 80–99.

Grohmann, Adolf (1955-56), 'Anthropomorphic and zoomorphic letters in the history of Arabic writing', *Bulletin de l'Institut d'Egypte* **38**, 117–21.

Grover, Satish (1981), *The Architecture of India: Islamic (727–1707 AD)*, New Delhi: Vikas Publishing House.

Guha-Thakurta, Tapati (1997), *Archaeology as Evidence: Looking Back from the Ayodhya Debate*, Calcutta: Centre for Studies in Social Sciences.

Hawting, G. R. (1999), *The Idea of Idolatry and the Emergence of Islam: From Polemic to History*, Cambridge: Cambridge University Press.

Hillenbrand, Robert (1988), 'Political symbolism in early Indo-Islamic mosque architecture: the case of Ajmīr', *Iran* **26**, 105–17.

Hirst, Damien (1997), *I want to spend the rest of my life everywhere, with everyone, one to one, always, forever, now*, New York: Monacelli Press.

Horovitz, J. (1911-12), 'The inscriptions of Muhammad ibn Sām, Qutbuddin Aibeg and Iltutmish!', *Epigraphia Indo-Moslemica*, 12–34.

Ibn Ḥanbal, Aḥmad ibn Muḥammad (1313/1895), *Musnad*, 6 vols, Cairo: Al-Matba'a al-Maymaniya.

Jacoby, Zehava (1992), 'Ideological and pragmatic aspects of Muslim iconoclasm after the crusader advent in the Holy Land', in Michalski, Sergiusz (ed.), *L'Art et les révolutions, Section 4: Les iconoclasmes*, Actes du XXVIIe congrès international d'histoire de l'art, Strasbourg 1–7 septembre 1989, Strasbourg: Société alsacienne pour le dévelopment de l'histoire de l'art, pp. 13–24.

Kastner, Jeffrey (1997), 'Art attack', *ARTnews* **96**, October, 154–6.

Kinney, Dale (1995), 'Rape or restitution of the past? Interpreting *spolia*', *Papers in Art History from the Pennsylvania State University* **9**, 53–67.

Kumar, Sunil (2001), 'Qutb and modern memory', in Kaul, Suvir (ed.), *The Partitions of Memory: The Afterlife of the Division of India*, New Delhi: Permanent Black, pp. 140–82.

Lehmann, Fritz (1978), 'The name and origin of the Aṭāla Masjid, Jaunpur', *Islamic Culture* **52**, 19–27.

Meister, Michael (1972), 'The "Two-and-a-half-day" Mosque', *Oriental Art*, n.s. **18** (1), 57–63.

Meister, Michael (1993), 'Indian Islam's lotus throne: Kaman and Khatu Kalan', in Dallapiccola, Anna Libera and Lallemant, Stephanie Zingel-Avé (eds), *Islam and Indian Regions*, Stuttgart: Franz Steiner, pp. 445–52.

Niranjana, Tejaswini (1992), *History, Post-Structuralism and the Colonial Context*, Berkeley and Los Angeles: University of California Press.

Nylander, Carl (1980), 'Earless in Nineveh: who mutilated Sargon's head? ', *American Journal of Archaeology* **84**, 329–33.

Page, J. A. (1926), *An Historical Memoir on the Qutb: Delhi*, Memoirs of the Archaeological Survey of India 22, Calcutta: Government of India Central Publication Branch.

Paret, Rudi (1960), 'Textbelege zum islamische Bilderverbot', in *Das Werk des Künstlers: Studien zur Ikonographie und formgeschichte Hubert Schrade zum 60. Geburtstag dargebracht von Kollegen und Schülern*, Stuttgart: W. Kohlhammer, pp. 36–48.

Paret, Rudi (1968), 'Das islamische Bilderverbot und die Schia', in Gräf, Erwin (ed.), *Festschrift Werner Caskel. Zum siebzigsten Geburtstag 5. März 1966 Gewidmet von freunden und Schülern*, Leiden: Brill, pp. 224–32.

Paret, Rudi (1976–77), 'Die Entstehungszeit des Islamischen Bilderverbots', *Kunst des Orients* **11** (1–2), 158–79.

Patel, Alka A. (2000), 'Islamic architecture of Western India (mid-12th–14th centuries): continuities and interpretations', unpublished Ph.D. thesis, Harvard University.

Pedersen, J. (1991), 'Masdjid', *The Encyclopaedia of Islam*, new edn, vol. 6, pp. 644–77.

Petrosyan, Yuri A., Akimushkin, Oleg F., Khalidov, Anad B. and Rezvan, Efin, A. (1995), *Pages of Perfection: Islamic Paintings and Calligraphy from the Russian Academy of Sciences*, St. Petersburg, Milan: Electa.

Pinder-Wilson, Ralph (2001), 'Ghaznavid and Ghūrid minarets', *Iran*, **39** 155–86.

Pope, Arthur Upham (1946), 'Representations of living forms in Persian mosques', *Bulletin of the Iranian Institute* **6** (1), 125–9.

Rashid, Abdur and Mokhdoomi, M.A. (1949), *Futuhat-i-Firoz Shahi*, Aligarh: Aligarh Muslim University.

Roux, Jean-Paul (1980), 'Mosquées Anatoliennes a décor sculpté', *Syria* **57**, 305–23.

Said, Hakim Mohammad (1989 [1410]), trans., *Al-Beruni's Book on Mineralogy: The Book Most Comprehensive in Knowledge on Precious Stones*, Islamabad: Pakistan Hijra Council.

Sastri, Hirananda (1937), 'Devanāgarī and the Muhammadan rulers of India', *Journal of the Bihar and Orissa Research Society* **23**, 492–7.

Scarcia, Gianroberto and Maurizio, Taddei, (1973), 'The Masǧid-i sangī of Larvand', *East and West*, n.s. **23**, 89–108.

Schick, Robert (1995), *The Christian Communities of Palestine from Byzantine to Islamic Rule: A Historical and Archaeological Study*, Studies in Late Antiquity and Early Islam, **2**, Princeton: Darwin Press.

Shokoohy, Mehrdad (1988), *Bhadreśvar, the Oldest Islamic Monuments in India*, Leiden: E. J. Brill.

Shokoohy, Mehrdad and Shokoohy, Natalie H. (1987), 'The architecture of Baha al-Din Tughrul in the region of Bayana, Rajasthan', *Muqarnas* **4**, 114–32.

Shokoohy, Mehrdad and Shokoohy, Natalie H. (1993), *Nagaur: Sultanate and Early Mughal History and Architecture of the District of Nagaur*, India, London: Royal Asiatic Society.

Shokoohy, Mehrdad and Shokoohy, Natalie H. (1996), 'Indian Subcontinent III, 6(iii)(b): 11th–16th century Indo-Islamic architecture: north', *Dictionary of Art*, vol. 15, New York: Macmillan, pp. 338–46.

Shokoohy, Mehrdad and Shokoohy, Natalie H. (2000), 'The Karao Jāmi' Mosque of Diu in the Light of the History of the Island', *South Asian Studies* **16**, 55–72.

Stewart, Peter (1999), 'The destruction of statues in late antiquity', in Miles, Richard (ed.), *Constructing Identities in Late Antiquity*, New York and London: Routledge, pp. 159–89.

Stewart, Tony K. (2000), 'In search of equivalence: conceiving Hindu–Muslim encounter through Translation Theory', *History of Religions* **40** (3), 260–87.

Stewart, Tony and Ernst, Carl (forthcoming), 'Syncretism', in Claus, Peter J. and Mills, Margaret A. (eds), *South Asian Folklore: An Encyclopedia*, New York: Garland.

Thapar, Romila (1994), *Cultural Transaction and Early India: Tradition and Patronage*, Delhi: Oxford University Press.

van Reenen, Daan (1990), 'The *Bilderverbot*, a new survey', *Der Islam* **67**, 27–77.

Vasiliev, A. A. (1956), 'The iconoclastic edict of the caliph Yazid II, A.D. 721', *Dumbarton Oaks Papers*, 9–10, 23–47.

Wagoner, Phillip B. and Rice, John Henry (2001), 'From Delhi to the Deccan: newly discovered Tughluq monuments at Warangal-Sulṭānpūr and the beginnings of Indo-Islamic architecture in southern India', *Artibus Asiae* **31** (1), 77–117.

Welch, Anthony (1993), 'Architectural patronage and the past: the Tughluq sultans of Delhi', *Muqarnas* **10**, 311–22.

Wensinck, A. J. [-Fahd, T.] (1997), 'Ṣūra 1. In theological and legal doctrine', *The Encyclopedia of Islam*, new edn, vol. 9, pp. 889–92.

Wink, André (1997), *Al Hind, the Making of the Indo-Islamic World*, vol. 2: *The Slave Kings and the Islamic Conquest 11th–13th Centuries*, New Delhi: Oxford University Press.

Wrigley, Richard (1993), 'Breaking the code: interpreting French Revolutionary iconoclasm', in Yarrington, Alison and Everest, Kelvin (eds), *Reflections of Revolution, Images of Romanticism*, New York and London: Routledge, pp. 182–95.

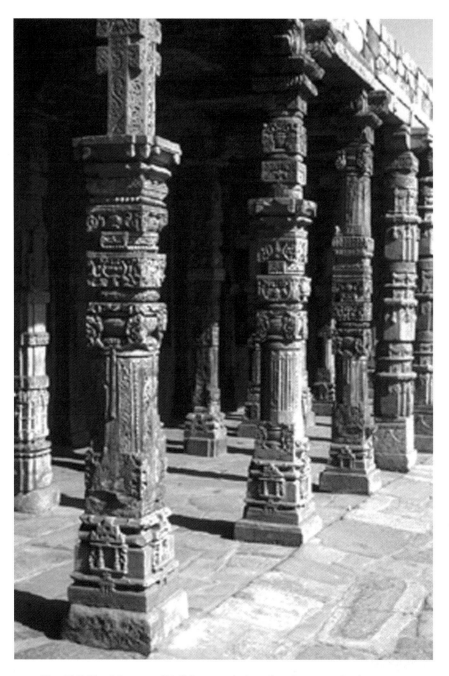

2.1 Ghurid Friday Mosque of Delhi, general view showing reused columns

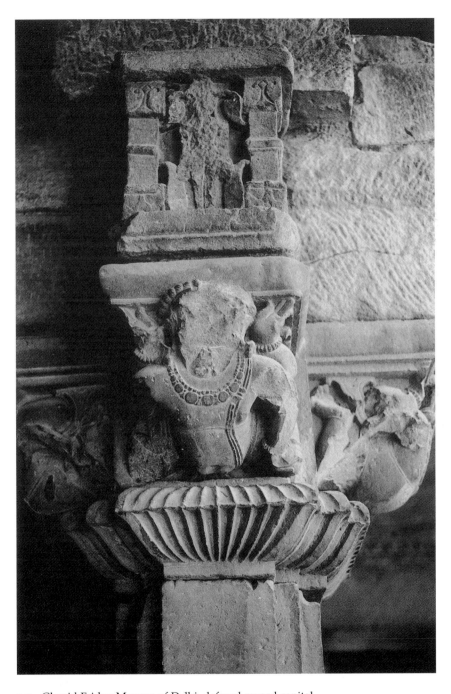

2.2 Ghurid Friday Mosque of Delhi, defaced reused capital

2.3 Ghurid Friday Mosque of Delhi, erased figure on reused pilaster

2.4 Ghurid Friday Mosque of Delhi, reused pilaster with central *kīrtimukha* figure
flanked by defaced nymphs (*apsaras*)

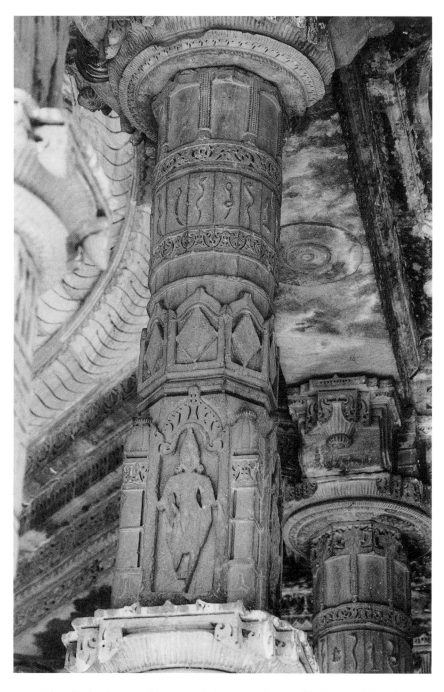

2.5 Arhai-din-ka Jhompra Mosque, Ajmir, erased figure with rhomboidal outline

The war against idols: the meanings of iconoclasm in revolutionary Mexico, 1910–40

Adrian A. Bantjes

I can imagine nothing significant where nothing is sacrificed … dismembered, burnt, pierced, tormented, harassed, tortured, massacred, stabbed, destroyed or annihilated.

Otto Mühl, Wiener Aktionismus group, 1963[1]

In his memoirs, the flamboyant Mexican muralist Diego Rivera recalls his first visit to a Catholic church as a child of 6. Unbeknownst to the young Diego's zealously anticlerical father, his devout aunt had taken him to Mass at the Church of San Diego in Guanajuato. Rivera was horrified by the unbridled baroque imagery he encountered:

On entering the Church, my revulsion was so great that I still get a sick feeling in my stomach when I recall it. … There were paintings all around of women and men sitting or walking on clouds with little winged boys flying above them. … In my own house, I had inspected my aunts' images of the Virgin Mary and Jesus Christ. I had scratched them and discovered that they were made of wood. I had put sticks into their glass eyes and through their ears to discover whether they could see, hear, or feel anything – always, of course, with negative results.

Not surprisingly, the budding jacobin created quite a scandal.

Suddenly rage possessed me, and I … climbed up the steps of the altar. Then, at the top of my voice, I began to address the astonished worshipers … . 'Stupid people! … You are so crazy that you believe that if I were to ask the portrait of my father … for one peso, the portrait would actually give me one peso.' … 'You talk of heaven, pointing with your fingers over your head. What heaven is there? … There are no boys with wings, nor any ladies or gentlemen sitting on clouds.' … 'In order to have the priests appease these idols to spare you … you give [them] … money … .' … At this point some terrified ladies began to scream. They made the sign of the cross in my direction, shouting, 'This child is Satan!' … . I faced the priest. 'What about you, you old fool?' … 'If there really is a Holy Virgin or anyone up in the air, tell them to send lightning, to strike me down or let the stones of the vault fall on my head. If you are unable to do that, Mr. Priest, you're nothing but a puppet taking money from stupid old women … . If God doesn't stop me, then there must be no God!' … [G]esticulating with my fists, I shouted, 'You see, there is no God! You're all stupid

cows!' ... Many rough-looking men had joined the old people, but when I said, 'There is no God,' they put their hands over their eyes and ears and ran away. They pushed each other in their panic to get out of the church, crying as they ran, 'The devil is here!'

(Rivera, 1991, pp. 5–7)

Apocryphal or not, the tale of the young Rivera is illustrative of the rationale that inspired many iconoclasts during the Mexican Revolution (1910-40). If we can believe his autobiography – a dubious proposition at best – a profound rationalist hatred of religious superstition led Rivera to scandalize the parishioners of Guanajuato. He was particularly repulsed by the disgusting proliferation of grotesque religious images. But Rivera also betrayed a deeper psychological motivation, namely to convince himself that the saints were not, as many believed, live beings, capable of miracles and divine punishment, but mere objects of wood and plaster used to deceive gullible Catholics and fatten the pockets of the clergy. To disprove their existence, Rivera taunted God and the saints and summoned their divine wrath.

Why should we pay attention to the avant-garde antics of a pathological liar like Rivera? Actually, the muralist's story reflects more than personal phobias. It is emblematic of the iconoclastic zeal that drove many revolutionary leaders, teachers, soldiers and peasants to burn and smash the images of saints and launch so-called 'defanaticization' campaigns throughout Mexico. The Mexican Revolution was more than a social and political revolution. It was also a cultural revolution, and, as in most modern cultural revolutions, iconoclasm was one of its distinguishing features.

Mexican iconoclastic outrages and the broader anti-clerical and anti-religious campaigns attracted the attention of government officials, politicians, journalists and Catholics in the United States and Europe. In his *Robbery under Law*, British writer and *enfant terrible* Evelyn Waugh eloquently decried 'the wanton destruction: the libraries thrown out into the gutters, the canvases slit up, the statues piled up and burned in the plaza, the whole bloody, degenerate business which culminated a year or two ago in the firing squads and the massacres' (1939, p. 214). Now Waugh was probably not the most knowledgeable or unbiased of Mexico analysts. An ultraconservative Catholic, he was on the payroll of the Cowdray Estate, which had been hard hit by Mexico's 1938 expropriation of foreign-held oil operations (Stannard, 1987, pp. 478–87). But he was certainly not the only foreign observer to take note of Mexico's revolutionary anticlericalism. Appalled by what he dubbed 'the fiercest persecution of religion anywhere since the reign of Elizabeth' (1960, p. 11), Waugh's fellow Oxford man and later friend, Catholic writer Graham Greene, in his celebrated novel, *The Power and the Glory*, describes the travails of the holy 'whisky priest' as he eludes the murderous revolutionary red-shirts, becoming a shabby symbol of Catholic endurance.

Far from being a mere figment of their imagination, the anti-religious formed an integral part of the revolution's broader cultural project. Naturally, iconoclasm was not a revolutionary invention, and one can find numerous historical precedents dating back to the Conquest. On his arrival in the realm of the Yucatec Mayans in 1519, Hernán Cortés warned the Cozumel chieftains that their evil gods would lead them to hell and begged them to destroy their 'idols of very grotesque figures' and replace them with the Holy Cross and a statue of the Virgin Mary. When they countered that their gods would punish the Spaniards by sinking their ships if they dared touch the images, 'Cortés ordered that we break them to pieces and toss them rolling down [the steps of the pyramid] … . [A]nd a very clean altar was constructed where we placed the image of Our Lady' (Díaz del Castillo, 1975, pp. 67–8). This was the beginning of a war missionaries waged on indigenous 'idols' to eradicate all traces of paganism. Franciscan friars in the Yucatán, for example, gathered the children of the Mayan nobility: 'The children then, after being taught, informed the friars of idolatries and orgies; they broke up the idols, even those belonging to their own fathers' (De Landa, 1978, p. 29).

We continue to encounter cases of iconoclasm throughout Mexican history. During the War of Independence, a royalist firing squad reportedly 'executed' an image of the revered Virgin of Guadalupe, a nationalist symbol and protectress of the independence fighters (Poole, 1995, p. 3). Popular iconoclasm aimed at undermining the power of the patron saint of a rival community was not uncommon. More recently, representatives of the post-Vatican II Roman Catholic Church, such as Bishop Sergio Méndez Arceo, have sought to establish a purer, modern form of spirituality by banishing excessive imagery from churches and suppressing the cult of the saints (Ingham, 1986, pp. 148–9).

But it was during the revolution that acts of iconoclasm became commonplace. Iconoclasm constituted a key aspect of the anti-religious 'defanaticization' campaigns that characterized the rule of revolutionary warlords from the late 1910s on. During the 1920s and 1930s national revolutionary leaders such as Plutarco Elías Calles and Lázaro Cárdenas granted their support to anticlerical and anti-religious campaigns featuring organized, systematic iconoclasm (Bantjes, 1997). Such campaigns involved not just the smashing and burning of saints' images and crosses, but also the prohibition of religious ritual, including Holy Mass and saints' festivals, the closure and destruction of churches, chapels and Catholic schools, the expulsion or assassination of priests, anti-religious or 'socialist' education, and the purging of believers from public office. Religious activity was forced into the catacombs for many years. These campaigns, which lasted over a quarter of a century, were implemented primarily at the local and regional level.

Defanaticization struck at the spiritual heart of Mexican existential security and threatened local and national identities. Catholics responded with boycotts, demonstrations, riots and armed rebellion. The so-called *Cristiada* (1926–29), a bloody Catholic peasant rebellion against the revolutionary state, was the most bitter and traumatic episode in this Mexican *Kulturkampf*, and jeopardized the very future of the revolution.

Why did Mexican revolutionary leaders risk antagonizing their main allies, the generally pious *campesinos* who constituted the backbone of the revolution? We must conclude that Mexican iconoclasm and defanaticization were at the very heart of the revolutionary state's drive to elaborate a rival, revolutionary, nationalist civil religion, with its own rites and symbols, designed to assume the functions of established religion. The Mexican Revolution's cultural project sought to create new loyalties, new mentalities and new identities among the ruins of civil war. There was, thus, a perverse, *creative* logic to the iconoclastic madness. It is this logic that I seek to explain below.

A second purpose of this essay is to test theoretical approaches to iconoclastic phenomena. Clearly an approach that, following Dario Gamboni (1997, pp. 11, 17, 24), emphasizes historicity, contextualization and specificity is called for. However, context alone fails to provide us with all the answers. The Mexican case is by no means unique. It reflects certain universal or, at least, western, attitudes towards images and their meanings. In this respect David Freedberg's cognitive, psychological methodology is particularly helpful. It allows us to interpret acts of iconoclasm as more than purely derivative phenomena and probe into the deeper psychological motivations of the iconoclast: 'any number of assaults of images … are predicated … on the attribution of life to the figure represented, or on the related assumption that the sign is in fact the signified'. The iconoclast 'feels he can somehow diminish the power of the represented by destroying the representation or by mutilating it'. 'The people who assail images do so in order to make clear that they are not afraid of them, and thereby prove their fear' (Freedberg, 1989, pp. 392, 402, 406, 415–16, 418). Or, as Mona Ozouf argues for the case of the French Revolution, there is 'fear behind all the bravado' (Ozouf, 1988, pp. 93–4).

Certainly in Mexico we should take the icon seriously as an aspect of historical reality, even as a historical actor in its own right. Episodes of iconoclasm had profound historical significance and serious repercussions. Here my intent is to combine both contextual and cognitive approaches in an effort to fathom the complex motivations of the revolutionary iconoclast. However, to understand the significance of religious images, both for iconoclasts and icondules, we first need to discuss their centrality in Mexican syncretic popular religion, which has its roots in the encounter of indigenous and European cultures during the sixteenth century.

Mexican popular religion and the meanings of religious images

Saints' images constitute the focal point of the composite or syncretic indigenous Catholicism that emerged in Mexico in the wake of the Spanish conquest. Evangelization and missionary iconoclasm interacted with indigenous spirituality to produce a new Mexican popular religion. Serge Gruzinski has found that, not long after the conquest, Indian chapels, oratories and private households 'were literally saturated with images'.

> By their profusion, Christian images became entrenched in the *pueblos*, implanting visible landmarks, which, together with the sanctuaries and the chapels, served as medium of indigenous Christianity. ... The evangelizers baptized *pueblos, barrios*, churches, chapels and people by drawing from the repertory of saints. ... [P]atron saints were perceived as an essential aspect of the *pueblo*'s identity, of its reality as of its supernatural.
>
> (Gruzinski, 1993, pp. 238–40)

Saints' images were gradually conflated with indigenous 'idols'. Initially, 'saints and "little idols" coexisted on the domestic altar. ... The Indians showed so passionate an attachment to these objects that their confiscation was generally the scene of particularly dramatic episodes' (Gruzinski, 1993, p. 245). Saints were not considered mere symbols or objects, but actual living entities, with their own idiosyncratic personalities, who maintained a complex, often familial, relationship with those who venerated them.

> The Indians never distinguished between the saint and its representations. ... The image was the saint, or rather, the saint was the saint. ... Obtained by merging the signifier (the object) with the signified (the divine entity), this immediacy probably constituted one of the driving elements that made the colonial environment plausible and gave a coherence, a unity, to data as disparate as Spanish priests, places of cult, liturgies and the Christian calendar, the territory, the house, death, etc. ... It was indeed an Indian Christianity[;] the matrix ... remained indigenous and close to what we know of prehispanic cults. The absence of distance between the signifier and the signified, the telescoping of sign and meaning, send us back to processes characteristic of the treatment that pre-conquest societies seem systematically to have reserved to their 'sacred'.
>
> (Gruzinski, 1993, pp. 249–50)

Peasants *served* the saint, the protector of the village or barrio, with offerings of flowers, candles, pine pitch and *mandas* (religious promises). Pilgrimages to the saint's sanctuary assumed regional or even national significance, as in the case of Nuestro Señor de Chalma, Nuestra Señora de San Juan de los Lagos and, most importantly, the Virgen de Guadalupe in Mexico City. Many saints received their own lands and herds of cattle, following pre-Columbian tradition. But when ineffectual, punishment of the saint/image was not uncommon. Carl Lumholtz, travelling through Tuxpan, Jalisco, in the early twentieth century, found that 'If saint or idol does not answer the prayers of

the people they sometimes give him a whipping.' As late as 1925, the villagers of Huistán, Chiapas, beat Saint Martin during bad years (Gruzinski, 1993, pp. 246–7; Gruening, 1940, p. 239).

The saint's day or fiesta became the most important occasion for Indian as well as hispanic *mestizo* communities to serve the saint and implore its protection. These festivals were not just religious celebrations but also had considerable political, social and economic significance. Ritual drinking, dancing, feasting and games accompanied most celebrations, reaffirming community identity. At the centre of the celebration was the image, which was often carried through town in a religious procession until the nineteenth-century Liberal Reform government outlawed such acts of 'external worship'. In a land characterized by dislocation and insecurity, saints were crucial in maintaining a degree of what Anthony Giddens calls 'ontological security' (1990, pp. 106–7), undergirding local world views and creating or fixing identities. As Gruzinski puts it, '[The] multiple connections [that] emerged from the image ... wove a continuous canvas, a coherent reality, in which a large part of Indian existence could find a meaning and a reason for being' (1993, p. 249).

The linkage between community identity and history is evident in the ubiquitous and formulaic foundational stories that link the saint with the establishment of a local chapel and cult. The saint is seen as an active participant in the community's development. Local myths often relate the discovery of the saint's image in a field, grotto, tree or river. Most commonly, however, the saint chooses the locale as its residence by becoming unbearably heavy while being transported across the country. A classic example is the story of Our Lady of Sorrows. According to an ancient Dominican manuscript, the image arrived in Oaxaca after a mysterious mule carrying a large crate joined a mule train, only to collapse and die in front of the Hermitage of Saint Sebastian. The crate contained the sculpted head and hands of the Virgin, and soon a cult developed in her honour (Garay, 2000, pp. 322–3). Today, the image resides in an impressive baroque sanctuary. Numerous ex-votos, some simple paintings on tin, others framed canvases commissioned by the wealthy, many dating back to colonial times, attest to her powers. They depict her miraculous intervention in shipwrecks, riding accidents and severe illnesses. Such offerings can be found in most Mexican churches, though today photographs of the individuals blessed or *milagros*, small metal images depicting body parts (eyes, hearts, arms, legs and so on), farm animals or even automobiles, have replaced the ex-votos.

By the eighteenth century, a well-defined Indian form of Christianity, centred on the cult of the saints, had solidified, becoming a crucial aspect of Mexican popular culture. In many regions, this Indian Christianity remained at the heart of rural cultures, both indigenous and hispanic, despite intense

and continuous efforts to impose modernity. Over the centuries, the Bourbon, liberal and revolutionary states, as well as the Tridentine, Enlightened and post-Vatican II Catholic churches, all fruitlessly sought to suppress Mexican folk culture, especially the 'pagan', 'idolatrous' aspects of the cult of the saints (Brading, 1991, ch. 22). As late as 1912, the *Catholic Encyclopedia* described the crucifixes in Indian churches as 'repulsive' (Gruening, 1940, p. 238). Paradoxically, zealous modernizing priests had much in common with their enlightened anticlerical opponents. All were missionaries of modernity. And all sought to eradicate this autonomous realm of local culture. Mexican rural folk resisted these waves of violent acculturation, which threatened their identity, ontological security and sense of reality.

The rich ethnographic literature on indigenous cultures attests to popular religion's survival into the twentieth century. Anthropologists such as Oscar Lewis (1963) and George M. Foster (1967), working in Mexico after the revolution, found the structures of religious faith in the countryside essentially unchanged. Here, local religion continued to serve as the most important cultural matrix by which peasants made sense of daily existence. Stephen Gudeman speaks of a 'saint system', a "total system" classifying and representing all aspects of worldly existence', which '[t]he individual can draw upon, manipulate, and use ... to make his own ordinary experiences understandable' (1976, pp. 725–7). Even today, the cult of the saints is alive and well in Mexico.

Modernity, religion and iconoclasm

The origins of Mexican defanaticization and iconoclasm can be traced back, via nineteenth-century liberalism, to the Enlightenment project of modernity, or what James Scott calls *high modernism* (1998, pp. 4–6), that 'inchoate Promothean [*sic*] aspiration, now made flesh, of men to transform nature and transform themselves: to make man the master of change and the redesigner of the world to conscious plan and purpose', to quote Daniel Bell (1988, p. 436). The Enlightenment dream ultimately involves the disenchantment of the sacred world and a 'transfer of sacrality', as Ozouf (1988, p. 262) calls it, to a new, sacred, civil religion of Man. Modernity and its rationalist, normalizing, totalizing drive to reforge human nature through the application of science and technology targets 'tradition' for drastic and often violent refashioning. This includes banishing 'ignorance', 'superstition' and 'fanaticism', all characteristics associated with popular religion (Sewell, 1985; Trías, 1998). Such condescension towards popular religion was found among both freethinkers and modern Catholics. Eighteenth-century enlightened Jansenist Catholics in Bourbon Spain and New Spain, such as Melchor

Gaspar de Jovellanos, abhorred the 'stupid superstition' of the vulgar classes, as expressed in the popular cult of images and miracle tales. Jovellanos was particularly repulsed by the grotesque Christ of Burgos, which he described as 'an effigy of the worst and most horrible form' (Brading, 1991, p. 509 and 2001, pp. 217–18).

From this modernist perspective, the adoration of religious images was considered particularly offensive, the epitome of superstition and fanaticism. Naturally, this was an ancient aversion, evident in the biblical exhortations against venerating graven images such as the Golden Calf. Since antiquity, the error of idolatry has been attributed to ignorant peasants, children and women. The image, only accessed through the weak senses, has consistently been associated with materialism, sensuality and corruption (Freedberg, 1989, pp. 283, 379). Efforts to ban and destroy images are a historical constant, reaching impressive proportions in eighth- and ninth-century Byzantium, in sixteenth-century Protestant Europe, and during the French Revolution. Episodes of iconoclasm have typified most modern revolutions, whether in France, Russia, China or Mexico. Arguments against images are diverse, ranging from Old Testament prohibitions to the condemnation of the squandering of resources associated with the veneration of religious statues (Freedberg, 1989, ch. 11). Irrespective of their origin, such ancient arguments became part of the modernist argument against idolatrous popular religion.

The hatred of religious images re-emerged in revolutionary Mexico. The Mexican revolution drew inspiration from an odd mélange of nostalgic nativism and globalizing modernity. Thus, its position towards popular culture was ambiguous. On the one hand, the revolution hoped to rebuild the rural economy on pre-Columbian rural bases and forge a new culture by drawing on the nation's rich indigenous past. On the other, it sought to create a modern, productive, nationalist, secular New Man (or *gente nueva*, new people), free of superstition and fanaticism. Revolutionary politicians, educators, soldiers and labour leaders repeatedly spoke out against popular religion and the veneration of images. School inspectors showed their distaste of popular religiosity and culture by decrying the cult of the saints. Mexican modernity's productivist, rationalist, moralistic and patriotic drive clashed with popular religion. At the centre of a whole realm of 'fanatic', ignorant and degenerate behaviour, such as pilgrimages, saints' festivals, drinking, gambling, poor hygiene, indigenous separatism, female ignorance, waste, backwardness and so on, was the saint and its image.

Examples of such attitudes abound. José Vázquez Luna, a federal school inspector in Sinaloa, was horrified by the 'superstitious' and corrupt behaviour he encountered among *serrano* campesinos and the Tarahumara Indians in the high sierra. The inhabitants of Santiago de los Caballeros, for instance, celebrated, 'saturated with alcohol … [the] religious festival in

honour of their Lord Santiago, whom they carry on their shoulders through the village to soften the egotistical heart of the Rain God'.[2] Rationalist and productivist education would combat such superstition. In Chiapas, for example, the revolutionary party rejoiced when the

> government decreed that all temples in the state should ... be made available for use as schools, libraries and workshops. ... [I]n very little time we will see in the naves of the church not the lamentable spectacle of a ... [people] on its knees before the macabre figure of a bloody Christ or before a mysterious window of a confessional, but rather desks and benches occupied by today's children.
>
> (Lewis, 1997, p. 144)

Anticlerical organizations, such as the Federation of Anti-Clerical and Anti-Religious Groups of Jalisco, sought 'radically to eliminate fetishist, supernatural theological interpretations', and to develop 'a scientific interpretation of natural and social phenomena'.[3] Legislation in Colima prohibited processions carrying 'the logs called santos ... because we now live in ... [an] age of enlightenment and we are occupied with light, not fanaticism' (Enríquez Licón, 1994, p. 163). A teacher from Manzanillo, Colima, clearly expressed the 'transfer of sacrality' many revolutionaries had in mind. Productive labour and class unity would replace religion:

> The praying of the Our Father has been substituted by the song 'Proletarian Red', set to the music of the Marseillaise, and instead of the worker crossing himself fearfully in front of the image of the Holy Trinity, with devotion and fervour, his hands raise the red and black shield, and afterwards he attends the early mass of labour, which always awaits him on the pier.
>
> (Enríquez Licón, 1994, p. 329)

Clearly, the only way to eradicate fanaticism was by physically removing its symbolic networks. As Governor Tomás Garrido Canabal of Tabasco simply put it, 'Religion will not be destroyed if its representatives remain, namely the priests, the idols and the temples' (Martínez Assad, 1979, p. 36).

Iconoclasm and defanaticization in revolutionary Mexico

In revolutionary Mexico, organized iconoclasm was primarily related to anticlericalism, with its roots in the fierce nineteenth-century struggle between the enlightened liberal state and a powerful Roman Catholic Church. But rabid anticlericalism, fuelled by the perception that the church had sided with counter-revolutionary political forces, often degenerated into anti-religiosity. Other forms of revolutionary iconoclasm did emerge. The widespread torching of haciendas represented not just the physical destruction of the administrative centres of the exploitative *latifundista* system, but also an assault on the most visible symbols of social and political

repression in rural Mexico. Still, most acts of iconoclasm involved religious and clerical symbols.

Spontaneous acts of iconoclasm were common during the armed phase of the revolution (1910-20), as evidenced by the fanatical religious persecution unleashed by the Constitutionalist revolutionary faction, whose leaders considered the church a dangerous rival of the new state and its teachings a drag on the process of modernization (Meyer, 1985, p. 68; Knight, 1986, pp. 503–5). Jean Meyer (1985, pp. 71-83) has amply documented the orgy of profanation that swept Mexico during the Constitutionalist military offensive of 1914. Revolutionary commanders such as Francisco Murguía, Antonio I. Villarreal, Manuel M. Diéguez, Alvaro Obregón, Joaquín Amaro, Salvador Alvarado and Plutarco Elías Calles, some of whom would soon become regional and national leaders, as well as numerous anonymous officers and soldiers, sacked and closed churches, arrested and expelled priests, and outlawed mass, baptism and other religious rites and sacraments. Saints' images were mocked, burned or 'executed' by firing squads. The Holy Host served as horse fodder, sanctuaries as barracks, and the hated confessionals, symbols of clerical humiliation, were piled in the streets and set on fire. When General Francisco J. Mújica occupied the capitol of Tabasco, he immediately quartered his battalion in the church of Esquipulas, burned the religious images, and changed the name of the city from San Juan Bautista to Villahermosa, thus establishing an enduring local iconoclastic tradition (Martínez Assad, 1979, p. 29).

As early as the late 1910s, and more generally during the 1920s and 1930s, iconoclasm became an important aspect of the well-orchestrated anticlerical and anti-religious campaigns developed and implemented by jacobin state governors and the central government. These were no longer isolated, spontaneous incidents, but were carried out systematically in states such as Sonora, Michoacán, Veracruz, Chiapas and Tabasco (Raby, 1974, p. 162).

As we have seen, many revolutionaries considered religion, and especially popular religion, with its emphasis on the cult of the saints, a nefarious form of idolatry in need of eradication. By removing the saint, one might root out all forms of fanaticism and benightedness. Iconoclastic discourse, by advocating the 'death' of the image, mirrored the popular belief that religious images were live beings. 'Muerto el ídolo, se acabó el culto', 'once the idol is dead, the cult is finished', stated one Yucatecan politician (Savarino, 1997, pp. 361). Thus, jacobins directed much of their anti-religious energy against the omnipresent images of saints. So-called *quemasantos* (saint burners), young revolutionary teachers, local politicos, policemen and army officers, abducted revered saints' images from churches and raided homes, schools and chapels, gathering smaller images and crosses, and later burned,

smashed or mutilated these, either away from the volatile public or on pyres during the new festivals of the revolution.

Revolutionaries were eager to destroy saints associated with miracles and pilgrimages, such as San Francisco Xavier in Sonora, Nuestro Señor de la Salud in Tabasco, La Purísima Concepción in Michoacán, and Nuestro Señor de Otatitlán in Veracruz (Martínez Assad, 1997, pp. 45, 48–9, 53; Williman, 1976, pp. 131–6; Becker, 1995, pp. 77–8; Bantjes, 1994, p. 268). San Francisco Xavier, for example, was the focus of the most important religious cult in northern Mexico, and widely venerated as a miracle worker by the Tohono O'odham or Pápago, but also by Yaqui and Mayo Indians and the hispanic population. In 1934, radical teachers carried off the miraculous image to the state capitol, Hermosillo, where it was burned in the ovens of the local brewery (Bantjes, 1998, pp. 13–14).

The case of the Black Christ of Otatitlán, Veracruz, is particularly illuminating. Since colonial times, the image and its sanctuary have been the centre of an important regional and supraregional cult. Pilgrims travel great distances to thank the Black Christ for miracles or to implore him to bestow upon them rain and fertility, bountiful crops and plentiful cattle, good health, and success in trade, hunting, fishing and love (Iwaniszewski, 1997, p. 256; Vargas Montero, 1997, p. 288). The saint's fiesta also has an important social and economic significance: pilgrims, both hispanics and Indians from Veracruz, Oaxaca, Tabasco and neighbouring states, enjoy a week of fairs, plays, dances and horse races (Velasco Toro, 1997, pp. 121–2 and 2000, p. 31). The Black Christ is well-known for his miracle cures. As one Oaxacan *alabado* (hymn)[4] relates,

A los enfermos sanaba	He cured the sick
De cualquier enfermedad,	Of any disease,
Es la salud de su pueblo,	He is the health of his people
En cualquier dolencia o mal.	In any affliction or illness.
Sanó cojos y tullidos	He healed the crippled and paralyzed.
A los mudos hizo hablar,	He made the dumb speak,
A los sordos dió el oido	He gave hearing to the deaf
Y a los ciegos el mirar. …	And vision to the blind. …
Pues de todas partes vienen	Well, they come from all regions
Llenos de amor y piedad	Full of love and piety
A dar cultos reverentes	To render reverent homage
A la Suprema Deidad.	To the Supreme Deity.

During the revolution, the anticlerical state outlawed this popular cult. A failed attempt to destroy the image cost the lives of several pilgrims, shot dead by village police while defending the saint. Then, in 1931, the sanctuary was forcibly closed and local priests were forbidden to officiate. On the night of 7-8 September, a group of anticlericals, supported by peasants and militiamen and headed by the town mayor, all henchmen of the radical state

governor Adalberto Tejeda, entered the church and carried away the statue. The next day they arrived at a palm grove on the banks of the Papaloapan river, where, according to oral tradition, 'they set about to burn [the sacred image] with firewood, palm fronds and dry leaves. When they saw that the image wouldn't burn, they cut off its head with a saw and carried it upstream to the village of Papaloapan, later to [the state capital] Xalapa' (Vergara Ruiz, 1997, pp. 99-101). Outraged villagers responded by ringing the church bells and marching through town to the cry of 'Long Live Christ King', shooting guns in the air. Meanwhile, a group of women and children went in search of the image. They saved the charred headless body and cross, which they carried back to the sanctuary covered with sheets. The revolutionary authorities in turn responded to this challenge by raiding private residences, taking the images of 'saints, virgins, and Christs', and then burning or smashing them on the town square while shouting that they 'weren't worth a damn' (Vargas Montero, 1997, pp. 99–101).

What happened with the Black Christ's head isn't entirely clear. According to some, it was used for a while as a paperweight or a footrest in governor Tejeda's office. Others claim that a local politician publicly exhibited it as a grotesque curiosity, after which it languished forgotten in a government warehouse for years. Catholics believe that it brought bad luck, sparking mysterious fires wherever it went (González Martínez, 1997, pp. 460–61; Velasco Toro, 2000, p. 101). But this was hardly the end of the cult, as we shall see in the conclusion.

Though during the 1930s the majority of iconoclasts were teachers or local policemen, iconoclasm was most effective when priests did the dirty work. This occurred in Tuxtla Gutiérrez, Chiapas, in 1934, when an alleged apostate priest publicly renounced his vocation and burned various 'fetishes', as well as his vestments. He denounced the

mystical cult of fetishes, from which [the people] indefinitely and hopelessly await their betterment … . I immediately proceed to incinerate my cassock and cap, priestly insignia or badges that I own, and I advise the people to forget about the futile adoration of these statues or dolls that for so long have been the cause of the backwardness and exploitation of the people, retarding notions of social progress, culture and advancement, as well as to aid General Cárdenas and Colonel Grajales in the beneficent and grand anticlerical task they are developing for your benefit.

(Tamayo Víctor, 1997, p. 133)

Some cases had a national impact. The most notorious act of revolutionary iconoclasm occurred in 1922, when iconoclasts attacked the Virgen de Guadalupe, the most widely venerated Marian advocation of the Americas. *La Guadalupana* is not just the patron saint of Mexico but a crucial, if not the main source of Mexican national identity. The Virgin symbolized a conservative alternative to the legitimacy of the revolutionary state, which

desperately sought to create new secular symbols of national identity. A powerful bomb went off in the Basilica at Tepeyac, but, miraculously, the sacred image survived unscathed.[5] Catholics reacted in disbelief and dismay, mobilizing across the country to protest the outrage. Less than a decade later, in 1931, they crowned the Virgin and spent more than one million pesos to refurbish the Basilica for the fourth centennial of her apparition. This sumptuous celebration attracted 50 000 pilgrims and outraged the government, which correctly interpreted the event as a challenge to the revolution and fiercely attacked it as yet another example of clerical extravagance (Negrete, 1988, pp. 67–73). In retaliation, that same year more than two thousand 'fetishes' were incinerated in Tabasco state on the Virgin's feast day, 12 December (Figure 3.1; Mártinez Assad, 1979, p. 45).

The dynamiting of a statue of the Sacred Heart of Christ, constructed in 1920 on the summit of the mountain of El Cubilete near Silao, Guanajuato, also sparked general condemnation. It was rumoured that agents of the revolutionary labour union CROM had planted the bomb. In the wake of the attack, the Catholic Church responded by constructing a huge, 250-ton image of Christ King to replace the old monument. Today it remains the centre of a national pilgrimage (Parsons, 1936, p. 33; Valles Septién, 1994, p. 82; Reich, 1995, p. 81).

Other images survived miraculously. When Tabasco Governor Garrido's militiamen came to fetch the image of the Cristo de la Salud in Mecatepec, enraged Catholics wrested it from the *quemasantos*, though it received a machete blow. Indians spirited it off to the neighbouring state of Veracruz, where it found a permanent home in the parish of La Preciosa Sangre de Cristo in Cosoleacaque. According to legend, the image had miraculously reappeared in the Coatzacoalcos river (González Absalón, 1997, pp. 509–10). In Villahermosa, Tabasco, a soldier rescued the revered Black Christ from the flames, disobeying Garrido's orders (Romero and Alvarez Mejía, 1952, p. 309). In the Mayo Valley of Sonora, police officers burned the 'Little Children', or saints' images of the Mayos, and torched their chapels. But one saint, San Juan, escaped by diving into a river in a hail of bullets. That spot is still considered sacred today (Bantjes, 1998, p. 7).

Despite the iconoclastic onslaught, most widely venerated saints survived, many of them hidden until the late 1930s or even 1940s from the prying eyes of the *quemasantos*. Catholics feared the worst for their patron saints, and often mobilized to ward off iconoclastic attacks, whether real or imagined. In Oaxaca City, for example, Catholics streamed to the sanctuary of the Virgen de la Soledad when ill-founded rumours spread that *quemasantos* planned to abduct the image.[6] In 1914, when Constitutionalist troops entered Chiapas, Zoque Indians hid the image of San Pascualito, a statue of a skeleton in a funeral cart with a syncretic pre-Columbian and Christian significance.

General Jesús Agustín Castro had ordered its destruction as an 'idolatrous' object. The *mayordomo* of the saint's cult, Antonio Morales, smuggled it into the hills. It was never found, though troops tortured believers in a futile attempt to discover its whereabouts. In 1934, Chiapas Governor Victórico Grajales unleashed a brutal and systematic iconoclastic campaign that claimed hundreds of religious images, statues and paintings. Once again, Catholics spirited away many popular miraculous images, such as San Pascualito and El Señor del Pozo (Our Lord of the Well) from the town of San Bartolomé de los Llanos (which, not surprisingly, was renamed Venustiano Carranza, after the revolutionary president). As late as the 1950s, anticlericals blatantly argued that the image of San Pascualito would best serve as kindling. After federal teachers burned numerous images at Rincón Chamula and confiscated the church to serve as an Indian boarding school, the Tzotzil Indians of neighbouring San Juan Chamula hid their saints and raised an armed force to ward off an expected attack of saintburners from the state capital. In Batacosa, Sonora, armed Mayo Indians drove off a detachment of rural police, thus saving the image of San Bartolo. All these saints are now once again the centre of important religious cults (Valles Septién, 1994, pp. 61, 64; Navarrete, 1982, p. 36; Lewis, 1997, pp. 145–6; Bantjes, 1998, p. 12).

Violence often erupted in towns where the *quemasantos* confronted irate Catholics. In Tlapacoyan, Veracruz, Catholics responded to the destruction of their saints by laying siege to the municipal palace, which they bombarded with burning chile bombs. In the course of a gunfight that killed 20, they shot the mayor, the police chief and five policemen and then mutilated their bodies (Williman, 1976, pp. 136–9). When Tabasco Governor Garrido arrived in Mexico City as the new Minister of Agriculture, he was accompanied by his red-shirts, anticlerical shock troops already infamous in their home state for their iconoclastic zeal. Saint burning – they incinerated an image of the Virgin of Guadalupe in a church in Cuernavaca, Morelos – and armed clashes with Catholics ensued, culminating in a deadly shootout in the neighbourhood of Coyoacán (Negrete, 1988, pp. 108-111; Martínez Assad, 1979, pp. 175, 219–26). We also find examples of reverse or retaliatory iconoclasm. In Paso del Macho, Veracruz, Catholics 'executed' a statue of President Benito Juárez (1806-72), a radical liberal reformer considered by many Catholics the architect of nineteenth-century anticlericalism (Reich, 1995, p. 41).

Not only widely venerated images were destroyed. Iconoclasts sought to remove religious images from the most intimate spaces of private life. Religious statues and other images were outlawed in all private schools in 1932 (Negrete, 1988, p. 161). Then, in many states, thousands of statues, prints and crosses were confiscated from churches, seminaries, Catholic schools and private homes, and burned in public, especially during the so-

called *Domingos Rojos* (Red Sundays), *Domingos Culturales* (Cultural Sundays) and other revolutionary festivals. Organized by local chapters of the revolutionary party, the Partido Nacional Revolucionario, these cultural programmes became a kind of iconoclastic civic ritual. Sometimes, major iconoclastic events were scheduled on the Anniversary of the Revolution on 20 November, the most important new ritual of the revolution. This happened in Tuxtla Gutiérrez, Chiapas, in 1934, when civil servants lit a huge bonfire composed of images they had removed from the church of San Marcos. Similar performances were staged simultaneously in Tapachula, San Cristóbal de las Casas, Chiapa de Corzo and Comitán (Tamayo Víctor, 1997, p. 82). Iconoclasm was sometimes followed by a process of resacralization, for example by replacing the saints with images of revolutionary martyrs such as Emiliano Zapata, Venustiano Carranza and Alvaro Obregón, as happened in Michoacán (Becker, 1995, p. 82). Church bells from the Cathedral of Villahermosa, Tabasco, were melted down and recast in the image of President Obregón (Martínez Assad, 2000, p. 8).

Iconoclasm could become an almost routine, formalized, bureaucratic activity. Federal teachers were expected to fill out bimonthly statistical forms computing the number of 'fetishes' burned during anticlerical school rallies. One Sonoran inspector instructed principals that at the 1934 Socialist Revolutionary Meeting,

all teachers, peasants and workers, children, women and adults, must bring to the Proletarian Bonfire all saints, images, sculptures, fetishes, banners, religious vestments, books, etc. that served the Church and the Clergy to lull people to sleep, make a pyre of all these and set fire to them while singing the Socialist Hymn, the Labor Hymn, the Marseillaise or the Mexican National Anthem.[7]

The Sonoran Director of Federal Education proudly wrote his superiors that teachers had incinerated thousands of images:

As proof of the spontaneous antireligious attitude that the children of the federal schools of the state of Sonora have assumed, I permit myself the honor of informing you of the following events: When I presented myself at the Mayo Indian village of Macoyahui to conduct my inspection, thirty-five children of both sexes came to meet me, declaring that they were waiting for me to burn the fetishes that were in the village church and in their houses, fetishes that had been valiantly extracted by the teacher, Miss Antonia Montes, with the aid of the Ejidal Commissariat and the Education Committee. Once the pyre had been lit, the little Indians started dancing a *pascola*, and to the gay sound of their native music, they started flinging the fetishes into the fire, one by one, until the pyre was converted into an enormous bonfire, which consumed those symbols of fanaticism and exploitation.

(Bantjes, 1998, p. 14)

Especially in the schools, iconoclasm had a didactic purpose, namely to teach

children that images were mere objects of wood or plaster, not living miracle workers. In Tabasco, Garrido's

cronies brought the image of some saint to the schools, they place[d] it in the middle of the school patio and each one of the boys and girls, who were armed with clubs, knives or machetes, would stab, hit, slash, kick or spit on it, so as to demonstrate that saints aren't capable of miracles.[8]

Similar acts of didactic humiliation and destruction occurred during revolutionary and anticlerical theatrical performances. In Mérida, Yucatán, an actress smashed an image of Christ on the floor during a play in the Casa del Pueblo, a cultural centre, causing a riot. Iconoclasm allowed the public a view of the innards of the image. After the statue of Santa Teodora was taken from the Cathedral in Xalapa, Veracruz, and publicly burned, its remains were brought to the police station for closer examination: it turned out to consist of 'a grotesque wire framework stuffed with cotton and tow and covered with a layer of wax' (Martínez Assad, 1979, pp. 48–9). Destruction was not invariably necessary. Besides participating in public acts of iconoclasm, during their carpentry classes Tabasco schoolchildren were encouraged to build 'the dolls called "saints" ', so as to learn 'how absurd and ridiculous it was to render homage to and venerate pieces of wood they had transformed into dolls with their own hands' (Martínez Assad, 1979, p. 74).

In school lessons, plays, official publications and speeches, a rich antireligious discourse mocked the saints and religion. This anticlerical poem from Chiapas, written in 1933, describes an attempt to humiliate a saint by proving its inability to perform miracles, in this case, to bring rain. This was a common theme in iconoclastic literature and theatre.

Unas gentes campiranas	Some country folk
Le gastaron una broma	Played a joke
Al ídolo de su aldea;	On the idol of their village;
Lo sacaron a pasear	They took him for a stroll
Por el campo, sí señor,	Through the country, yes, Sir
Y con sencilla expresión	And with a simple expression
Le dijeron cara a cara:	They told him face to face:
'Oye santito de palo,	'Hey, you little wooden saint,
Como el cura nos ha dicho	As the priest has told us
Que haces milagros, tata,	That you perform miracles, brother,
Te pedimos que nos eches	We ask that you give us
Una catarata cumbre	A real downpour
Para salvar la milpita.	To save the cornfield.
Si no haces el milagro,	If you don't perform this miracle,
Aquí te quedas, santito,	You stay right here, little saint,
Como un mojón del ejido.'	As a marker of the commons.'
Y como ninguna lluvia	And as no rain
Hasta la fecha cayó,	Has fallen up till now,

El ídolo de la aldea	The village idol
Fue puesto por el gentío	Was placed by the crowd
A guisa de mojonera.	As a landmark.

<div align="right">(Tamayo Víctor, 1997, p. 107)</div>

In several states (Veracruz, Tabasco, Chiapas, Guanajuato, Oaxaca and so on), legislation sought to eradicate the religiously charged sacred topography, often replacing saints' names with those of nineteenth-century liberal heroes, martyrs of the revolution, politicians or writers (Williman, 1976, pp. 144–6; Martínez Assad, 1979, p. 38; Lewis, 1997, p. 142).[9] For instance, in 1932 the Veracruz state Congress introduced legislation desacralizing (and, often, resacralizing) the names of numerous towns and villages. San Cristóbal was renamed Carlos A. Castillo, after a crony of Governor Jara's. San Juan Evangelista became Santana Rodríguez, after a revolutionary hero. The *ranchería* Santa Teodora was renamed after President Alvaro Obregón, while Santa Lucrecia became Jesús Carranza, named after a revolutionary general and brother of President Carranza. Dual names, indicating the superimposition of a saint's name on an indigenous designation, had the religious prefix removed: San Nicolás Citlaltepetl became simply Citlaltepetl, Santiago Tlilapan became Tlilapan. At least thirty Veracruz towns were renamed.[10] Some iconoclasts went even further: in jacobin Tabasco even the religious greeting '*adiós*' was outlawed (Martínez Assad, 1979, p. 198).

The revolutionary attack on sacred nomenclature indicates a wider interest in refashioning the sacred landscape, which was saturated with religious significance, a vast symbolic network of roadside shrines, crosses, saints' fields and pastures, pilgrims' routes, miraculous sites, grottoes and churches. This sacred landscape was to be secularized through the creation of a new network of statues of revolutionary heroes, monuments, civil shrines, plazas for revolutionary rallies, official buildings and, in the countryside, rural schools and open-air theatres. The best example of a sacred revolutionary monument is the Monumento a la Revolución (Monument to the Revolution) in Mexico City. Starting in the 1940s, the bodies of the most revered revolutionary martyrs, such as Francisco I. Madero, Venustiano Carranza, Francisco Villa and others, were interred here. The Monumento Obregón in Mexico City, a large marble cupola-capped structure completed in 1935, contains relics of the assassinated president, namely his arm, shot off during a revolutionary battle and preserved in a large jar of formaldehyde kept in a niche, and a fragment of the floor of the restaurant where he was martyred in 1928 (Benjamin, 2000, ch. 5). Ironically, Obregón became a secular saint when a religious fanatic, irate at his anticlerical stance, assassinated him in a restaurant on that very spot.

In rural areas, the village shrine functioned for centuries not just as a space for religious gatherings, but as a symbol of village pride, history and identity

(Christian, 1989, p. 44). Now its central place was to be usurped by the rural school, while the federal teacher was to replace the village padre. Church annexes, convents and, in many cases, even churches were confiscated and closed or converted into school buildings, union headquarters, cultural centres, libraries, government offices, workshops and ejidal granaries. In many states, all or most churches remained closed for extended periods, often years, while in Sonora, Tabasco and Veracruz dozens of churches were burned, dynamited, torn down for street widening projects or blatantly demolished by schoolchildren wielding pick axes (Martínez Assad, 1979, p. 45; Bantjes, 1997, pp. 100–10; Williman, 1976, p. 131; Negrete, 1988, p. 138).

Conclusion: modernity and the many meanings of revolutionary iconoclasm

What can we conclude about the meaning and impact of acts of iconoclasm in revolutionary Mexico? As we have seen, the religious image in Mexico is polysemic, not just a symbol of narrowly defined spirituality. For believers, the santo may be an animate entity that can work miracles and protect individuals and communities against disease, accidents, natural calamities and violence. The ontological security of many Mexicans depends directly on their relationship with the saint and its image. At a symbolic level, the saint's image is the focal point of the community, even, in the case of the Virgin of Guadalupe, of the Mexican nation. An entire network of political, economic, cultural and gender relations (the indigenous political hierarchy of elders, or cargo system, regional fairs, ritual dances, women's sodalities and so forth) is centred on the cult of the saints.

Likewise, revolutionary iconoclasm has a range of meanings. Following Gamboni's contextual approach, we must, of course, locate iconoclasm within the political context of the church–state conflict. The new revolutionary state sought to undermine the social, cultural and political influence of the Roman Catholic Church through anticlerical and anti-religious campaigns. Iconoclasm frequently accompanied local attempts to establish political control and implement radical agrarian, labour and cultural reform. It was part of the revolutionary package.

However, there is clearly more to iconoclasm. Even the Catholic Church has advocated a clerical form of iconoclasm quite similar to that of its radical opponents. Thus, from a broader perspective, iconoclasm must be interpreted as part of the enlightened effort of the Mexican elite and middle class to suppress popular culture, including folk religion, and forge New Men, productive, secular, progressive and modern. The Mexican revolution was a cultural revolution or, to use Theda Skocpol's term, 'a metaphysical

revolution' (1985, pp. 94–5), which sought to reshape the essence of Mexican culture, identity and everyday life. From this perspective, the Mexican revolution has much in common with those in other modernizing nations, such as the Soviet Union. Thus, Mexican iconoclasm must be seen as an integral part of the Enlightenment dream of modernity.

In this context, Mexican revolutionary iconoclasm served as a didactic tool to convince schoolchildren, fanatic women (*beatas*), and ignorant peasants and Indians that saints are not living miracle workers, but man-made creations of wood, plaster, wax and paint. Only by witnessing the destruction of their beloved santos would the benighted campesinos finally come to understand the materiality and artifice of images and the clerical trickery they had fallen victim to. Iconoclasm also had a moralizing and productivist goal, that is to end wastefulness and deprivation and foster the development of productive capitalist habits.

Iconoclasm thus played a key role in the revolutionary cultural project. In the Mexican context, the phenomenon must be defined broadly. Richard Clay's definition, 'breaches in the physical integrity of representational objects' (forthcoming), is useful in that it avoids exclusive focus on 'art', an inappropriate concept in this context, where saints' images were seldom considered art, but rather actual animate entities. With Clay, I would also argue that a narrow focus on images limits our range of iconoclastic events. In Mexico, not just images, but also crosses, churches, cemeteries, rituals, religious names, even practices (Mass, pilgrimages), words and priests' bodies must be considered icons or signs, and their obliteration as acts of iconoclasm. Thus, the concept of *semioclasm* may be more appropriate than that of iconoclasm (Clay, forthcoming). The sacred image was only the most important sign in an intricate semiotic network that included everything from sacred landscapes to chapels to priests. It was this symbolic network that was targeted by revolutionary iconoclasm. The saint in particular, but also the church, the priest and so on had to be eliminated in order to eradicate an entire realm of backward peasant behaviour and finally establish the modernist utopia.

But the deeper fear that Ozouf and Freedberg find among French revolutionary iconoclasts or contemporary destroyers of museum art is also evident in the Mexican case. Context alone fails to explain the vehement personal taunting of God and the saints one finds in many cases of Mexican iconoclasm. Rivera's scandalous behaviour was in part didactic, in part a replaying of episodes of the French Revolution, but possibly also an effort to convince himself of the helplessness of the gods. Many Mexican jacobins were steeped in Catholic culture and even included in their ranks a fair number of ex-seminarians. For them, iconoclasm signified a highly personal rejection of Catholic visual culture and an attempt to prove to themselves and

others the impotence of the saints. For example, Tabascan politician Arnulfo Pérez H. proudly signed his name with the accompanying motto, 'Personal Enemy of God' (Tamayo Víctor, 1997, p. 86). Though it is ultimately impossible to read the minds of Mexican iconoclasts, one might hypothesize that the *quemasantos* had much in common with contemporary pathological iconoclasts who see behind the plaster or wooden object a real being capable of striking back and in need of obliteration. Thus, Mexican iconoclasm may be considered part of a long iconoclastic tradition dating back to biblical times that reflects an ancient fear of images.

Most authorities would agree that iconoclasm is seldom mindless vandalism, but instead deliberate, meaningful, creative, a 'means of communication in [its] own right' (Gamboni, 1997, p. 22). What is really destroyed is not just the signifier, but especially the signified, that is the meaning or, better, meanings of the sign. Iconoclasm is frequently the first step in a broader attempt to establish, through the elimination or resignification of old signs, a new symbolic or discursive system. Thus, Clay's term *semiomorphosis*, or sign transformation, is quite useful for our purposes (Clay, 2006).

In Mexico, semiomorphosis meant the desacralization of popular Catholicism and its symbols and its substitution by a new state-dominated revolutionary civil religion and imaginary through a 'transfer of sacrality'. The saints' images were to be replaced by statues of revolutionary heroes, sacred names by revolutionary nomenclature, priests by socialist teachers, chapels by schools, the Bible by the Constitution, Mass by the Red Sunday, pilgrimages by nationalist rallies, piety by productivity, superstition by science. Local identities based on religious symbolism were to be superseded by a homogeneous national identity and culture.

Mexican iconoclasm, implemented inconsistently by fits and starts, was a terrible fiasco. Not only did its didacticism fail to convince a profoundly religious people, it actually backfired, fostering resentment and swelling the counter-revolutionary ranks with Catholic peasants ready to die for their beliefs and way of life. Instead of discarding their saints, they were able to make sense of religious persecution and iconoclasm by incorporating these into their religious-magical discourse, interpreting iconoclastic episodes as a second passion, martyrdom, divine commands or miracles. This response empowered them to resist attempts to create new identities, loyalties and a revolutionary civil religion, and actually strengthened local religious praxis.

We clearly see this phenomenon in the case of Black Christ of Otatitlán. It is quite illuminating to see how believers have interpreted the burning of Christ's image and incorporated it into the pilgrimage. The cult was renewed three years after the image's incineration. An entirely new image of the Black Christ was sculpted to replace the old image, though most people believe that

only the head was replaced and added to the original body and cross (Velasco Toro, 2000, pp. 102). The original head was finally returned to the church 14 years after being carried off and was placed in a separate glass case in the sanctuary (Vergara Ruiz, 1997, pp. 99–101).

Catholics made sense of the image's destruction in various ways. Some saw the events as a second passion of Christ. The Black Christ was 'assassinated', as one religious song puts it, only to be resurrected miraculously. Another *alabado* uses the verb *ultrajar*, which means to outrage, offend, abuse, depreciate, despise, to describe the event: 'Cuando fuiste ultrajado/quedó el pueblo sin producto/también tu templo sagrado/dos años quedó de luto' (When you were offended/the village was left unproductive/your holy temple also/remained in mourning for two years) (Vargas Montero, 1997, pp. 299). The image's destruction is here clearly linked to a decline in the village's economic productivity until its miraculous resurrection. In one mazatec/chinantec story, when the head of Christ's image was thrown into a raft, a wind funnel appeared, followed by a bright light and the reappearance of Christ. Others claim that Christ returned by floating back down the Papaloapan River. One story even interprets iconoclasm as a divine command. The iconoclasts never did understand their actions, but God desired the image's destruction because the children who worshipped it had been hurting their necks due to its awkward angled position on the church wall. The new head solved this problem by facing the viewer directly (Velasco Toro, 2000, pp. 102–3, 136–41). Divine retribution followed desecration. According to legend, the three individuals responsible for taking the image died a violent death, pleading for mercy (González Martínez, 1997, pp. 461). Thus, iconoclasm was explained according to the believer's cultural and religious discursive repertoire.

Today, the 'assassination' of the Black Christ has also been incorporated into the pilgrimage itself. During the week-long religious festival, on the morning of 3 May, pilgrims leave in procession with religious banners and musicians to the place of the burning in a plantain grove, which is marked by a small monument generally referred to as 'the tomb'. Here they engage in *limpias*, or ritual cleansing practices with laurel leaves, and bless ears of corn, which are returned to the fields impregnated with the sacrality of the spot. Next to the tomb is a deep hole marked with a cross, from which the pilgrims extract holy earth, which is brought back to their villages and mixed with the earth of their *milpas* or cornfields to cleanse them and assure a good harvest. The pilgrims pray the rosary, make offerings, applaud and shout *vivas* to the Black Christ and then return to the sanctuary with music and fireworks (González Martínez, 1997, pp. 462–3).

Back in the sanctuary, there is a special space devoted to the 'Divine Decapitation of Christ', and a large oil painting depicts the 'Profanation' of

Christ. The head of the Black Christ and what is believed to be the original cross are worshipped separately from the new image. Thus the cult of Our Lord of Otatitlán is extended and strengthened by incorporating the decapitation as a second passion and resurrection (González Absalón, 1997, p. 539; Velasco Toro, 2000, p. 135). Far from extinguishing the cult by destroying the image, the iconoclasts only managed to foster a widening of the cult. The damaged remains of the original image are given a new meaning within the context of the ancient pilgrimage.

At a spectacular auto da fé held at Maní, Yucatán, in 1562, the great Franciscan iconoclast Fray Diego de Landa destroyed 5000 Mayan 'idols', as well as numerous codices or 'works of the devil' (De Landa, 1978, iii). Undoubtedly, he firmly believed that this dramatic act of iconoclasm would root out the pagan superstitions of the natives and implant Christianity in that distant realm of the Spanish Empire. Little did he know that his virulent acts would only serve to establish a novel form of unorthodox indigenous religiosity based on the adoration of a new set of idols. Nearly four hundred years later, de Landa's modernist successors sought, yet again in vain, to eradicate the very Indian Christianity the Franciscan had inadvertently fostered.

Notes

1 Michael Rush (2001), 'A veteran foe of fakery with a cattle-prod style', *The New York Times*, 18 February, p. 33.
2 Inspector federal José Velázquez Luna to Gobernador provisional, Sinaloa, 3 October, 1936, Fondo Dirección General de Educación Primaria, Secretaría de Educación Pública, Archivo Histórico 318.5, Mexico City.
3 Gaveta 1, ACCION ANTIRELIGIOSA, inv. 16, exp. 16, fojas 1-8, Archivo Plutarco Elías Calles, Archivos Plutarco Elías Calles y Fernando Torreblanca (henceforth APEC), Mexico City. Compare the art of contemporary Italian multimedia artist Fabrizio Plessi, which features rotating black confessionals with built-in television screens spewing red-hot hellfire.
4 'El Sr. de Otatitlán que se venera en su Santuario. Alabado en obsequio de su Milagrosa Imagen', Oaxaca, Oaxaca.
5 *Excélsior* (Mexico City), 15, 18, 19 November 1921.
6 Interview by author with lic. Luis Castañeda Guzmán, Oaxaca, Oaxaca, 14 January 2002.
7 Martín Mercado to teachers, October 10, 1934, Secretaría de Educación Pública, Archivo Histórico 366.6, Mexico City.
8 Profesor Manuel de Esesarte, Los Angeles, 1934, Archivo Fernando Torreblanca, Secretaría Particular, Fondo Plutarco Elías Calles, Serie Conflicto Religioso, 1929–1934, ESESARTE, MANUEL DE, APEC, Mexico City.
9 Adolfo Maldonado, Secretario General de Gobierno Guanajuato to Inspectores de Culto, 2 November 1934, exp. 1.40(57)43, Fondo Secretaría General del Gobierno, 1er Departamento, Serie Gobernación, Archivo General del Gobierno del Estado de Guanajuato.
10 *Enciclopedia municipal veracruzana* (1998), Xalapa: Gobierno del Estado de Veracruz.

References

Bantjes, Adrian A. (1994), 'Burning saints, molding minds: iconoclasm, civic ritual, and the failed cultural revolution', in Beezley, William H., Martin, Cheryl English and

French, William E. (eds), *Rituals of Rule, Rituals of Resistance: Public Celebrations and Popular Culture in Mexico*, Wilmington, Del.: Scholarly Resources Books, pp. 261–84.

Bantjes, Adrian A. (1997), 'Iconoclasm and idolatry in revolutionary Mexico: the de-Christianization campaigns, 1929–1940', *Mexican Studies/Estudios Mexicanos* **13** (1), Winter, 87–120.

Bantjes, Adrian A. (1998), *As If Jesus Walked On Earth: Cardenismo, Sonora, and the Political Culture of the Mexican Revolution in Sonora, 1929–1940*, Wilmington, Del.: Scholarly Resources Books.

Becker, Marjorie (1995), *Setting the Virgin On Fire: Lázaro Cárdenas, Michoacán Peasants, and the Redemption of the Mexican Revolution*, Berkeley: University of California Press.

Bell, Daniel (1998), *The End of Ideology: On the Exhaustion of Political Ideas in the Fifties*, Cambridge, Mass.: Harvard University Press.

Benjamin, Thomas (2000), *La Revolución: Mexico's Great Revolution as Memory, Myth, and History*, Austin: University of Texas Press.

Brading, D. A. (1991), *The First America: The Spanish Monarchy, Creole Patriots, and the Liberal State 1492–1867*, Cambridge: Cambridge University Press.

Brading, D. A. (2001), *Mexican Phoenix. Our Lady of Guadalupe: Image and Tradition Across Five Centuries*, Cambridge: Cambridge University Press.

Christian, William A., Jr. (1989), *Person and God in a Spanish Valley*, Princeton: Princeton University Press.

Clay, Richard (forthcoming), 'Iconoclasm, vandalism or sign transformation during the French Revolution', in Boldrick, Stacy and Clay, Richard (eds), *Iconoclasm: Contested Objects, Contested Terms*, Aldershot: Ashgate.

Díaz del Castillo, Bernal (1975), *Historia verdadera de la conquista de la Nueva España*, Madrid: Espasa-Calpe.

Enríquez Licón, Dora Elvia (1994), 'El paraíso perturbado (Colima en la posrevolución)', unpublished MA thesis, Universidad de Colima, Facultad de Ciencias Políticas y Sociales.

Foster, George M. (1967), *Tzintzuntzan: Mexican Peasants in a Changing World*, Boston: Little, Brown.

Freedberg, David (1989), *The Power of Images: Studies in the History and Theory of Response*, Chicago: University of Chicago Press.

Gamboni, Dario (1997), *The Destruction of Art: Iconoclasm and Vandalism since the French Revolution*, New Haven: Yale University Press.

Garay, José Antonio (2000), *Historia de Oaxaca*, Mexico: Editorial Porrúa.

Giddens, Anthony (1990), *The Consequences of Modernity*, Stanford: Stanford University Press.

González Absalón, Carlos Bernardo (1997), 'El camino de una fe. Etnografía de la peregrinación de Cosoleacaque al Santuario de Otatitlán', in Velasco Toro, José (ed.), *Santuario y región. Imágenes del Cristo Negro de Otatitlán*, Xalapa: Instituto de Investigaciones Histórico-Sociales, Universdad Veracruzana, pp. 503–84.

González Martínez, Joaquín R. (1997), 'Peregrinaciones de abril y mayo a través del Papaloapan. Aproximación geoetnográfica al culto del Cristo Negro', in Velasco Toro, José (ed.), *Santuario y región. Imágenes del Cristo Negro de Otatitlán*, Xalapa: Instituto de Investigaciones Histórico-Sociales, Universdad Veracruzana, pp. 405–500.

Greene, Graham (1960), *The Lawless Roads*, 3rd edn, London: Heinemann.

Gruening, Ernest (1940), *Mexico and Its Heritage*, New York: D. Appleton-Century.

Gruzinski, Serge (1993), *The Conquest of Mexico: The Incorporation of Indian Societies into the Western World, 16th–18th Centuries*, Cambridge: Polity Press.

Gudeman, Stephen (1976), 'Saints, symbols, and ceremonies', *American Ethnologist* 3 (4), November, 709–29.

Ingham, John M. (1986), *Mary, Michael, and Lucifer: Folk Catholicism in Central Mexico*, Austin: University of Texas Press.

Iwaniszewski, Stanislaw (1997), 'Cotidianidad y cosmología: la representación social del espacio en Otatitlán', in Velasco Toro, José (ed.), *Santuario y región. Imágenes del Cristo Negro de Otatitlán*, Xalapa: Instituto de Investigaciones Histórico-Sociales, Universidad Veracruzana, pp. 205–60.

Knight, Alan (1986), *The Mexican Revolution*, vol. 2: *Counter-Revolution and Reconstruction*, Cambridge: Cambridge University Press.

de Landa, Friar Diego (1978), *Yucatan Before and After the Conquest*, New York: Dover.

Lewis, Oscar (1963), *Life in a Mexican Village: Tepoztlán Restudied*, Urbana: University of Illinois Press.

Lewis, Stephen E. (1997), 'Revolution and rural schoolhouse: forging state and nation in Chiapas, Mexico, 1913-1948', unpublished Ph.D. thesis, University of California, San Diego.

Martínez Assad, Carlos (1979), *El laboratorio de la revolución: el Tabasco garridista*, Mexico: Siglo XXI.

Martínez Assad, Carlos (2000), 'Tomás Garrido Canabal: "La prenda del Callismo"', *Boletín* 8, Mexico: Fideicomiso Archivos Plutarco Elías Calles y Fernando Torreblanca.

Meyer, Jean (1985), *La cristiada*, vol. 2: *El conflicto entre la iglesia y el estado 1926–1929*, Mexico: Siglo XXI.

Navarrete, Carlos (1982), *San Pascualito Rey y el culto a la muerte en Chiapas*, Mexico: Universidad Nacional Autónoma de México.

Negrete, Martaelena (1988), *Relaciones entre la iglesia y el estado en México, 1930–1940*, Mexico: El Colegio de México, Universidad Iberoamericana.

Ozouf, Mona (1988), *Festivals and the French Revolution*, Cambridge, Mass.: Harvard University Press.

Parsons, Wilfrid (1936), *Mexican Martyrdom*, New York: Macmillan.

Poole, Stafford (1995), *Our Lady of Guadalupe: The Origins and Sources of a Mexican National Symbol, 1531–1797*, Tucson: University of Arizona Press.

Raby, David L. (1974), *Educación y revolución social en México (1921–1940)*, Mexico: SEP.

Reich, Peter Lester (1995), *Mexico's Hidden Revolution. The Catholic Church in Law and Politics since 1929*, Notre Dame, Ind.: University of Notre Dame Press.

Rivera, Diego (1991), *My Art, My Life: An Autobiography*, New York: Dover.

Romero, S. J., José, A. and Juan Alvarez Mejía, S. J. (1952), *Directorio de la Iglesia en México*, Mexico: Buena Prensa.

Savarino Roggero, Franco (1997), *Pueblos y nacionalismo, del régimen oligárquico a la sociedad de masas en Yucatán, 1894–1925*, Mexico: INEHRM.

Scott, James C. (1998), *Seeing Like a State: How Certain Schemes to Improve the Human Condition Have Failed*, New Haven: Yale University Press.

Sewell, William H., Jr. (1985), 'Ideologies and social revolutions: reflections on the French case', *Journal of Modern History* 57 (1), March, 57–85.

Skocpol, Theda (1985), 'Cultural idioms and political ideologies in the revolutionary reconstruction of state power: a rejoinder to Sewell', *Journal of Modern History* 57 (1), March, 89–96.

Stannard, Martin (1987), *Evelyn Waugh: The Early Years 1903–1939*, New York: W. W. Norton.

Tamayo Víctor, Esperanza (1997), 'Desfanatización religiosa en Chiapas de 1930–1940 (Cuando las campanas callaron)', unpublished BA thesis, Escuela Nacional de Antropología e Historia, Mexico City.

Trías, Eugenio (1998), 'Rethinking religion', in Derrida, Jacques and Vattimo, Gianni (eds), *Religion*, Stanford: Stanford University Press, pp. 95–110.

Valles Septién, Carmen (ed.) (1994), *La ruta de los santuarios en México*, Mexico: CVS Publicaciones.

Vargas Montero, Guadalupe (1997), *'Venimos a cumplir con la promesa*: Las peregrinaciones corporadas del oriente', in Velasco Toro, José (ed.), *Santuario y región. Imágenes del Cristo Negro de Otatitlán*, Xalapa: Instituto de Investigaciones Histórico-Sociales, Universidad Veracruzana, pp. 263–355.

Velasco Toro, José (1997), *'Vamos al Santuario del Señor de Otatitlán*: Expresión numinosa de un ámbito regional', in Velasco Toro, José (ed.), *Santuario y región. Imágenes del Cristo Negro de Otatitlán*, Xalapa: Instituto de Investigaciones Histórico-Sociales, Universidad Veracruzana, pp. 121–2.

Velasco Toro, José (2000), *De la historia al mito: mentalidad y culto en el Santuario de Otatitlán*, Xalapa: Instituto Veracruzano de Cultura.

Vergara Ruiz, Gustavo (1997), 'Otatitlán en el perfil del tiempo', in Velasco Toro, José (ed.), *Santuario y región. Imágenes del Cristo Negro de Otatitlán*, Xalapa: Instituto de Investigaciones Histórico-Sociales, Universidad Veracruzana, pp. 47–107.

Waugh, Evelyn (1939), *Robbery under Law: The Mexican Object-Lesson*, London: Chapman and Hall.

Williman, John B. (1976), *Iglesia y Estado en Veracruz, 1840–1940*, Mexico: SepSetentas.

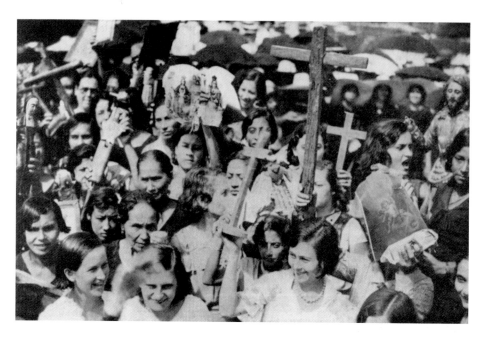

3.1 *Women and children bring religious articles to be publicly burned*, from article by George Creel, 'The Scourge of Tabasco', Collier's, 23 February 1935

Fallen idols and risen saints: western attitudes towards the worship of images and the 'cultura veterum deorum'[1]

Beate Fricke

The Second Commandment forbids the creation and veneration of graven images, and for much of the Early Middle Ages devotional images and sculpture were absent in the West, with the exception of the city of Rome.[2] However, images – and more specifically sculpture in the round – experienced a dramatic revival in western medieval art from the late ninth century onwards.[3] To date, scholars have had difficulty explaining such a fundamental change in using and creating Christian images.[4] Though monumental sculpture never appears in the East, it emerged in the West after the debates about the Second Council of Nicaea, and the Imperial court's reactions to that council, the *Libri Carolini* and the so-called iconoclasm in Byzantium.[5] As westerners were called upon to articulate their position towards appropriate forms of image veneration and the true nature of an image of God, they started to reconsider their own image culture.[6] The revival of monumental sculpture can be seen as one of the consequences of the western reaction to Byzantine iconoclasm, an invitation to rethinking their own usage of images in the religious cult.[7] In negating Byzantium's rigorous position, western theologians re-examined their own traditions of venerated religious objects such as relics, the cross and the equating of images with the sacrament, the latter a misunderstanding of the text of the second Council of Nicaea on the part of the writer of the *Libri Carolini*.[8] By the ninth century a crucial difference between West and East was abandoned. While in Byzantium sacred bodies were dissected and their fragments and particles were spread as relics,[9] it appears that in the West such practices continued to be a sacrilege until the late ninth century.[10] In Byzantium all parts, even miniscule and unsightly relics of the saint's body, were considered to possess the same power as the intact corpse and the saint himself. Conversely, in the West, it was the one sacred site, the tomb of the saint, that mattered. Tiny fragments, contact relics and the like could not compare with an intact body, the *corpus incorruptum* of a saint. The impact of

these profoundly differing premises for the genesis of sacredness and the use of imagery should not be underestimated. After the ninth century an increasing number of infringements against the idea of the *corpus incorruptum* and a growing number of *furta sacra*, sacred thefts, were documented. The Franks based their cultural and political supremacy in the prologue of the *Lex Salica* § 4 on the fact that they did not feed the bodies of martyrs to wild animals nor dissect the corpses. Rather they adorned and embellished the martyrs' remains.[11] This argument was due to their eagerness to legitimize the numerous instances of *translatio* of relics during the first half of the ninth century within the context of an *imitatio romae* – an imitation of Rome.

In this process, an essential reconsideration of a distinct western image culture took place, and westerners first became conscious of the different paths taken by the two cultural inheritors of Roman Antiquity. By recalling an earlier period of their own iconoclasm, the destruction of antique statues, westerners articulated their own position in the debate on Christian images, specifically in saints' lives. I will argue in the following that this conscious grasp of the past contributed to the western negation and negotiation of Byzantine accusations of idolatry. The destruction of idols was recounted from this slant in western iconoclastic history, for instance in hagiography.

The essential difference between the western and the eastern Christian images was the apparent absence of icons or any cultic venerated Christian figurative image in the western medieval culture of Gallia and the Carolingian territories. The only images that were considered to have supernatural, magic or divine powers in western culture were idols.[12] For the purposes of this essay I will apply the term 'idol' to all statues of pagan gods and goddesses that were venerated in cults, the only kinds of images that were explicitly considered 'forbidden' by western authors of the Carolingian period. These remains of pagan cults form the arena in which it was discussed what a Christian image should be and which aspects of images should be rejected. Descriptions of idol destruction became a recurrent literary *topos* as early as the writings of Gregory the Great, but the present analysis will weigh previously neglected early medieval sources (mainly *c*.AD 600–900) that articulate western attitudes towards idols in Gallia in a sophisticated way.[13] After scrutinizing these written sources describing idols and their destruction I will compare the results with pictorial sources such as illuminated manuscripts. Tracing the negation of pagan images in depictions of idolatry alongside written representations reveals a peculiar fact: while written legends develop a particular 'pictorial' language (for example by invention of a metaphorical scene) to reject images, depicted idols are often used as an iconic formula 'literally' enriching the depiction with a speaking sign to indicate former pagan culture and its error. The reader as well as the beholder allays the suspicion of his own cultic practices involving images.

The contemporary Christian rituals, including after a short period monumental images, were purified by negating the past practices of image veneration and rejecting them as idolatry even though those practices were almost identical. Even if the idols seem occasionally to stand on the margins of the depicted event or narrated story, their role as anti-images still demonstrates what were held to be the 'right' attitudes toward the 'wrong' image. In other words, by exploring anathema, we may understand how early medieval Christians differentiated their images from those used to honour Roman gods or the deities of Gaul, how their demonic inhabitants were sensed and recognized, how divine and demonic forces could be differentiated, and exactly how Christian imagery was rooted in antique tradition. In rejecting and negating the idol, Christianity absorbed, acculturated and incorporated into western medieval culture the antique idea of an image. By doing so, western Christianity preserved the antique image culture, by the very destruction of its images.

Interactions of paganism with Christianity in the conversion of Gaul

From Late Antiquity onwards, broken idols, or antique effigies of pagan gods, litter saints' lives, missionary accounts, ecclesiastical histories and chronicles of Gaul. However, it is still unclear how widely and how long pagan cults survived in Christianized Gaul because these sources are mostly written from a Christian viewpoint. Almost no pagan voice informs us about this period in Gaul, and only recently have doubts been raised over whether the Christianization of northern Europe was rather less complete than normally assumed.[14] Despite the widespread opinion that the Christianization of Gaul was completed by the end of the fourth century, western hagiographies suggest a much later date.[15] At least as late as *c.* AD 600 pagan rituals and cults, as well as religious artifacts, must have been alive and flourishing in Gaul if Gregory of Tours can mention an image of Berecynthia (the Gaulish mother-goddess or *magna mater*) that was carted from field to field and vineyard to vineyard to guarantee the harvest.[16] Indeed, as Jean Hani has persuasively argued, the *magna mater* cults of Isis and Ceres probably metamorphosed seamlessly into the army of 'black' Madonnas that still populate churches all over central France.[17] Gregory the Great had, in fact, advocated a strategy of 'absorption' in a contemporary letter to Augustine (AD 599/600).[18] In this letter, he advised missionaries to choose the sites of destroyed pagan temples as the locations for their new Christian churches. Whatever the case, clerical censure was visited not only upon public rituals like the Berecynthia procession, but also upon the many breeds of private devotion. Thus, Gregory also reports that Gallus torched an

entire pagan sanctuary (probably the present Saint Gereon in Cologne) after witnessing the donation of wooden ex-votos of affected body parts – in spite of the fact that the Synod of Auxerre (AD 580) had only just forbidden this practice (the creation and ritual use of figurative ex-voto) – not to mention vast pagan banquets on the premises.[19] When Gallus burned the temple and its idols, he was following in the footsteps of Roman predecessors like Pope Symmachus (AD 498–514) whose struggle against Manichaeism culminated in the public immolation of their texts and idols in front of the Constantinian basilicas ('ante fores basilicae Constantinianae ... omnia simulacra vel codices ... incendio concremavit' (all idols and manuscripts were burned in a fire outside the Constantian basilicas)), and then their definitive exile.[20]

Obviously, if pagan belief survived in such well-connected and flourishing cities as Cologne, then it must have thrived in rural areas that lay far off the main traffic routes and beyond the direct control of clerical authorities.[21] It is probably for this reason that local priests in rural Gaul were entrusted with battling all forms of heresy, but particularly pagan cults. As late as the early eleventh century, Bernhard of Angers mentions that idols were intensively venerated and pagan customs still widespread throughout the Auvergne.[22]

How to distinguish a false idol: the characteristics of idols in descriptions of their destruction

Although several early texts describe idols in detail and characterize their material and spiritual qualities, by the ninth century, toppled antique statues no longer receive particularly detailed description. We read simply *idolum contrivit* (idol smashed) or *simulacrum destruxit* (idol destroyed) in saints' lives, and the sources centre more on their heretical usage. But there was no need to describe idols in detail because for ninth-century writers the crucial fact was that idols were artifacts of human appearance. As Hrabanus Maurus states in his *De diis gentium* (*c*. AD 844): 'idolum autem est simulacrum quod humana effigie factum et consecratum est' (The statue was an idol made with a human appearance and consecrated).[23] The definition is significant because, in Hrabanus' eyes, an idol compounds two chief errors in its creation and its veneration, in that it is made by human hands and resembles a human. This was not a new idea, for Tertullian (d. AD 225) had first defined the intimate connection between idols, sin and idolatry, articulating a Christian platform against a background of the Jewish tradition that linked idolatry with polytheism and sexual sinfulness.[24] He was followed by Optatus, who crystallized this position at the end of the fourth century:

idols, unless they are made, cannot exist ... nor can an idol come to be without

artifice. In idols there is no natural power, but it is joined and entwined with it by human error; a power is reckoned in idols, which was not born there … an idol is nothing of itself and, while it is worshipped, is nothing.[25]

The most influential ideas about the true nature of the false gods or demons were spread by Martin of Braga (d. AD 579). His explanations about the historical origin and the nature of idols are recorded in his widely read *De correctione rusticorum*, which amounts to a short history of paganism. The fallen angels after turning into demons used the people's fading memory of their creator and thus started a campaign of forgery. The devil and his demons appeared in various shapes, talked to the people and were subsequently venerated by them. They abused the names of sinful humans, such as Jupiter and Mars; one of them pretended to be Saturn and another claimed to be Venus. This 'history' of the origin of paganism combines at first some elements of the interpretation of euhemerism and demonic thought as well as the common separation of idolatry from worship of natural creatures such as trees, springs, winds and the like (see Harmening, 1979, pp. 280–84). Martin of Braga's interpretation and use of the pagan past for the Christian present represents quite an early example of Christian historical misrepresentation (*Geschichtsklitterung*). It will form the model for later receptions of the past modelled and redesigned according to contemporary needs in Christian images. Furthermore, according to the euhemeristic explanation of Isidore of Seville (d. AD 638) the so-called 'gods' had originally been humans who had simply acquired divine status because their effigies had received such intense veneration; with the cult of fame they first acquired immortal memory, and thence divinity.

All Christian writers agreed that idols are vain, mute, deaf objects made by human hands. All these *topoi*, in fact, convene in the *Vita* of Sixtus II:

But they must be led again to the temple of Mars: and they must sacrifice. Indeed, if they refuse to implore and sacrifice in this place, they must be beheaded. After being guided outside the walls through the Appian Gate, Sixtus began to say: Here are the *vain, mute, deaf idols made of stone*: before them the miserable (pagans) kneel down so that they lose eternal life: And he spoke to the temple of Mars: Christ, the Son of the living God, will destroy you: and after the blessed Sixtus had said this, all Christians answered: amen. And at once a part of the temple collapsed and was destroyed. (my emphasis)[26]

The motifs in this source were so widely diffused in the later saints' lives that often the site itself became a metonym for the event. An army of later saints will destroy the self-same idol of Mars, in the same sanctuary right outside the Porta San Sebastiano, again and again.[27] To sharp eyes it was always obvious that the idol of Mars was vain, mute, deaf and made of stone, but misbelief is in the eye of the beholder, and it is the very veneration of such artifacts that enables demonic forces to colonize their empty shells, and thence enjoy supernatural powers.

In the ninth century, a priest, saint or divine sign was required to decide whether the effects were diabolical or heaven-sent when Christian statues started effecting miracles. Thus, one newly created Christian statue was visited first by a swarm of devilish wasps and then by divine bees, who 'certified' this object of veneration.[28] Divine signs were necessary because even saints could make mistakes. Saint Martin, for example, went to the extent of magically (and temporarily) halting a funeral when he mistook a corpse for an idol.[29] On other occasions the forces of nature ratified a saint's actions. When Saint Zeno had annihilated all idols in Verona, and established Christian sanctuaries throughout, the city flooded but the waters, miraculously, entered no church.[30]

A still more common *topos* is the actual, divine destruction of an idol. An exceptional instance of this motif may be found in the *Life of Wulfilaic* by Gregory of Tours. Gregory recounts Wulfilaic's destruction of a statue of Diana on a mountain in the Ardennes (close to Cardignan). Wulfilaic, with all the zeal of the quite recently converted (he was of Longobard origins), narrates how he became a Stylite in order to convert the pagans and topple their idol. The gimmick helped Wulfilaic avoid fame, and all its attendant perils ('vanam tota intentione cupiens gloriam evitare' (with the intention to avoid the greed for vain fame)), and become a living saint by spending months squatting atop an empty column opposite one dedicated to Diana:

I found here a statue of Diana, which these impious people worshipped like a god. I also erected a column, on which I stood with great suffering as I had no protection for my feet. And since winter had already arrived as usual, I was so tormented by the chill that its extreme rigour very often froze the nails from my feet, and ice hung from my beard like guttered wax. … When we eagerly asked him what he had eaten and drunk there, and how he had toppled the idols of that mountain, he said: My food and drink were a husk of bread, vegetables, and a little water. When a crowd from the nearby villages began to come to me, I (constantly) taught them that Diana was nothing, the idols were nothing, and that the worship that they thought her due was nothing; and also the songs, which they sang in the course of their excessive banquets, were shameful: but instead they should make a sacrifice of praise to the Almighty God, who made heaven and earth. I also often prayed that God might deign to drive the people away from that error after the idol had been destroyed. The mercy of God convinced those simple minds to bend their ears to the words from my mouth, in order that they might follow God after abandoning the idols. Then, after mustering some of them, with their help I eventually had the strength to destroy that huge idol, which I could not smash by myself: and I had already shattered the rest of the small statues, which were easier to break. After gathering at that statue of Diana many tried to haul it down with ropes, but all their labour was in vain. I approached the church, and kneeled down and tearfully begged divine mercy, so that what human labour was not able to topple divine power might destroy. As I came out after the prayer, I approached the workers and grasped the rope, and as soon as we started to pull, the idol immediately crashed to the ground at the first attempt, and by smashing it with iron hammers I reduced it to dust.[31]

As was the case in the life of Sixtus II, the deadness of the idol is contrasted with that living Christian God who can destroy all artifacts: 'Christ, son of the living God, will destroy you.'[32] The dusty remains of the toppled pagan deity are buried according to the Christian funeral ceremony for terrestrial corpses: 'Dust to dust … as God said to Adam, "Dust you are and to dust you shall return"' (Genesis 3:19). The saint remains present, almost like an animated (literary) image of a saint on a column in the written account of his life. The written account paves the way for installing pictorial representations and even free-standing images of the saint to recall him and his celestial powers before Christian eyes.

How living Christian saints competed with dead pagan deities

The story of Wulfilaic is the only record in western Europe of the chiefly Syrian phenomenon of Stylitism. We are obviously meant to understand that the 'living saint', Wulfilaic, the instrument of divine will, confronts the dead relic of paganism, but at the same time the episode is supremely ambivalent, because to do so he must become a living corpse himself. Wulfilaic must have been the exception that proved the rule, for his totemistic impulse was vehemently opposed by the local bishop, a fact not mentioned in his hagiography. Wulfilaic clinched the parallel between living icon and extinct idol by gambling on the symmetry of columns, and his pregnant words hit home: 'jugiter nihil esse Dianam, nihil simulacra, nihilque quae eis videbatur exerceri cultura' (again and again, Diana was nothing, the idols were nothing, and that the worship that they thought her due was nothing). In other words, Wulfilaic monumentalizes Diana's perpetual (*jugiter*) ignominy.

With the job of conversion done, through the mercy of God, Wulfilaic is not simply content to topple the statue of Diana. Although most pagan statues in Germanic and Gaulish cities were recycled as the building blocks in fountains or town walls, Wulfilaic felt he had to hammer the statue of Diana to smithereens. After all, it was devoid of inner life.[33]

The agenda of destroying idols to convert pagans eventually became so well-travelled that saints even dreamed it:

On the next night the priest himself saw in a dream those idols, which were worshipped by the pagans, smashed by the divine Godhead and strewn on the ground, after being reduced to dust. … The people ran to the priest's cell, and an entire crowd of the pagans kneeled down before him, and by crying and weeping, all of them implored the mercy of the Lord, and promised the priest that they needed the Martyr as their patron, and that they would completely convert to God after abandoning their idols, if the hail stopped. … the pagans, after being baptised in the name of the trinity, destroyed the statues, which they worshipped, and threw them into the lake near the village and the river. Since then in that place both the Catholic faith and the virtue of the Martyr were proclaimed even more.[34]

Both cases show that not only was it necessary for saints to compete with idols, but that the public adoration of saints eventually supplanted the multitude of pagan demi-gods. The next step was to start venerating an image of these saints. At first these were painted – several are mentioned from Late Antiquity on – but the oldest preserved statue dates only from the last quarter of the ninth century, namely the statue of the Ste Foy at Conques. For the image, whether painted or sculpted, to be seen as effective, the faithful clung to the idea of animation. In fact, Bernhard of Angers records that petitioners could tell by the miraculous expression on the face of the statue of St Gerald (on the altar in Aurillac), whether their requests had been denied or accepted.[35] The contrast between the static and brilliant, gilded head of Ste Foy (which began life as the portrait of a late antique emperor) and her mesmerising gaze could only further engender this impression. For enamel orbs with dark inserts seem to endow this mask with sight, a technique that had been standard practice in classical sculpture and occasionally, albeit rarely, in medieval statues like the golden Madonna of Essen or the (destroyed) Crucifix of Benna, at Mayence. Since saints were regarded as human beings that had already achieved eternal life, but whose *numina* still haunted the mortal remains preserved below altars, or in reliquaries, it was a short step to believing that the windows of their souls, their eyes, could be so brilliant. It is in this way that, in the popular imagination, Christian automata met head on the challenge from pagan idols inhabited by nociferous demons.

'Conversion' of a heathen site

Two seventh-century sources record the destruction not just of idols, but of whole ensembles of them, as well as the 'conversion' of entire sacred sites previously frequented by pagans. I have already mentioned Gregory the Great's decree that pagan temples in Gaul and England, or other pagan sites, be converted to Christian use, and Jonas of Susa reports in his *Vita Columbani* (*c.* AD 642), that Saint Columban erected his monastery at Annegray (Haute-Saône), where:

there was a great and thick concentration of images of stone, that filled the woods, and in the old times the pagans honoured them with wretched worship and impious rituals, and dedicated their execrable ceremonies to them; only wild animals and beasts, a multitude of bears, buffaloes and wolves lived in those places.[36]

The site was negative in just about every conceivable way: it was populated not only by a plethora of idols – that were venerated by the pagans, and no doubt possessed by demons – but also by wild animals of all types and sizes. These

wild creatures as well as the power of demons animating cult-images were able to endanger the moral and physical health of Christians. The enchanted images possessed invisible powers to implant devilish desires in pure hearts, to hurt and to seduce upright souls to commit idolatry. Conversely, Christian images were only a medium to communicate with Christ or the Saints. The saint's divine power had celestial origins and his or her image itself should never be the immediate subject of adoration in the West. Thus the account of a past action of a saint in former times destroying false images and converting the site to a Christian sacred place forms the *sine qua non* to introduce Christian imagery (for example an image depicting this particular saint) and its ritual use at the very same place, formerly ruled by enchanted, devilish images. In short, we appreciate the saint's power to convert this hell-hole into a pleasant place of prayer by the scale of the challenge he confronted. While Jonas of Susa only says that the idols were made of stone, the early seventh-century hagiographer Warnahar describes a second destroyed ensemble in more detail. In the *Acta Tergeminorum* he writes that an image of Nemesis and the idols of 12 further temples were destroyed in Langres:

> The twin saints … ordered their servants to destroy the statue of Nemesis and to completely eliminate the twelve temples, which had been built on their estate, and then to scatter the statues of the idols far and wide after smashing them to bits; the servants fulfilled all that had been ordered by their masters.[37]

This sort of orgy of idol destruction will remain a frequent *topos* until the eleventh century.[38] Finally, we should note that Wettino's scenario introduces yet another topos – namely that of buildings being turned to Christian worship. The colonization of pagan sanctuaries is recorded in multiple sources: in the life of Vigor of Bayeux, the saint is explicitly ceded such a site by King Childebert I, where he builds a church after first eradicating a large, stone, female idol (*effigies lapidea in specie mulieris*).[39] The same story is repeated in the early seventh century *Fundatio monasterii Blandiniensis* and *Vita Bavonis*, both of which mention an ancient sanctuary of Mercury located on a mountain near Gent, whose idol Saint Amandes had to first destroy before founding a church dedicated to Saint Peter.[40]

Idolatry depicted: the negated image venerated by the pagans

Although depictions of figures sacrificing to or venerating idols decorated the walls of late antique sanctuaries, tombs and religious objects, they are thereafter quite rare in western art until the Carolingian period.[41]

The distant (to Christian eyes) relationship between pagan adorer and cherished idol is the subject of the illumination to Psalm 37:1 (Figure 4.1) in

the Stuttgart Psalter.[42] This illumination of the phrase 'noli aemulari in malignantibus' (Fret not thyself because of evildoers) resumes the tradition of Tertullian by considering idolatry the chief sin of human beings.[43] To the left is the half-figure of a nude deity set on a low column above some stairs and pedestals. The sanctuary is vaulted by an arch on two columns, and a shield lies on the floor next to the steps like a military trophy. Two brownish, winged demons bracket the idol and two kneeling pagans venerate the deity and offer sacrifice. Another man is shown heading for King David, on the right margin, and with his veiled hand he approaches the king in a gesture of devotion. Most revealing of all is what is not represented, God Himself, venting all his wrath on the false idol. The Christian respect for the second commandment is made obvious by the exclusion of even the customary divine hand, pointing down from heaven. By contrast the idol's nudity summons up antique statuary, and the absurdity of its posturing gestures conflict with the forthright gesture of David. Whereas previously the idol on a column has simply set the scene, now it had lost its passivity and begun to participate fully in the creation of meaning.

The consequences of God's wrath, however, are illustrated aniconically, in the shape of the reddish rays issuing from a sun-like disk at the upper right margin (Figure 4.2).[44] The image depicts Psalm 78:58: 'For they provoked him to anger with their high places, and moved him to jealousy with their graven images.' On the left a man with a censer climbs a ladder up to two idols, one on a column and the other on a pedestal. A winged demon appears below the left idol and in front of its pedestal. This left idol represents a naked Hercules with a club and next to him stands a veiled female figure who is either a goddess or a temple servant. Four men prostrate in prayer face an empty hill on the right margin.[45] The Stuttgart Psalter's division of the scene between the new chosen people, the Christians who follow the righteous path, and the unbelievers erring on the wrong path is a pictorial elaboration beyond the strict letter of the actual text.

A still more dramatic illustration of the contrast between Christians and Jews is found in the same manuscript's illumination to Psalm 106:38: 'And shed innocent blood, even the blood of their sons and of their daughters, whom they sacrificed unto the idols of Canaan: and the land was polluted with blood' (Figure 4.3).[46] Here two idols atop columns, probably Astarte and Moloch, regard the sacrifice of a girl and a boy while two winged demons carry crowns up to them. The accusation of human sacrifice was a continuous current in the Jewish-Christian controversies from the earliest times, but the underlying message in this scene is somewhat broader: the Lord's sacrifice of his own son, Jesus Christ, has made obsolete the senseless sacrifice of living children to inane idols.

A fourth example in the same manuscript presents the pair of idols to bear

out a different point, encapsulated in the words of Psalm 135:18: 'They that make them are like unto them: so is every one that trusteth in them.'[47] The prophet's words mean that humans are made in God's likeness, and the scene implicitly criticizes the psychological gulf between pagans and their exalted gods instead of the preferable Christian community in the Spirit. It follows that the semi-nude idols are surrounded by all the empty apparatus of worship – baldachin, twin hills and so on – but otherwise nothing in their visible appearance legitimizes their veneration.[48]

Finally, and quite rarely, the manufacture of an idol, in this case the golden calf, is actually shown in the illumination to Psalm 106:19: 'They made [a calf] in Horeb, and worshipped the cast image'[49] (Figure 4.4). The metal is shown being mined from the earth and then beaten on an anvil. This detail appears immediately below the breaking of the mosaic stone tablets with the Ten Commandments, the clear inference being that the idol's manufacture breaks the Law.

Idols as spectators on the margins

Although written sources are rife with destructions of idols, images of this blight cannot be found in western medieval art earlier than the eleventh century.[50] On the other hand, intact and naked idols frequently figure as mute and marginal spectators from the ninth century onwards in Carolingian art, especially in Psalters and Bibles but also in illuminated manuscripts of writings by Prudentius.[51]

It is hardly surprising that the Carolingians should illustrate Prudentius, for idolatry and its attributes play a decisive role in the formation of Christian virtue in his *Psychomachia*, precisely because they are the antithesis of collective Christian values.[52] St Paul had first introduced idolatry into the canon of vices and in the hands of Tertullian, Prudentius and others helped define the new Christendom, again because it stood in diametrical opposition to the blind faith in an invisible God that was the foundation of the new religion.

The long neglected illuminations to the *Psychomachia* merit inspection for the visibility of their reception of ancient Roman values, and their subsequent transformation in Christian art, in particular representations of the clash between Faith and Idolatry.[53] This clash is the first of seven between the vices and the virtues that will culminate in the coronation of martyrs by Faith and the construction of the Temple of Wisdom by victorious virtues.

The personifications of Faith and 'Worship-of-the-old-gods' (*Cultura veterum deorum*) fight the first duel. The pictorial mode follows the text closely. For example *Cultura*'s shoulders are naked and exposed (*nuda*

umeros), her hair untidy (*intonsa comas*) and her arms raised (*exerta lacertos*). The internal effects of the attack are described even more fully in the text, though they are only discretely expressed by the facial expressions in the illumination. Thus, Faith shows mild consternation while 'Worship-of-the-old-gods' exudes aggression. Although the poem is silent about the appearance of Faith's adversary, mentioning only the body parts struck in the fight, the illumination conveys the struggle with drama: an upright, defensive Faith staves off the assault of 'Worship-of-the-old-gods' (or 'Idolatry' as she will come to be called in the later manuscripts), whose entire body swerves into her first attack, axe brandished overhead and dishevelled hair streaming. The text itself gives no scenery – the entire poem exists in a sort of aspatial timelessness, which underpins its allegorical nature – but the illuminator of the Bern manuscript supplies the props of altar, idol and bull.

In the illumination of the next scene (Figure 4.5), the stance and heavy forms of the nude idol recall late antique boxers, and the representation of the idol is not at all a specific statue type of a god. In earlier representations, like the late antique Vatican Vergil, the cult-image would have been glimpsed through the columns of the temple Pronaos but in the new pictorial rhetoric of the ninth century, idolatry is reduced to its basic ingredients: a column and a statue.[54] But these statues are not simply silent witnesses, aloof from terrestrial events (like gods), but rather the earthbound messengers of former times, when idols on columns were animated by the potential evils of man's idolatry, not by any terrestrial powers of their own.

Intact idols regarding Christian martyrdoms and saints fragmented of former deities

The contrast between the unscathed idol, untouched by the cruelties perpetrated at his feet, and the suffering of crushed Idolatry points again to the inanity of the effigy. This second illumination (Figure 4.5) depicts Prudentius' verses 30–35.[55] Faith triumphs over 'Worship-of-the-old-gods'. 'She smites her foe's head down' (*illa hostile caput phalerataque tempora vittis labefactat*), 'lays in the dust that mouth that was sated with the blood of beasts' (*et ora cruore de pecudum satiata solo adplicat*), 'and tramples the eyes under foot' (*et pede calcat*), 'squeezing them out in death' (*elisos in morte oculos*).

In sharp focus, we now watch Faith blinding her enemy with well-aimed blows. The dying vice spreads her hands and her body is convulsed by her death throes, finally succumbing to the strokes from the powerful limbs of victorious virtue. A young bull is also visible behind the altar, the sacrificial food of the beast-eating vice.[56]

While 'Worship-of-the-old-gods' is annihilated, her attribute, the idol itself, remains intact on its perch. He therefore epitomizes pagan folly through his impotent irrelevance to the actual struggle. The point is driven home by a miniature in the same manuscript, though this time illustrating Prudentius' *Peristephanon*, where an idol on a column reappears though it is not mentioned in the text nor required for the event represented.[57] We begin to understand that this idol, in fact, serves both as a mnemonic to the past phenomenon of Christian persecution and to underscore the blindness of the educated students, who torture their former teacher with their styluses.[58] In our manuscript Idolatry lies crushed and broken, because she alludes to the real smashing of idols. However, from the eleventh century onwards, when an actual destruction of an idol is depicted, the fragmentation of the cult-image into body fragments begins to occupy the foreground (as in Gregory the Great's Vatican *vita* of Saint Benedict). After this time, the pattern of a destroyed idol, smashed into useless fragments by the powers of the saint, replaces the inactive but intact idol present in earlier depictions. This depiction recalls the former times of missionary activities and real destructions of idols. In later images, we see a parallel drawn between a saint's destruction of an idol, and his own destruction in his martyrdom, for example in the fresco cycle of Sant'Urbano alla Caffarella, painted during the pontificate of Urban II (AD 1088–99).[59]

These kinds of analogies in narrative scenes refer to the enduring vividness of pagan elements in Christian culture, particularly present in the cult of saints and the veneration of their relics, their fragmented remains. The powerless and dead fragment of a former idol represents the counterpoint to Christian relics: the useless relic of vain and graven stone must give way for the reliquary instilled with true power from above. The same has to be considered in the role of the 'new' locally rooted saints as opposed to the 'ancient' gods, still venerated by pagans. The reliquary's complex relationship between image and relic has been a topic of several studies, but in looking at contemporary discourse on these issues, the full complexity of a reliquary's importance comes to light. The fragmented sacred remains needed to be incorporated into artful reliquaries whose figurative and imaginary form alluded to their former as well as their present – invisible – appearance. These two forms of representation, one might say a twofold mimesis, form a pivotal element of Christian image culture.

First, as we have seen, the depiction and description of an idol has been used since the Carolingian period as an iconic formula for paganism and false image-worship. Furthermore, the 'iconic' appearance of idols in narrative contexts in depicted scenes as well as written accounts underlines the reception of the other past by rejecting and negating formerly venerated images. The naked, mute, deaf and 'untouched' male idol on top of a column

turns into the sign of idolatry. Second, the newly venerated and installed local saints with their relics, statues and the written accounts of their miracles replace the pagan gods. This acculturation of pagan culture negates images only at a first view. In fact, by negating the pagan image culture Christians conserved formerly pagan customs and adapted them according to their needs. Christian statuary could only emerge after most important Gaulish or Roman statues were bashed to pieces and their temple sites converted. The reuse of pagan imagery – mantled and incorporated in Christian imagery – is based on the rejection of the other, pagan traditions. The most obvious example for this practice is the statue of the Christian female martyr Ste Foy at Conques which incorporates a late antique golden head from a male emperor. The apparently paradoxical rebirth of life-size statues in the context of the negation of images venerated by former pagan culture seems peculiar only at first sight. As we have seen, the new use of monumental sculpture in western Christianity by the end of the ninth century is the fruit of the reconsiderations of western roots reaching back to the imagery of Late Antiquity and the extensive debates on idolatry. What has always been neglected in this context, probably because it seems to teeter on paradox, is the impact that pagan culture made on this supposedly exclusive, Christian phenomenon. Thus, hitherto the survival of antique statues of emperors and gods, especially Gaulish mother-earth types, has almost completely escaped detection as possible precedents.[60] Nonetheless, to gauge their possible influence on the reinvention of monumental Christian sculpture in the ninth century one must first ascertain that pagan cults, and hence statue veneration, remained active in Gaul at least until the seventh century. Second, it has to be determined that their memory lingered in the Christian consciousness until the ninth century once paganism had actually become extinct. Most importantly, we must realize that we can best understand what a cult image represented to Christians by understanding what it was not, and what it must strenuously avoid becoming: an idol. In fact, the reasons given by western sources for the destruction of idols provide an astonishingly broad range of insights in the acculturation of the religious past during the period normally dubbed 'the crisis of the image'.

Notes

1 This article was written in Rome with the support of a grant from the Gerda-Henkel Foundation. I would like to thank Anne McClanan and Jeffrey Johnson for offering me the opportunity to present this material, which is drawn from my doctoral thesis, 'The Statue of Sainte Foy in Conques and the Revival of Monumental Sculpture in Christian Art'. A special thanks for his constant, ever inspiring and constructive criticism goes to Gerhard Wolf. Furthermore, I am grateful to Fabio P. Barry, Caroline J. Goodson, Robert Coates-Stephens, Tobias Kämpf and Tina Sessa for reading and commenting on the paper, as well as to Marco Conti for translating the Latin passages.
2 Among the vast literature disputing exactly what the second commandment does or does not

prescribe and its impact on the artistic production I refer to the more recent studies of Gutmann (1989), Julius (2000), Kühnel (2001), and Keel (2002). For the western perspective the work of Reinhard Hoeps (1999) is extremely original and fruitful.

3 The oldest surviving medieval Christian statue of Ste Foy de Conques is conventionally dated to the late ninth century. Within a century there was a widespread revival of Christian statuary, much of it either Marian statues or busts of saints. In addition, numerous larger than life crucifixes (of the Cologne Gero-cross type) were produced in Germany and northern Italy around the year 1000. Scholars are baffled by the approximately four hundred year interval between explicitly Christian, late antique statues and the sudden reappearance of the Christian cult statue in the shape of Ste Foy. There are very few examples of older preserved statues, for example Steinbach, Cividale or Müstair. Their dating oscillates between the fifth and the sixteenth centuries. See Beutler (1964) and (1982) and Wirth (1995).

4 Almost every explanation has hinged on the relationship of sculpture to the cult of relics. The most popular argument remains that articulated in 1952 by Harald Keller. Keller claimed that because sculpture contravened the Mosaic prohibition against graven images, it could only have been reintroduced in its capacity as a reliquary. That is, the statue reintegrated the often fragmented saints into whole and wholesome images suitable for veneration. Attractive as this 'king's two bodies' explanation seemed, Ilene H. Forsyth drew attention to the fact that very few of the Madonnas actually contained relics. A summary and a bibliography of the relevant contributions to this controversy can be found in Beer (2002), p. 129. The most influential studies are Keller (1952); Haering Forsyth (1972), pp. 121 f.; Belting (1990), pp. 331–47; further elaborated by Fehrenbach (1996), p. 57.

5 For further discussion on the *Libri Carolini*, see *Opus Caroli Regis Contra Synodum (Libri Carolini)* (1998), ed. by Ann Freeman in collaboration with Paul Meyvaert; Freeman (1957, 1965, 1971 and 1985); and Kessler (1993).

6 'An image can exercise no mystic function. Contrary to the western stand, that its value is not due to the virtue of the saint it depicts' *(Opus Caroli Regis (Libri Carolini)* I, 17, in the following cited as OCR no sanctity resides in the common clay, wax, or wood out of which an image is made (OCR I 2). As Freeman elaborates further the implication in the remarks on images in the OCR is that the 'value of an image is determined by the success of the artist in fulfilling his intention, and by the adaptability and intrinsic worth of the materials he has used. ... It is commonly assumed, he [Theodulf] says, that a beautiful woman with an infant in her arms represents Virgin and Child, but how is even an artist to be sure that the two were not originally intended as Venus and Aeneas?' (OCR IV 21). As he remarks [in the following Latin quotation of OCR IV 16] 'it is quite possible for figures of the Virgin and of Venus to be identical in everything but their inscriptions, and if these are lacking, or if the images have been pulled down from their proper places and allowed to remain in a fallen state, how is anyone to determine which one should be set up again and venerated as the Mother of God?' *(Offerentur cuilibet eorum, qui imagines adorant, verbi gratia duarum feminarum pulcrarum imagines superscriptione carentes, quas ille parvipendens abicit, abiectasque quolibet in loco iacere permittit. Dicit illi quis: 'Una illarum sanctae Mariae imago est, abici non debet; altera Veneris, quae omnino abicienda est', vertit se ad pictorem quaerens ab eo, quia in omnibus simillimae sunt, quae illarum sanctae Mariae imago sit vel quae Veneris? Ille huic dat superscriptionem sanctae Mariae, illi vero superscriptionem Veneris: ista, quia superscriptionem Dei genitricis habet, erigitur, honoratur, osculatur; illa, quia inscriptionem Veneris, Aeneae cuiusdam profugi genetricis, habet, deicitur, exprobratur, exsecratur. Pari utraeque sunt figura, paribus coloribus, paribusque factae materiis, superscriptione tantum distant).* Quoted after *Opus Caroli Regis Contra Synodum* (1998), p. 528, l. 41–p. 529, l. 8. Translation taken from Freeman (1957), p. 697.

7 This thesis is further elaborated in my dissertation 'Idolatry, image culture and gift exchange regarding the statue of the Ste Foy of Conques: Reflections upon the genealogy of sculpture'. The reactions and interactions of Byzantine and western theologians and their influence on the development in western positions towards image veneration will be studied in further detail by an analysis of the so-called acts of the councils of Frankfurt 784 and Paris 825.

8 S. Acta Conc. Nic. II, Act. 6 (Mansi 13, 262 E–263 C), cf. Feld (1990), p. 18.

9 See the legitimation by Jerome in his letter to Riparius of 404 in which he rejects the respective reprovals of Vigilantius. Jerome (1996) *Epistulae I-LXX*, ed. Isidor Hilberg, 2nd edn, Vienna: *Corpus Scriptorum ecclesiasticorum latinorum (CSEL)* **54**, Epistula nr. 109.

10 See Geary (1978) and Angenendt (1994), p. 154: 'Die in der Forschung allgemein vorfindliche Auffassung, die Gebeinteilung sei eigentlich von Anfang an üblich gewesen, muß revidiert werden; ja, bis ins 10. Jahrhundert dürften Teilungen sogar als frevelhaft gegolten haben und darum nur ausnahmsweise vorgekommen sein.'

11 'Sanctorum martyrum corpora, quem Romani igne cremaverunt vel ferro truncaverunt vel besteis lacerando proiecerunt, Franci super eos aurum et lapides preciosos ornaverunt.' (The bodies of saints and martyrs, which were burnt, cut into pieces or thrown in front of wild animals to be gorged, were adorned by the Franks with gold and precious stones'). Quoted after *Opus Caroli Regis Contra Synodum* (1998), p. 2.

12 See Freeman (1998), introduction to *Opus Caroli Regis*, p. 25 and p. 118, l. 24 ff. (*OCR* I, 2), p. 119, l. 1–9 (*OCR* I, 2), p. 179, l. 9–21 (*OCR* I, 16) and p. 185, l. 14 ff. (*OCR* I, 17). For the protest of the *Libri Carolini* against the Greek attempts to equalize images with real holy things, see Chazelle (1986), pp. 165 f.

13 Criticism against the common misuse of Gregory the Great's comments on the use of Christian imagery is articulated by Chazelle (1990).

14 'There might well have been ... two systems as both alive and interacting to a much later point in time than anyone would have said until recently' MacMullen (1997), p. 2. See also Poly (1980), particularly pp. 429–81; Dierkens (1984); Hillgarth (1986); Fletcher (1997); van Oort und Wyrwa (1998); Lauranson-Rosaz (1987); and Yitzhak (2002).

15 Unfortunately, there are hardly any recent critical editions of most of the sources cited here. Even dates cannot always be given with reliable arguments. If no recent edition is available, unless otherwise specified, all citations are from Migne, *Patrologia Latina* (*PL*), *Monumenta Germaniae* (*MGH*) or the *Acta Sanctorum* (*AS*).

16 Gregory of Tours, *De gloria confessorum*, c. 76; for an English translation, see Gregory of Tours (1988), *Glory of the Confessors*, trans. Raymond Van Dam, Liverpool. The name Berecynthia is derived from the particular deity venerated by the Phrygian tribe of the Berekynther.

17 Hani's study also provides a depiction of a statuette of a Gaulish mother-goddess that is preserved in the museum of Prunay-le-Gillon. Hani (1995), fig. VI. It is important to note in this context that several cult statues, most notably that which Augustus installed on the Palatine, had heads of black stone.

18 Gregory the Great, *Regestum*, *MGH Scriptores* XI, pp. 37 and 56. My thanks to Robert Coates-Stephens for bringing this source to my attention.

19 *Vitae patrum* 6, 2: *MGH Scriptores rerum Merovingicarum* 1, 681: 'Erat autem ibi fanum quoddam diversis ornamentis refertum, in quo barbaries proxima libamina exhibens usque ad vomitum cibu et potu replebatur; ibique et simulacra ut deum adorans, membra secundum quod unumque dolor attigisset, sculpebat in ligno. Quod ubi sanctus Gallus audivit, statim illuc cum uno tantum clerico properat, accensoque igne, cum nullus ex stultis paganis adesset, ad fanum adplicat ac succendit' (There was a sanctuary full of different ornaments, in which the barbarians living nearby performed their libations and so crammed themselves with food and drink that they vomited; there they also carved from wood statues, which they worshipped like god, and members of the body, according to the pain, by which each member was affected. When saint Gallus heard this, he immediately went there with one cleric, and after lighting a fire, since none of those foolish pagans was present, he set fire to the sanctuary and burned it). Concile of Auxerre, cap. 3: 'Non licet ... sculptilia aut pedem aut hominem ligneo fieri'. (It is forbidden ... to carve sculptures from wood, and either a foot or a man). The same prohibition was spoken by Pirmin in Scarapsus c. 22: 'Membra ex ligno facta in trivios et arboribus vel alio nolite facire neque mittere, quia nulla sanitate vobis possunt praestare' (Do not make or place members of wood in public roads, on trees or other places, because they cannot give you any healing).

20 *Liber Pontificalis* 53, cap. 5, ed. L. Duchesne (1886), vol. 1, p. 261, l. 8–9. Interestingly, in the *Liber Pontificalis* the same pattern repeats itself during the pontificates of Hilarius, Gelasius and Hormisdas – but in those cases, statues are not mentioned.

21 So assume Bredekamp (1975), p. 94 and Angenendt (1999).

22 For example, at the seventh-century Council of Clichy the local priest's obligation is articulated as: 'Et quando Deo iubente fides catholica iam ubique in Gallis perseuerat, si qui tamen bonosiaci aut occulte heretici esse suspicantur, a pastoribus ecclesiae sollicite requirantur et ... ad fidem catholicam Domino presule reuocentur' (And since, according to God's command, the Catholic faith is well established in Gaul, if some people are suspected to be followers of Bonosus or to be heretics in disguise, they must be eagerly summoned by the pastors of the church and ... must be led back to Catholic faith with the intercession of God). Can. 5: *Sources chrétiennes* 354, p. 352, quoted after Godding (2001), p. 413 and *Liber Miraculorum Sancte Fidis*, I.13, ed. Luca Robertini (1994), pp. 112 f. For the lively history of the classical tradition (*Fort-* or *Nachleben*) in the Auvergne in a broader context, see the groundbreaking study of Lauranson-Rosaz (1987). In particular, for developments at the time around the millenium, see Barthélmy (1999).

23 Hrabanus Maurus (*c.*842/847) 'De diis gentium: "Idolatria idolorum servitus sive cultura interpretatur. Nam latreia graece, latine servitus dicitur, quae, quantum ad veram religionem attinet, non nisi uni et soli Deo debetur. Hanc sicut impia superbia sive hominum sive daemonum sibi exhiberi vel iubet vel cupit; ita pia humilitas vel hominum vel angelorum sanctorum sibi oblatam recusat, et cui debetur ostendit. Idolum autem est simulacrum, quod humana effigie factum et consecratum est, juxta vocabuli interpretationem."' An illuminated manuscript of this text dating shortly after 1022 but copying a Carolingian precedessor in Fulda and its numerous depictions of the pagan gods is discussed by Himmelmann (1986), p. 5.

24 For example, Salomon venerating the idols of his wives; for the Jewish development, see Halbertal and Margalit (1992).

25 Fourth book against the Donatists, Optatus (1997).

26 'Sed ducantur ad templum Martis iterum: et sacrificent. Quod si noluerint supplicare et sacrificare in eodem loco capite truncentur. Educti igitur foras muros portae apiae coepit beatus Xistus dicere: *ecce idola vana muta surda et lapidea*: quibus miseri inclinantur: ut perdant vitam aeternam: Et dixit ad templum Martis: Destruet te Christus filius dei vivi: et cum hoc dixisset beatus Xistus: Responderunt omnes christiani: amen. Et subito cecidit aliqua pars templi: et comminuta est.' Vita Sixtus II.: Passio sanctorum Xisti Episcopi felicissimi et agapiti martyrum II, p. 650, l. 52; my emphasis; for the history of the *vita* and the *passio* of San Sisto, see Amore (1975), pp. 140–42.

27 Just to give two examples of further saints' lives describing the destruction of the same image of Mars in this temple: in the collection of Mombritius the '*Passio Sancti Stephani Papae*', vol. II, p. 496, l. 33/49 or the '*Passio sancti Cornelii Papae*', vol. I. p. 373, l. 45. For the textual and archaeological evidence for the Temple of Mars on the Via Appia, see Valentini and Zucchetti (1940), p. 91, n. 2.

28 For a recent edition of this text and French translation, see Goullet and Iogna-Prat (1996). For the interpretation of the source, see Haering Forsyth (1972); Schmitt (1987), pp. 284–5; and Remensnyder (1990), pp. 362–3. This miracle is reported for the creation of the statue of the Madonna of Clermont-Ferrand. See also the bees clotting upon the statues of Antoninus the Pious in Etruria as recorded in the *Historia augusta. Scriptores Historiae Augustae* (1921).

29 Sulpitius Severus, Vita Martini, c.12: 'Nam fere quingentorum passuum intervallum erat, ut difficile fuerit dinoscere, quid videret. Tamen, quia rusticam manum cerneret et agente vento lintea corpori superiecta volitarent, profanos sacrificiorum ritus agi credidit, quia esset haec Gallorum rusticis consuetudo, simulacra daemonum candido tecta velamine misera per agros suos circumferre dementia. Levato ergo in adversos signo crucis imperat turbae non moveri loco onusque deponere. Hic vero mirum in modum videres miseros primum velut saxa riguisse. Deinde, cum promovere se summo conamine niterentur, ultra accedere non valentes ridiculam in vertiginem rotabantur, donec victi corporis onus ponunt. Attoniti et semet invicem aspicientes, quidnam sibi accidisset, taciti cogitabant. Sed cum beatus vir conperisset exequiarum esse illam frequentiam, non sacrorum, elevata rursum manu dat eis abeundi et tollendi corporis potestatem. Ita eos et, cum voluit, stare conpulit et, cum libuit, abire permisit.' (For there was a distance of nearly half a mile between him and the crowd, so that it was difficult to discover what the spectacle he beheld really was. Nevertheless, because he saw it was a rustic gathering, and when the linen clothes spread over the body were blown about by the action of the wind, he believed that some profane rites of sacrifice were being performed. This thought occurred to him, because it was the custom of the Gallic rustics in their wretched folly to carry about through the fields the images of demons veiled with a white covering. Lifting up, therefore, the sign of the cross opposite to them, he commanded the crowd not to move from the place in which they were, and to set down the burden. Upon this, the miserable creatures might have been seen at first to become stiff like rocks. Next, as they endeavored, with every possible effort, to move forward, but were not able to take a step farther, they began to whirl themselves about in the most ridiculous fashion, until, not able any longer to sustain the weight, they set down the dead body. Thunderstruck, and gazing in bewilderment at each other as not knowing what had happened to them, they remained sunk in silent thought. But when the saintly man discovered that they were simply a band of peasants celebrating funeral rites, and not sacrifices to the gods, again raising his hand, he gave them the power of going away, and of lifting up the body. Thus he both compelled them to stand when he pleased, and permitted them to depart when he thought good). For the Latin text, see Berschin (1986), p. 203; English translation taken from Sulpitius Severus (1894).

30 'His ita gestis petiit beatissimus Zeno, ut ei licentia tribueretur, omnia idola destruendi, et basilicas in Christi nomine fabricandi', *Vita Zenonis*, AS April t. 2, 1675, p. 70–71, eighth century.

31 Gregory of Tours, *Historia Francorum* 8.15: 'Repperi tamen hic Dianae simulacrum, quod populus hic incredulus quasi deum adorabat. Columnam etiam statui, in qua cum grandi cruciatu sine ullo pedum perstabam tegmine. Itaque cum hiemis tempus solite advenisset, ita rigore glaciali urebar, ut ungues pedum meorum saepius vis rigoris excuteret et in barbis meis aqua gelu conexa candelarum more dependeret. ... Sed cum nos sollicite interrogaremus, quis ei cybus aut potus esset, vel qualiter simulacra montis illius subvertisset, ait: Potus cibusque meus erat parumper panis et oleris ac modicum aquae. Verum ubi ad me multitudo vicinarum villarum confluere coepit, praedicabam iugiter, nihil esse Dianam, nihil simulacra nihilque quae eis videbatur exercere cultura; indigna etiam esse ipsa, quae inter pocula luxuriasque profluas cantica proferebant: sed potius Deo omnipotenti, qui caelum fecit ac terram, dignum sit sacrificium laudis inpendere. Orabam etiam saepius, ut simulacrum Dominus dirutum dignaretur populum ab hoc errore discutere. Flexit Domini misericordia mentem rusticam, ut inclinaret aurem suam in verba oris mei, ut scilicet, relictis idolis, Dominum sequeretur. Tunc convocatis quibusdam ex eis, simulacrum hoc immensum, quod elidere propria virtute non poteram, cum eorum adiutorio possim eruere: iam enim reliqua sigillorum quae faciliora fuerant, ipse confringeram. Convenientibus autem multis ad hanc Dianae statuam, missis funibus trahere coeperunt; sed nihil labor eorum proficere poterat. Tunc ego ad basilicam propero, prostratusque solo, divinam misericordiam cum lacrimis flagitabam, ut quia id humana industria evertere non valebat, virtus illud divina destrueret. Egressusque post orationem, ad operarius veni, adprehensumque funem, ut primo ictu trahere

coepimus, protenus simulacrum ruit in terra, confractumque cum malleis ferreis in pulverem redegi.' Latin text taken from the edition by Oldoni (1981), vol. 2, pp. 266–8. See Bredekamp (1975), p. 95, as well as footnote 305; Young (1975), p. 44; Greenhalgh (1989), p. 207.

32 'Destruet te Christus filius dei vivi.' Vita Sixti II, Passio sanctorum Xisti Episcopi felicissimi et agapiti martyrum II, p. 650, l. 52

33 See the evidence for Jupiter columns presented in Schultze (1887) and Waas (1939).

34 Gregory of Tours, Liber miraculorum cap. 6: 'Ipse quoque sacerdos sequenti nocte videt per somnium simulacra illa quae a gentilibus colebantur numine divino comminui, atque in pulverem redacta solo prosterni.Concurrit vulgus ad cellulam, prosternitur eorum sacerdote omnis caterva gentilium, et mixto cum lacrymis ululatu, cuncti Domini misericordiam deprecantur, pollicenturque sacerdoti, si grando recederet, et Martyrem patronum expeterent, et ad Deum ejus relictis simulacrorum cultibus integro de corde transirent. … gentiles in Trinitatis nomine baptizati, statuas quas coluerant confringentes, in lacum vico amnique proximum projecerunt. Ab eo enim tempore in loco illo et fides catholica, et Martyris virtus est amplius declarata.' See Knoegel-Anrich (1992), p. 60. In chapter five of the same source, Gregory mentions two further idols, statues of Mars and Mercury located in a large sanctuary close to Brioude: 'ubi in colomnam altissimam simulacrum Martis Mercuriique colebatur' (where on a very high column Mars and Mercury were venerated). The same ensemble of Mars and Mercury on a very high column appears verbatim in Knoegel-Anrich (1992), no. 253.

35 Liber Miraculorum Sancte Fidis (1994), I.13, pp. 112 f.

36 Krusch, MGH SS Rer Mer. IV, 76, Vita Columbani I., c. 10: 'Ibi imaginum lapidarum densitas vicina saltus densabant, quas cultu miserabili ritoque profano vetusta paganorum tempora honorabant, quibusque execrabiles ceremonias litabant; solae ibi ferae ac bestiae, ursorum, bubalorum, luporum multitudo frequentabant.' See Knoegel-Anrich (1992), n. 35: A forest full of stone images next to Luxueil, no. 336.

37 Warnahar, PL 80, 191, Acta Tergeminorum c. 3, 11: 'Sancti vero gemini fratres … servis suis praeceperunt, ut simulacrum Nemesis confringerent et duodecim templa, quae in domo eorum erant constituta, funditus everterent, ipsas etiam idolorum statuas simul in confractionem redactas protinus dissiparent; feceruntque servi omnia quae fuerant a dominis imperata.' Nemesis is very rarely represented in early medieval art and literature. One of the very few monuments to depict her is a reused marble slab on the pulpit of Torcello. See Polacco (1976).

38 In the ecclesiastical story of Hamburg, there are the three images of the gods Wodan, Thor and Freier in the temple of Uppsala mentioned on the occasion of the missionary activitiy of Adam of Bremen, who describes them in the early eleventh century as having a large phallus and so on. Gesta pontificum Hammaburgensis ecclesiae, lib. IV, cap. 234, PL 146, col. 642–4. A couple of idols which this description might fit are preserved in the Museum of Schleswig in Schloß Gottorf, depicted in Lippold (1993), p. 313. In the eighth century, the vita of abbot Aridius (d. AD 591) reports the destruction of three idols close to the village of Moeno near Limoges. Vita of abbot Aridius, cap. 45. Wettino's Vita Galli (AD 816/824) recounts that, in Bregenz, saints Gallus and Columban overthrew, and then tossed into Lake Constance, a triplet of gilt-bronze gods (tres … imagines aereas et deauratas) and for good measure rededicated the shrine to Saint Aurelia. Wettino, Vita Bavonis, cap. 6: 'Tres ergo imagines aereas et deauratas superstitiosa gentilitas ibi [in Bregenz] colebat. … Nempe desiderio destruendi eorum superstitionem vir dei Columbanus iussit Gallum ad populum recitare. … [Gallus] sublatas imagines comminuit petris atque in profundum deiecit maris [Bodensee]. … Vir dei Columbanus aquam benedixit atque sanctificando loca contaminata ecclesiae sanctae Aureliae honorem pristinum restituit. [833/4]' (The superstitious pagans worshipped there three bronze, gold-plated idols … Therefore, the man of God Columbanus, wishing to destroy their superstition, ordered Gallus to make a speech before the people. … after removing the idols [Gallus] smashed them with stones and threw them into the deep of the sea. … The man of God Columbanus blessed the water, and by hallowing those polluted places, he restored honour to the church of Saint Aurelia). These tales make a representative selection, for we could add hundreds of other instances where the only detail that remains unclear is the exact number of effigies destroyed. We are told that they are plurima simulacra, multa sculptilia or idola (plenty of idols, many sculptures or false images), but no more. Vita Gaugerici episcopi Camaracensis (d. AD 623/626, written end of seventh century) lib. 3, c. 13, in Krusch, MGH SS Rer mer. III, 657. His vita reports of destroyed idols in Cambrai on the site of the church of St Medard. The vita of Hugberti episcopi Traiectensis (d. AD 727, written in the mid-eighth century), chapter three tells us of idols destroyed by burning in the Ardenna, in Brabant and close to Antwerp: 'idola plurima et sculptilia, quae colentes erant in Ardoinna, igne cremanda destruxit. … Ea vero similia in Texandria et in Bracbante plurima simulacra et multa sculptilia destruxit et sanctuaria per diversa loca in honore sanctorum martyrum proprio sudore construxit' (He destroyed a large number of idols and sculptures, which were worshipped in the Ardennes, and had to be burned with fire … He also destroyed a large number of similar statues and sculptures in Texandria and in Brabant, and with his sweat built sanctuaries in honour of the holy martyrs in different places).

39 Vita Vigoris Baiocensis (lived in the sixth century, his vita was written in the ninth or tenth century) cap. 8, AS Nov. I, p. 301.

40 See Knoegel-Anrich (1992), no. 472, early seventh century: 'contrivit ergo idolum, subvertit aram, succidit lucos atque ipsum locum dedicavit in honore principis apostolorum Petri, cui Blandinium [St.-Pierre-au-mont-Blandin] indidit vocabulum' (Therefore he smashed the idol, overturned the altar, cut down the woods that were holy [to the pagans], and dedicated that place in the honour of Peter, the prince of the apostles, and gave it the name of Blandinum). Cf. no. 508. See also Greenhalgh (1989), p. 205. In the later version of this story in the *Vita Bavonis*, written in the first half of the ninth century, the author talks of idols *'simulacra'* and *'idola'*. Ch. 4, ed. Krusch, *SS Rer Mer.* IV, 537: 'In eodem etiam castro [Gent] indiderat olim antiquitas simulacra nefanda et idola, quae pro deo illic a populo colebantur. Ibidem vero consistens praefatus dei pontifex [Amandus] pro nomine Christi omnia fana destruxit, idola contrivit et ad sanctam christianitatem omnes revocavit. Basilicam autem ibi in honore beati Petri apostoli fecit construi.' (In the same castle [Gent], the ancient inhabitants had once placed impious statues and idols, which were worshipped by the population instead of God. Since the pontifex of God mentioned before [Amandus] lived there, he destroyed all the sanctuaries in the name of Christ, smashed the idols and brought everybody back to the holy Christian faith. He also had a church built there in honour of the blessed Peter).

41 See, for example, the mid-third century fresco fragment of a worshipper of Hercules from the necropolis on the Via Laurentina, preserved in the magazin of the Museo Archeologico, Ostia Antica. Inv. nr. 155. See Tata (2000).

42 Württembergische Landesbibliothek Stuttgart, Stuttgarter Psalter, fol. 42v.

43 All English Bible quotations are taken from the King James Version; the numbers of the psalms follow the numeration of the Vulgata. Origines (*PG* 12, 1320 ff) had considered passage from Dt. 32, 31. See Eschweiler et al. (1968), p. 85. Cf. Tertulian Idol. 1,1 as well as Vulg. Sap. 13–15.

44 Württembergische Landesbibliothek, fol. 94r. The Latin text of the psalm is as follows: 'Et in ira concitaverunt eum in collibus suis et in sculptilibus suis ad aemulationem eum provocaverunt.'

45 Cf. Chludov, London and Barberini Psalters. In these psalters the idol is positioned on top of the hill. See Eschweiler et al. (1968), p. 114.

46 Fol. 122r, Latin text: 'Et effuderunt ... sanguinem filiorum suorum et filiarum suarum, quas sacrificaverunt sculptilibus Chanaan.'

47 Fol. 150v, Ps. 135: 18: 'Similes illis fiant qui faciunt ea et omnes qui confidunt in eis.'

48 The women with the burning lamp might be Selene or Artemis as goddess of the night; cf. the mosaic of the Diana-Nemesis in Parndorf (Burgenland) Kenner (1954), p. 334 and fig. 151. The right god lacks any attribute; he might be Zeus or a cosmical personification. The scene is also depicted in the psalters of London and Barberini, as well as in Ms. Vat. grec. 1927 in the Biblioteca Apostolica Vaticana.

49 Fol. 121r, Ps. 106: 19: 'Et fecerunt in Choreb et adoraverunt sculptile', cf. Ex 32. Below the calf on front of the altar it is written: 'Hic vitulus quem fecerunt Iudei ex auro puro et adoraverunt eum pro Deo.' Cf. the psalter illumination to the psalters of Chludov, Paris grec 20, London, Barberini, Bristol and Munich, Ms. slav. 4.

50 An early example is depicted in the manuscript of the *vita* of Saint Benedict in the Vatican Library (Ms. vat. lat. 1202) showing the destruction of an idol of Apollo or the eleventh or twelfth century fresco of St. Urban in the church of Sant'Urbano alla Caffarella in Rome. In antiquity there are examples showing the fall of the idol of Nebukadnezzar or the destruction of Dagon's idol by the Ark of the Covenant, for example in the frescoes of Dura Europos. The frescoes are the last known that depict authentically destroyed statues of Baal; see Himmelmann (1986), p. 5 The action itself is depicted on the drawing in the Roman catacomb of Via Latina; see Stewart (1999). In Byzantium the depiction of toppled idols appears earlier, for example in the Menologion of Basil I, Vat. gr. 1613, fol. 125, where St Cornelius topples an idol, or in the Roman drawing in the anonymous hypogeum of the Via Paisiello, Rome; fig. 8.2, in Stewart (1999).

51 The selection of manuscripts in this essay form only a small part of the material which will be the basis for a chapter of my forthcoming doctoral dissertation.

52 Prudentius composed the *Psychomachia* ('Struggle for Man's soul'), an epic poem about the virtues and vices between 405 and his death in 410. The quotations and translations are from Prudentius (1949).

53 The illuminated manuscripts of the *Psychomachia* of Prudentius have been studied thoroughly only by Woodruff in 1929 and Katzenellenbogen in 1933, after the corpus of Stettiner in 1895. Yet the *Psychomachia* is the first Christian epic poem and one of the most widely diffused texts of the Middle Ages: 16 illuminated manuscripts dating from the ninth to the thirteenth century alone are known. See Stettiner (1895 and 1915), Woodruff (1930) and Katzenellenbogen (1933).

54 Vatican Vergil, fol. 45v depicts the Temple of Apollo with his image and on fol. 33v Dido sacrificing, 4. lib. Aeneis, l. 56-64, depicition in Wright (1993), pp. 36 and 46. Another example may be found in the Utrecht Psalter, at the illumination to Psalm 78.

55 Bern manuscript of the *Psychomachia* on fol. 35r, Burgerbibliothek Bern, Cod. 264.

56 The ensemble of sacrificial altar and bull represents a continuous tradition from antiquity, as the example of the Vatican Vergil underscores. Or as in this image from the Carolingian era, Harley Psalter, ninth century, London, detail to Psalm 27, fol. 15r.

57 Bern manuscript, martyrdom of Cassian, fol. 61r; for depiction see Homburger (1962).
58 Hucbald, who died in 930, amplifies this aspect in an even more sophisticated scene in his later version of the saint's life, his *Passio S. Cassiani*, chapter 15: 'Ast alter … totius stilum viribus imprimens et per obliquum in dexteram partem raptim deorsum ducens tali cachinno reliquos in risum ciebat: "Abba ecce prima tui nominis primaque notarum sillaba! Sed quia non adeo tibi et nobis hoc nomen congruit, puncto huic sillabe superposito hoc ipsum, quod nobis fueras, Asper nota signabit."' See Berschin (1991), III.1, p. 364.
59 See Noreen (1998), p. 286, fig. 44 and p. 382, fig. 151.
60 An example of a statuette of a Gaulish mother-goddess, preserved in the museum of Prunay-le-Gillon, is depicted in Hani (1995), fig. VI. The only exceptions are the remarks on this influence by Haering Forsyth (1972), pp. 20–22.

References

Amore, Agostino (1975), *I Martiri di Roma*, Rome.

Angenendt, Arnold (1999), 'Die Christianisierung Nordwesteuropas', in Stiegemann, Christoph and Wernhoff, Matthias (eds), *799. Kunst und Kultur der Karolingerzeit. Karl der Große und Papst Leo III. in Paderborn*, vol. 2, Mainz: Zabern, pp. 420–33.

Angenendt, Arnold (1994), *Heilige und Reliquien. Die Geschichte ihres Kultes vom frühen Christentum bis zur Gegenwart*, Munich: Beck.

Barthélemy, Dominique (1999), *L'an mil et la paix de dieu. La France chrétienne et féodale 980–1060*, Paris.

Beer, Manuela (2002), 'Ottonische und frühsalische Monumentalskulptur', in Beuckers, Klaus G., Cramer, Johannes and Imhof, Michael (eds), *Die Ottonen. Kunst-Architektur-Geschichte*, Petersberg: Imhof, pp. 129–52.

Belting, Hans (1990), *Bild und Kult. Eine Geschichte des Bildes vor dem Zeitalter der Kunst*, Munich: Beck.

Berschin, Walter (1986), *Biographie und Epochenstil im lateinischen Mittelalter*, vol. 1: *Von der Passio Perpetuae zu den Dialogi Gregors des Großen*, Stuttgart: Hiersemann.

Berschin, Walter (1991), *Biographie und Epochenstil im lateinischen Mittelalter*, vol. III.1: *Karolingische Biographie 750–920 n.Chr.*, Stuttgart: Hiersemann.

Beutler, Christian (1964), *Bildwerke zwischen Antike und Mittelalter*, Düsseldorf: Schwann.

Beutler, Christian (1982), *Die Entstehung der nachantiken Statue und der europäische Indiviudalismus*, Munich: Prestel.

Bredekamp, Horst (1975), *Kunst als Medium sozialer Konflikte. Bilderkämpfe von der Spätantike bis zur Hussitenrevolution*, Frankfurt: Suhrkamp.

Chazelle, Celia M. (1986), 'Matter, spirit, and image in the Libri Carolini', *Recherches Augustiniennes* **21**, 163–84.

Chazelle, Celia M. (1990), 'Pictures, books, and the illiterate: Pope Gregory I's letters to Serenus of Marseilles', *Word & Image* **6**, 138–53.

Dierkens, Alain (1984), 'Superstitions, christianisme et paganisme à la fin de l'époque mérovingienne. A propos de l'Indiculus Superstitionum et pagniarum', in Hasquin, Hervé (ed.), *Magie, Sorcellerie, parapsychologie*, Brussels, pp. 9–26.

Eschweiler, Jakob, Fischer, Bonifatius, Frede, Hermann Josef and Mütherich, Florentine (1968), 'Der Inhalt der Bilder', in *Der Stuttgarter Bilderpsalter. Bibl. fol. 23 Württembergische Landesbibliothek Stuttgart*, vol. II: *Untersuchungen*, Stuttgart: Schreiber, pp. 55–150.

Fehrenbach, Frank (1996), *Die Goldene Madonna im Essener Münster. Der Körper der Königin*, Ostfildern: Tertium.

Feld, Otto (1990), *Der Ikonoklasmus des Westens*, Studies in the history of Christian thought 41, Leiden: Brill, pp. 14–20.

Fletcher, Richard (1997), *The Barbarian Conversion: From Paganism to Christianity*, New York: H. Holt and Co.

Freeman, Ann (1957), 'Theodulf of Orleans and the "Libri Carolini"', *Speculum* 32, 663–705.

Freeman, Ann (1965), 'Further studies in the Libri Carolini', *Speculum* 40, S. 203–89.

Freeman, Ann (1971), 'Further studies in the Libri Carolini, III: the marginal notes in Vaticanus Latinus 7207', *Speculum* 46, 597–612.

Freeman, Ann (1985), 'Carolingian orthodoxy and the fate of the Libri Carolini', *Viator* 16, 65–108.

Freeman, Ann (ed.) in collaboration with Paul Meyvaert (1998), *Opus Caroli Regis Contra Synodum (Libri Carolini)*, MGH Concilia II, supplement 1, Hannover: Hannsche Buchhandlung.

Geary, Patrick V. (1978) *Furta Sacra: Thefts of Relics in the Central Middle Ages*, Princeton.

Godding, Robert (2001), *Prêtres en Gaule mérovingienne*, Bruxelles, Subsidia hagiographica 84.

Goullet, Monique and Dominique Iogna-Prat (1996), 'La Vierge en « Majesté » de Clermont-Ferrand', in *Marie: Le culte de la vierge dans la société médiévale. Études réunies par Dominique Iogna-Prat, Éric Palazzo und Daniel Russo*, Paris, pp. 383–405.

Greenhalgh, Michael (1989), *The Survival of Roman Antiquities in the Middle Ages*, London: Duckworth.

Gutmann, Josef (1989), *Sacred Images: Studies in Jewish Art from Antiquity to the Middle Ages*, Northampton.

Haering Forsyth, Ilene (1972), *Throne of Wisdom: Wood Sculptures of the Madonna in Romanesque France*, Princeton: Princeton University Press.

Halbertal, Moshe and Margalit, Avishai (1992), *Idolatry*, Cambridge, Mass. and London: Harvard University Press.

Hani, Jean (1995), *La Vierge Noire et le Mystère marial*, Paris: Trédanich.

Harmening, Dieter (1979), *Superstitio. Überlieferungs- und theologiegeschichtliche Untersuchungen zur kirchlich-theologischen Aberglaubensliteratur des Mittelalters*, Berlin: Schmidt.

Hillgarth, J. N. (1986), *Christianity and Paganism, 350–750: The Conversion of Western Europe*, Philadelphia: University of Pennsylvania Press.

Himmelmann, Nikolaus (1986), 'Antike Götter im Mittelalter', *Trierer Winckelmannsprogramme* 7, Mainz: Zabern, pp. 5–13.

Hoeps, Reinhard (1999), *Aus dem Schatten des Goldenen Kalbes – Skulptur in theologischer Perspektive*, Paderborn: Schöningh.

Homburger, Otto (1962), *Die illustrierten Handschriften der Burgerbibliothek Bern. Die vorkarolingischen und karolingischen Handschriften*, Bern: Seebst verlag der Burgerbibliothek.

Julius, Anthony (2000), *Idolizing Pictures: Idolatry, Iconoclasm and Jewish Art*, London.

Katzenellenbogen, Adolf (1933), 'Die Psychomachie in der Kunst des Mittelalters', Diss. Hamburg.

Keel, Othmar (2002), 'Das biblische Bilderverbot und seine Auslegung im rabbinisch-orthodoxen Judentum und im Christentum', in Blickle, Peter, Holenstein, André, Schmitt, Heinrich Richard and Sladeczek, Franz-Josef (eds), *Macht und Ohnmacht der Bilder. Reformatorischer Bildersturm im Kontext der europäischen Geschichte*, Munich: Oldenbourg, pp. 65–98.

Keller, Harald (1952), 'Zur Entstehung der sakralen Vollskulptur in der ottonischen Zeit', in Bauch, Kurt (ed.), *Festschrift Hans Jantzen*, Berlin, pp. 71–90.

Kenner, H. (1954), 'Keltische Züge in römischer und romanischer Kunst', in *Frühmittelalterliche Kunst in den Alpenländern*, Olten and Lausanne: Grat.

Kessler, Herbert L. (1993), '"Facies Bibliothecae revelata": Carolingian art as spiritual seeing', in *Testo e immagine nell'alto Medioevo*, Settimane di Studio del Centro Italiano di Studi sull'alto Medioevo XLI, Spoleto, vol. 2, pp. 533–84.

Knoegel-Anrich, Elsmarie (1992), *Schriftquellen zur Kunstgeschichte der Merowingerzeit*, Hildesheim, Zurich and New York: Olms (reprint of the 1932 edn, Darmstadt).

Kühnel, Bianca (2001), 'Jewish art and "iconoclasm". The case of Sepphoris', in Assmann, Jan and Baumgarten, Albert I. (eds), *Representation in Religion*, Leiden, pp. 161–80.

Lauranson-Rosaz, Christian (1987), *L'Auvergne et ses marges (Velay, Gévaudan) du VIIIe au XIe siècles. La fin du monde antique?*, Le Puy-en-Velay: Chaiers de la Haute-Loire (Achives Départementales de la Haute-Loire).

Liber Pontificalis 53, cap. 5 (1886), ed. L. Duchesne, vol. 1, Paris.

Liber Miraculorum Sancte Fidis, I.13 (1994), ed. Luca Robertini, Spoleto: Centro italiano di studi sull' Alto Medioevo.

Lippold, Lutz (1993), *Macht des Bildes, Bild der Macht. Kunst zwischen Verehrung und Zerstörung bis zum ausgehenden Mittelalter*, Leipzig: Edition Leipzig.

MacMullen, Ramsay (1997), *Christianity and Paganism in the Fourth to Eighth Centuries*, New Haven: Yale University Press.

Noreen, Kirsten (1998), *Sant'Urbano alla Caffarella. Eleventh-Century Roman Wall Painting and the Sanctity of Martyrdom*, Baltimore: diss., Johns Hopkins University.

Oldoni, Massimo (1981), *Gregorio di Tours. La storia dei Franchi*, vol. 2, Milan: Mondadori.

Optatus (1997), Fourth book against the Donatists, *Vs the Donatists*, trans. M. Edwards Liverpool, pp. 93–4.

Passio Sancti Stephani Papae, vol. II, p. 496, l. 33/49

Passio Sancti Cornelii Papae vol. I. p. 373, l. 45.

Polacco, Renato (1976), *Sculture paleocristiane e altomedievali di Torcello*, Treviso: Marton.

Poly, Jean-Pierre (1980), *La mutation féodale Xe-XIIe siècles*, Presses universitaires de France.

Prudentius (1949), 2 vols, English trans. H. J. Thomson, Cambridge, Mass. and London: Harvard University Press (The Loeb Classical Library 387).

Remensnyder, Amy G. (1990), Un problème de cultures ou de culture? La statue-reliquaire et les joca de sainte Foy de Conques dans le Liber miraculorum de Bernard d'Angers, *Cahiers de civilisation médiévale* **33/4**, 351-79.

Schmitt, Jean-Claude (1987), 'L'Occident, Nicée II et les images du VIIIe au XIIIe siècle', in Boesflug, F. and Lossky, N. (eds), *Nicée II, 787–1987. Douze siècles d'images religieuses. Actes du Colloque international Nicée II tenu au Collège de France*, Paris: Ed du Cerf, pp. 271–301.

Schultze, Victor (1887), *Geschichte des Untergangs des griechisch-römischen Heidentums*, Jena, vol. 2, Bd. 2.

Scriptores Historiae Augustae (1921), 3 vols, Loeb Classical Library, London and Cambridge, Mass.: Harvard University Press.

Stettiner, Richard (1895 and 1915), *Die illustrierten Handschriften des Prudentius*, 2 vols, Berlin.

Stewart, Peter (1999), 'The Destruction of Statues in Late Antiquity', in Miles, Richard (ed.), *Constructing Identities in Late Antiquity*, London and New York: Routledge, pp. 159–89.

Sulpitius Severus (1894) 'On the Life of St. Martin', trans. and notes Alexander Roberts, in *A Select Library of Nicene and Post-Nicene Fathers of the Christian Church*, Second Series, Vol. 11, New York.

Tata, Margherita Bedello (2000), 'Alfresco con scena di sacrificio', in *Aurea Roma*, Kat.-nr. 131, Rome: L'Erma di Brettschneider, p. 508.

Valentini, Roberto and Zucchetti, Giuseppe (1940), *Codice topografica della città di Roma*, vol. 1, Rome: Tipografia del Senato.

Van Oort, J. and Wyrwa, D. (eds) (1998), *Heiden und Christen im fünften Jahrhundert*, Leuven: Peeters.

Waas, Christian (1939), 'Wer hat die Mainzer Iuppitersäule zerstört?', *Saalburg Jahrbuch* **9**, 97–103.

Wirth, Jean (1995), 'Die Bildnisse von St. Benedikt in Mals und St. Johann in Müstair', in Meier, Hans-Rudolf (ed.) *Für irdischen Ruhm und himmlischen Lohn. Stifter und Auftraggeber in der mittelalterlichen Kunst*, Festschrift für Beat Brenk zum 60 Geburtstag, Berlin: Reimer, pp. 76–90.

Woodruff, Helen (1930), *The Illustrated Manuscripts of Prudentius*, Cambridge, Mass.

Wright, David H. (1993), *Der Vergilius Vaticanus: ein Meisterwerk spätantiker Kunst*, Graz: Akademische Druck- und Verlagsanstalt.

Yitzhak, Hen (2002), *Paganism and Superstition in the time of Gregory of Tours: Une question mal posée!?*, in Mitchell, Kathleen and Wood, Ian (eds), *The World of Gregory of Tours*, Leiden: Brill, pp. 229–40.

Young, B. (1975), 'Paganisme, christianisme et rites funéraires mérovingiens', *Archéologie Mediévale* **7**, 5–81.

4.1 Stuttgarter Psalter, *c.* AD 820, 'Noli aemulari in malignantibus'

94.

τ habitare fecit in taber naculis eoru tribz israhel
τ temptauerunt & exacer bauerunt dm excelsum
& testimonia eius non custodierunt
tauerterunt se & non seruauerunt pactum
quem admodum patres eorum conuer sisunt
in arcum prauum
— in ira concitauerunt eum incollibus suis
& insculptilibus suis ad aemulationem
eum prouocauerunt

udiuit ds & spreuit & ad nihilum redegit ualde isrt
trepulit tabernaculum silo
tabernaculū suū ubi habitauit in hominibus
t tradidit incaptiuitatem uirtutem eorum
& pulchritudinem eorū inmanus inimici
t conclusit ingladio populum suum
& hereditatem suam spreuit
uuenes eorum comedit ignis
& uirgines eorum nonsunt lamentatae
acerdotes eorum ingladio ceciderunt
& uidue eorum non plorabuntur

4.2 Stuttgarter Psalter, *c.* AD 820, 'Et in ira concitaverunt eum in collibus suis et in sculptilibus suis ad aemulationem eum provocaverunt'

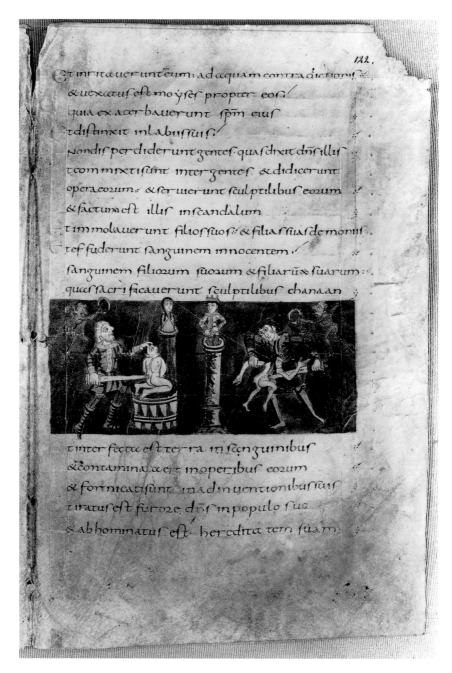

4.3 Stuttgarter Psalter, *c.* AD 820, 'Similes illis fiant qui faciunt ea et omnes qui confidunt in eis'

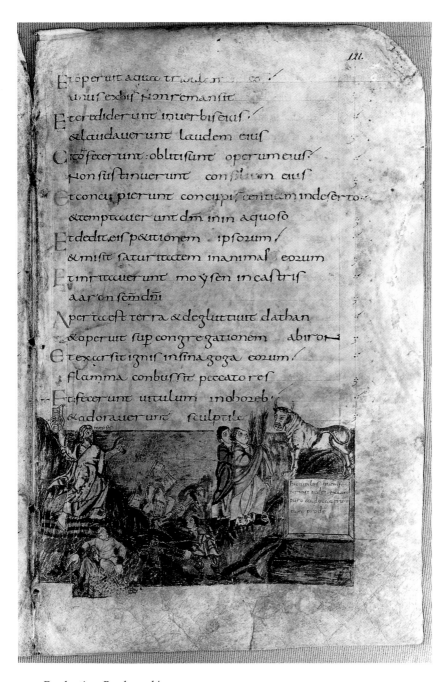

4.4 Prudentius, *Psychomachia*, verses 30–35

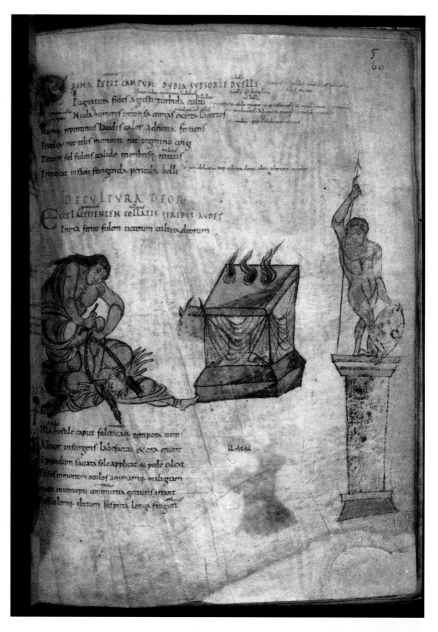

4.5 Stuttgarter Psalter, *c.* AD 820, 'Et effuderunt […] sanguinem filiorum suorum et filiarum suarum, quas sacrificaverunt sculptilibus Chanaan'

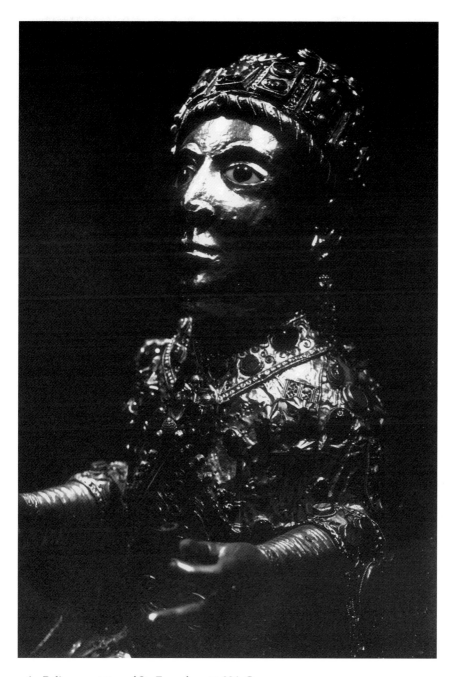

4.6 Reliquary statue of Ste Foy, after, AD 886, Conques

Seeing is believing but words tell no lies: captions versus images in the *Libri Carolini* and Byzantine Iconoclasm

Liz James

The period known as Iconoclasm in Byzantine history marks a point when the whole eastern Christian world was affected by a dispute over the role and function of images in religious worship. This clash was perhaps the most wide-ranging and disruptive quarrel ever about pictures, lasting for over a century and affecting the entire Byzantine Empire. The results of its final resolution in 843 are still present in Orthodoxy today in the presence and use of images in religious devotion. Had Iconoclasm triumphed, Orthodoxy would be a very different form of Christianity. This essay looks at one element in the dispute about images, the question of the positions occupied by images and words in the appropriate portrayal of the divine, the issue at the root of Byzantine Iconoclasm. I intend to look at one very specific passage in the text known as the *Libri Carolini* to consider, against the backdrop of Iconoclasm and debates about the nature of images, what it might tell us about the perceived roles and interactions of words and images in the Carolingian West and the Byzantine East. The debate about images for East and West was also a dispute about man's relationship to God and the relationship of the material world to the spiritual. In this context, we tend to find either images or words favoured as the 'right' means of communication with the divine, and the other problematized as 'false' or 'deceptive'. For the Byzantines, seeing seems to have been believing, but in the *Libri Carolini*, words appear as a more reliable form of communication.[1] Does this dichotomy really work or is it that both had potential for truth and for falsity in the struggle to convey the immaterial through the material, whether words or images?

The period of Byzantine Iconoclasm began in 726 when the first Iconoclast emperor, Leo III, gave public support to the destruction of religious images, and succeeding Iconoclast emperors maintained power until the reign of the Iconophile empress Eirene and the restoration of images in 787. A second period of Iconoclasm followed between 815 and 843, when images were

finally restored to their place in religious worship by the empress Theodora.[2] During the Empire's struggle over images, western Christian rulers also took their own stands. The pope, Hadrian I (772–95), was largely in favour of the Iconophile position, but Charlemagne, King of the Franks, appears to have taken a very different attitude, one closer to that of the Iconoclasts.[3] Charlemagne's interests were both religious, striking a blow for correct belief against idolatry, and political. The 790s were a period of Frankish expansion and conflict with Byzantine interests in Italy and the Balkans, and the king was also eager to assert himself against the female ruler of the Byzantine Empire. Charlemagne's rejoinder to the Iconoclastic controversy survives in the form of the so-called *Libri Carolini*, more correctly titled the *Opus Caroli regis contra synodum*, written between 790 and 793, almost certainly by Theodulf of Orleans.[4] These offered a response to the empress Eirene's church council, the Second Council of Nicaea (Nicaea II) in 787, which had restored images to their place in religious devotion. However, because of the pope's support for Nicaea II, the *Libri Carolini* were never circulated and disappeared into obscurity in Charlemagne's court library. Nevertheless, in terms of their theological and political implications, they form a significant statement of the Carolingian position (see Freeman, 1957).

The *Libri Carolini* served a twofold purpose. On the one hand, they had a political focus. They were a chance to discredit the eastern Empire by attacking its orthodoxy. They offered an opportunity for Charlemagne to assert Carolingian differences and superiorities to Byzantium by denouncing the many ways in which that empire, led by a woman, had clearly strayed from Christian practice. On the other hand, they had a religious motive. They present what scholars have seen as a carefully worked out and consistently argued theological riposte to Byzantium about the conception of the nature and role of religious images. They offer a model that stands in sharp contrast in many ways to the views of both the Iconoclasts and the Iconophiles on images (see, for example, Chazelle, 1986, 1993 and 2001, esp. pp. 43–4; Freeman 1994). However, the decrees of Nicaea II reached the Carolingians in an inaccurate and error-strewn Latin translation, one which may even have been based on a florilegium, an anthology of quotations, of the Council.[5] The nature of the text that Theodulf was working from led him to believe that the Iconophiles believed that artistic images were owed the worship normally reserved for the Trinity, a reverence described in Latin as *adoratio* and in Greek as λατρεία (latreia or adoration), rather than veneratio or προσκύνεσις (proskynesis or veneration). Consequently, the *Libri Carolini* sought to refute the apparent Byzantine belief that painted images should be given the same worship as God. They therefore misrepresented in a major fashion the Byzantine position on images and were, in some ways, not a response at all. The Byzantines, incidentally, paid them little or no attention whatsoever.

Here my concern is not with the political significances of the *Libri Carolini*, though these form a necessary backdrop to any discussion of the text. Rather, I am interested in the insights one specific passage may offer into the perceived natures of images and words and their relationship to God in the period of Iconoclasm. The passage in the *Libri Carolini* tells the story of a man who venerated pictures.

He was shown two pictures of beautiful women without captions. The painter supplied one picture with the caption 'Virgin Mary' and the other with the caption 'Venus'. The picture with the caption 'Mother of God' was elevated, venerated and kissed; while the other, because it had the caption 'Venus', was maligned, scorned and cursed, although both were equal in shape and colour and made of identical material and differed only in caption.[6]

This, the text indicates, shows the folly of worshipping images.

This story touches on the crux of the Iconoclastic dispute: what are religious images and how should they be treated? Iconoclasm was a dispute about the correct representation of God. The Byzantine view of images, held by both sides in the Iconoclast dispute, was that, insofar as an image looked like its original model, it displayed accurately and even was indeed that model: 'Every artificial image is a likeness of that whereof it is the image and it exhibits in itself, by way of imitation, the form of its model', as a leading Iconophile put it, and 'Every icon ... is of the same substance with the subject depicted on it' in the words of a leading Iconoclast.[7] The problem that arose from this belief was the question of how a corporeal image could be made after the image of the incorporeal and divine God: how an icon depicting Christ could be an icon of Christ (Ladner, 1953). Byzantine Iconoclasts believed that religious images broke the Second Commandment and were idolatrous.[8] Further, they argued that such images were either impossible, in the sense that it was not possible to portray the divine through human means and base materials, or blasphemous and heretical because they confused the natures of Christ. 'This man [the painter] makes an image and calls it Christ: now the name "Christ" means both God and man. Hence he has either included ... the uncircumscribable Godhead in the circumscription of created flesh or he has confused that unconfusable union.'[9] In other words, because images of Christ either did not portray Christ's divinity or muddled his nature, therefore they were not true images of Christ at all and so not worthy of veneration: 'Either the divine quality is also depicted in that icon [of Christ] ... or you perceive Christ as being only a mere man.'[10]

The Iconophile response was based on the premise that the honour given to the image was conveyed to the prototype, the person imaged: 'Whereas in the case of the imitative picture and its model, that is of Christ and Christ's image, granted that the person of Christ is one and the same, the reverence [due to them] is also one.'[11] The crucial word here is 'reverence': venerating

pictures was not a worship of the image but an honouring of the individual depicted. As the eighth-century Iconophile theologian John of Damascus said

Now when God is seen in the flesh conversing with men, I make an image of the God whom I see. I do not worship matter; I worship the Creator of matter who became matter for my sake ... who worked out my salvation through matter. Never will I cease honouring the matter that wrought my salvation. I honour it but not as God.[12]

God is worshipped; his image honoured. In this context, the Iconophiles answered the Iconoclast accusation that images of Christ only represented his humanity by arguing that because Christ had been incarnated and thus made visible in the fullness of his humanity and of his divinity, he could be portrayed. They also asserted that the image and the person were not the same thing, as the Iconoclasts had claimed, but rather, as John of Damascus said, 'An image is of like character with its prototype but with a certain difference.'[13] Most significantly within this context, the icon and its prototype were identical in appearance and so an icon of one individual could not be confused with the image of another. For the Byzantines, seeing was believing. Byzantine miracle stories often concern saints identified by their likeness to their icon.[14] The Iconophile patriarchs Photios and Nicephoros both esteemed images above words and the Iconophile theologians John of Damascus and Theodore the Studite declared sight to be the most important of the senses.[15]

Not only that, John of Damascus also made it clear that the depiction of God was not so much allowable as vital, indeed incumbent for the believer, as the only means of contemplation. The *Horos* or *Definition* of Nicaea II concluded that

We preserve all the traditions of the Church, which for our sake have been decreed in written or unwritten form, without introducing an innovation. One of these traditions is the making of iconographic representations – being in accordance with the proclamation of the gospel – for the purpose of ascertaining the incarnation of God the Word ... and for being of an equal benefit to us as the gospel narrative. For those which point mutually to each other undoubtedly mutually signify each other.[16]

As this suggests, images carried an equal weight with Scripture: 'That which the narrative declares in writing is the same as that which the icon does [in colours].'[17] Images were for veneration of the figure imaged.

The more these [icons of Christ, the Virgin and the saints] are kept in view through their iconographic representation, the more those who look at them are lifted up to remember and have an earnest desire for the prototypes ... One may render them the veneration of honour: not the true worship of our faith, which is due only to the divine nature ... He who venerates the icon venerates the hypostasis of the person depicted on it.[18]

The *Libri Carolini* took an attitude that brought them close to the perspective of the Byzantine Iconoclasts, but with key differences.

We neither destroy in common with the former council [the Iconoclast Council of 754] nor adore with the latter [Nicaea II] ... We permit the use of images in the churches of the saints, not that they should be adored but in order to recall past events and for the adornment of the wall.

(Opus Caroli regis III, 16)

In both the extract from the *Horos* of Nicaea II cited above and this excerpt from the *Libri Carolini*, it becomes apparent how significant the flaw in translation from Greek to Latin of the terms for 'veneration' and 'worship' was. The *Libri Carolini* argued that because images were man-made, material not divine, they could not and should not receive adoration. Artistic images of the divine were not owed worship in the same way that God was to be worshipped, contrary to what Theodulf thought the Byzantine Iconophiles to believe. Rather, the Scriptures offered true knowledge of the divine. For a manufactured representation to be an image in the true sense of the word, the *Libri Carolini* argued that it needed some contact with its prototype or to be an emission from the prototype: neither of these things could happen when a picture was manufactured. An image of a saint recalled a saint, which was a good thing, but it should not be adored or worshipped; such veneration was reserved for the saint. The image was, simply, a material object that was neutral. It did not have the power to lead the beholder to a contemplation of immaterial things. 'God is not to be sought in visible or manufactured things but in the heart; he is to be beheld not with the eye of flesh but only with the eye of the mind.'[19] Looking at images was in direct contrast to the Christian's true search for God, for although the material world was good, it existed separately from the spiritual realm. The mortal who wanted to approach God, therefore, must do it through spiritual means alone, for art would not and could not bring the viewer closer to the heavenly realm. Indeed, there was a risk intrinsic in the use of art for 'it may be that learned men can avoid adoring images by venerating not what they are but what they represent; nevertheless, in doing so, they create a pitfall for the unlearned who venerate and adore only what they see' *(Opus Caroli regis* II, 21). This is a sentiment that also reveals some of Theodulf's misconceptions about the Byzantine veneration of images, for this distinction between matter and spirit was not one drawn by the Byzantines.

The *Libri Carolini* hold that images had a historic and an aesthetic function, used 'in order to recall past events and for the adornment of the wall'. They could, if accurate, promote memory: 'Art can bring to the beholder the memory of events that actually occurred and lead minds from falsehood to the contemplation of truth.'[20] They were useful for the recollection of the past and for decoration but they should be neither worshipped nor destroyed. 'Since we recognise that they [images] play no role in accomplishing the mystery of our redemption, it follows that no damage to the Catholic faith

can result from either their omission or display' (*Opus Caroli regis* II, 21). This was a view that neither the Iconoclasts nor the Iconophiles in Byzantium would have found themselves in agreement with, and a view that explains why Theodulf felt no need for a theology of images to match the turmoil of Byzantine Iconoclasm.

It is the central role of likeness in artistic depiction that distinguished imagery from the written word for Theodulf. It was also an issue that concerned the Byzantines intimately, since both sides in the Iconoclastic dispute believed that the image had to resemble the prototype. However, where the Byzantines held that 'That which the narrative declares in writing is the same as that which the icon does', the *Libri Carolini* took the line of 'non in picturis sed in Scripturis': not in images but in the Scriptures.[21] Theodulf saw the written word as a sign that could evoke thoughts of things to which it did not bear a resemblance.

Which single word of the Lord and the Apostles can be represented by painters? Painters have a certain ability to remind one of things that have happened. Such things, however, as are understood by reason and expressed in words can be expressed not by painters but by writers through verbal discourse.[22]

The variety of subjects that art could bring to life was smaller than that which words could, and so, the *Libri Carolini* suggested, it was easier to recognize things from words than from pictures. This was because the written word could evoke the thoughts of things to which it did not bear a resemblance (Chazelle, 1986, p. 174). Many things that could not be depicted could be recorded in writing, such as the wisdom of the saints, their qualities and their virtues. Not only that, Theodulf also followed Hrabanus Maurus, the respected scholar, abbot of Fulda and archbishop of Mainz, who said that writing was better than painting, for writing revealed the truth by its appearance, words and meaning, whilst pictures were snares, unable to arouse faith.[23] Thus the *Libri Carolini* are perceived as treating writing as a superior form of religious communication to pictures, as the Iconoclasts in Byzantium did (Gero, 1973, p. 16; Chazelle, 1986, p. 169). Words are a better and more complete and reliable form of communication; the Bible proclaims the importance of writing by its existence as a written text; words are needed to understand the Scriptures. Seeing might be believing, but sight can be deceived and, in contrast, so it seems, words tell no lies (*Opus Caroli regis* I, 17, pp. 185–9). The *Libri Carolini* display a great fear of images being false, but little apprehension that words might also be deceptive.

In this context, if we return to the story of the man directed to worship an image through its label, the point of a title or caption appears to be that it conveys identity accurately and truthfully (Chazelle, 1986, p. 174). Resemblance is so critical to an artistic representation that the viewers may

make mistakes in identifying its subject matter if the image is badly formed, damaged or has lost its inscription.[24] Once an image is removed from its rightful place and has no inscription or identifying symbol, how is the viewer to know if the Virgin he thinks he sees is not actually meant to be Venus?[25] This understanding of the *Libri Carolini* has informed interpretations of the story of the deceived image-worshipper. It is seen as a story that deals with the word–image dichotomy and that privileges words above images, captions above pictures. Thus Michael Camille has used it to say that the captions enabled the viewer to distinguish between true and false images on a very basic level of literacy. He suggests that the oft-voiced distrust of the materiality of painted images, seen in the inability of the worshipper to distinguish between them, was placated by their being defined through language, in the form of the captions (Camille, 1985, esp. pp. 33–4). Rosamund McKitterick (1990, p. 309) has suggested that whilst Theodulf was making a point about the images, it is important to note that it is the written word which gives the picture in this case its identity and its power. Her argument is that in Carolingian society, words were esteemed as superior to images in the communication of the truth, in contrast to ninth-century Byzantine writers who esteemed images above words or, more accurately, sight above hearing. Similarly, Celia Chazelle (1986, p. 174) has suggested that the *Libri Carolini* make the point that works of art without a titulus are difficult, if not impossible to identify. The viewer of the two images, 'Virgin Mary' and 'Venus', can identify them as women but does not know which women they are, or indeed which is which, until he reads the titulus. A further passage in the *Libri Carolini* makes a similar point. Book 4.21 notes how a person discovering an unlabelled statue of a female with a child may find it difficult to establish whether this is Mary with Christ, Sara with Isaac, Rebecca with Jacob, Venus with Aeneas, Andromache with Astyanax unless there is a label.[26] The point appears to be that words are superior to images because even subjects capable of visual representation are more often and more accurately recognized from verbal descriptions than from man-made images.

However, this perceived duality between word and image, of word versus image, is perhaps more complicated than it seems. The assumption appears to be that word and image perform similar functions but that one or the other is privileged in a particular society. The *Libri Carolini* account is certainly more intricate than this straightforward division between words and images makes it appear. The story of the two images comes in the middle of a chapter attacking Epiphanius the Deacon. Its purpose is to prove Epiphanius wrong when he says that we give the image the first place of honour through the name of signification (*per nomen significationis*) and by kissing it, receive sanctification. The *Libri Carolini* say that this is nonsense.

> If the inscription of the name leads them [images] to the honour of these saints, the names of whom are written, then any old thing on which the name of any old saint is written ascends to the honour of that saint – wood, stone, clothes, whatever are inscribed with the name of some saint go to the honour of those same saints whose names are noted.
>
> (*Opus Caroli regis* IV, 16, p. 528, l. 32)

This seems to say that the inscribed names cannot make those things (wood, stones or whatever) enumerated produce honour for those whose name they bear, nor can the holy names make the inscription honour the saints in any way. Just writing a name is not enough. It is at this point that the story of the two images is told. The point that the *Libri Carolini* makes, however, is that 'sanctification is given to inanimate objects not by any inscription whatsoever, but by sacerdotal consecration and the invocation of the divine names' (*Opus Caroli regis* IV, 16, p. 529, ll. 18–19). No sanctification can inhere in images through any old inscription, and whether labelled 'Mother of God' or not, the image has the same value lying down as standing up: the words, the inscription, make no difference. For Theodulf, this is where the Byzantines have strayed from Orthodoxy by failing to understand the relationship between matter and spirit. This is where the division really lies. It is not between word and image but between conveying matter and spirit.[27]

In this way, the story becomes one about how words and images can both be equally valueless in the communication of the divine. Granted the image-worshipper identified the picture by the captions, but this points up the folly of both image and caption. Would the caption have worked on an empty board? This seems unlikely. For the caption to work, it needed an image and, the *Libri Carolini* make clear, an image that bears some relation to that caption. This is not Magritte's *The Treason of Images* (*Ceci n'est pas une pipe*) (see Foucault, 1973, 1982). Rather the implication is that caption and image must correspond in some fashion. Despite the emphasis placed by scholars on the caption and its significance, the caption is meaningless without the right sort of image.

Not only that, in this story, although seeing is believing, words do tell lies. The written word does give the image a form of identity for the literate worshipper, as McKitterick notes, and it does serve to identify the image, but it is untrue. The captions are false or misleading captions, designed to lead the worshipper astray. If they give power, it is through telling untruths. As Theodulf says, any old thing can be labelled 'Virgin Mary' but the label should not give that thing holy status and words are not themselves holy. Language does not placate the distrust of material images; rather it highlights it through its own potential to mislead. Can a description ever be as clear as an image?[28] In ninth-century Byzantium, Theodulf's story would have been meaningless. An image of the Virgin and one of Venus would not and should

not have looked alike. The Byzantine theory of images developed during Iconoclasm meant that each must look like its prototype, and the Virgin and Venus were very different prototypes. Reading the image in Byzantium depended on the visual clues rather than the verbal; the theology of the icon was a visual one.

The Byzantines were well aware that the written word could be false.[29] In the seventh century, Anastasios of Sinai had pointed out that material signs, a term which appears to include images, were superior to written texts because texts were likely to be falsified.[30] During the Iconoclastic dispute, demonstration of the veracity of a text was a major concern. Church councils stressed the accuracy of the texts they used to establish the theological points they made. The Sixth Ecumenical Council of 680-81 had combed archives, collated texts and verified signatures and handwriting in order to confirm the authenticity of its written sources, and this approach intensified during Iconoclasm (see Brady, 1936, esp. 290–91; Brubaker, 1989, esp. pp. 28–30). The *Acts* of Nicaea II appear to provide verbatim testimonies of how the Iconoclasts erased passages about icons from books, and elaborate checkings of citations took place throughout this Council.[31] The Byzantines were also aware of the problems of labels. A story which echoes that of the *Libri Carolini*'s deceived image-worshipper is told in an eighth-century text, the *Parastaseis syntomoi chronikai*. This describes how the emperor Julian put up statues of Apollo and Artemis in Nicomedia and claimed that they were statues of himself and his wife and should be revered as such. As a result of this, the *Parastaseis* says, many were deceived and fell into idolatry.[32] Although the Julian story makes no mention of labels on the deceitful statues, it is clearly as a result of verbal or written instructions – false words – from the emperor that the two statues are said to confuse the unwary.

What matters about words is both their veracity per se and, as with images, their power, for telling truth or lies. Captions did carry power for the Byzantines. In the *Parastaseis*, it is often as a result of reading inscriptions or prophecies about statues that the spectator is made aware of their malevolent forces. In one story, as soon as the inscription on a particular statue is read, the statue falls on the head of the reader, killing him, and in another, an observer of a statue comments 'I would have been better off if I had not read the inscription' (Kazhdan, 1987, ch. 28, pp. 90–91; ch. 65, pp. 146–7). Although the *Parastaseis* is often seen as a text that describes the malevolent power of images, it also treats words and inscriptions as potentially dangerous too.

Words also possessed power and magic qualities, especially for the initiate. A seventh-century story told of St Symeon the Holy Fool tells how he rendered a sorceress ineffective by giving her an amulet on which was inscribed a Christian prayer that she, being illiterate, was unable to read, but which she recognized as magical through the presence of the letters.[33] Magical

incantations in Byzantium were language-based. Here written words appear as strange, powerful, dangerous and frequently incomprehensible in their formulaic arrangement of letters on a page.[34] The incantation in a fourth-century papyrus in Leiden repeats the vowels in three columns in different but senseless combinations.[35] Amulets often include incantations or words with a quasi-scriptural formulation or even words that appear as gibberish and meaningless to us.[36] A ring in the Kelsey Museum of Archaeology, Ann Arbor, for example, depicts a holy rider with an inscription that reads 'ogyrdkmapeotufzezouzerbe'.[37] Henry Maguire has argued that repeating geometric patterns functioned as intensifying magical agents, with reiteration strengthening their power; in this context he has also suggested that the repeating nature of letters in magical formulae and patterns increased their potency. This can be pushed a stage further. Repeated letters do not only engage with language; they are also visual patterns whose power resides in their visual nature in an oral society as well as in their role as texts.[38] Monograms of people's names on buildings or on seals, for example, also used letters to create visual patterns, again mystical and only comprehensible to the initiate.[39] The St Symeon story underlines the nature of these words not as communicators of information but as incomprehensible magical signs whose potency resided in their appearance. In the *Parastaseis*, it is 'philosophers' who have the skill to decode words about statues.[40] For others lacking this knowledge, words may appear as visual signs, not verbal. The visual appearance or pattern of the letters in the Leiden papyrus I mentioned above may be as significant and powerful as the verbal quality.

In understanding the power of words and images in this context, it needs to be remembered that both medieval West and East were primarily oral/aural cultures. Reading took place aloud and, certainly in the West, as late as the twelfth century, seeing and hearing, rather than reading and writing, secured the truth of a statement.[41] Writing was a skill not widely available and written words to the illiterate viewer might have looked as awesome as images, and certainly less easy to comprehend.[42] The Book of God was a book open only to the initiate who could read the symbols (McCormick, 1993, p. 100). Amulets using words may represent a harnessing of the power of something not understood, something regarded with some suspicion and mistrust in some sources. The magic of texts was particularly pronounced in the Byzantine and Frankish worlds where the spoken language was not the same as the written (McCormick, 1993, pp. 100–101). This disjuncture between written and spoken words must have added a level of magical power to the written word perhaps not always appreciated in an age where the majority of us are literate and have expectations of how words will work. Where Goodman has suggested that pictures work as cues decoded as substitutes or as supplements to language and that they interfere

between the reader and the written language, we need to recognize that this may be true in a literate culture where texts come first and images second, but may not be the right order in the medieval world where the written language is not always the spoken one.[43] Words are not there only to be read, but also to be looked at.

Although Theodulf's story clearly concerns a literate iconophile and is clearly a view of words held by a literate person, nevertheless, his story about the captions underlines the magical power of words. His captions fulfil an almost magical role in providing identity, even a false identity. The Iconoclastic dispute about images, waged across the written texts of the Church Fathers, proved by brandishing the written word across the floor of a Church Council, is perhaps a belief in the same magical significance but on a different level of literacy.

The *Libri Carolini* have been cited as evidence of the mistrust of the materiality of the painted image which could be placated through language. Camille has suggested that on a basic level of recognition, literacy meant being able to distinguish between true and false images. Yet we have seen that language can be false and misleading, concealing the distinction between true and false images. So, is seeing believing and do words tell the truth? The captions story told in the *Libri Carolini* is also about false labels, words that deliberately lie about pictures that are false because man-made. Both have the capacity to be valueless in communicating the divine. Perhaps rather than seeing images and words as rivals, each setting out to do the same thing, with one better at this task than the other, we should consider that both are concerned not with each other but have the power to lead the viewer/auditor to something that lies beyond both.[44] Both point the individual to the contemplation and perception of what is beyond: the object for which word and image are both signifiers. In the medieval world, both West and East, this was God. The *Libri Carolini* perhaps indicate that neither words nor images were adequate for this purpose.[45] Image and text have different powers and do different things, but share a purpose. Thus this story can also be read as how a text about a work of art actually does not talk about the image but about something different, about how to communicate or not communicate with God. The important thing is neither text nor image, but rather how both or either can direct the believer to God (Kessler, 1994). Making text into image and image into words is perhaps not about a divide but about the unification of two powerful tools. In thinking about Iconoclasm, we tend to think in terms of a dispute over images and the meaning of images. In Byzantium, unlike the West, it was also a dispute less over the legitimacy of the human figure in art than over how man could best and most legitimately and accurately portray the heavenly image. Both words and images could do so but also, significantly, both can mislead.

Notes

1 Chazelle (1995) raises some important points on this theme. See also Noble (2001).
2 There is a vast literature on Byzantine Iconoclasm. *The Oxford Dictionary of Byzantium*, A. Kazhdan et al. (1991), 'Iconoclasm' gives a brief and easily accessible potted history and useful references; see also Brown (1973), Bryer and Herrin (1977), Brubaker and Haldon (2001), and Haldon (1990), esp. pp. 405–24.
3 On the question of why a politico-theological debate in Byzantium was taken to the Carolingian West, see McCormick (1993); on the 794 Carolingian Council of Frankfurt as a response to Nicaea II and the political consequences of it, see Auzépy (1997); on the resulting clash with the pope, see Freeman (1985). For the politics around the *Libri Carolini*, see also Speck (1978), esp. pp. 163–5 and 185. On the general political background, see Herrin (1989), esp. pp. 344–444.
4 Text of the *Libri Carolini*, ed. A. Freeman, *Opus Caroli Regis Contra Synodum (Libri Carolini)*. Concilia, Tomus II, Supplementum I, *MGH* (1998). I have referenced citations from the *Libri Carolini* to this edition as *Opus Caroli regis*. See also Freeman's introduction, especially pp. 23–50 on Theodulf as author. For the text of Nicaea II, see Mansi (1901–27), vols 12 and 13. A partial translation of the sixth session of the council is available in Sahas (1986).
5 Gero (1973) suggests the author of the *Libri Carolini* was working from a florilegium. Auzépy (1997: 291), disagrees. See also Freeman (1985), esp. in this context, p. 87 and n. 87.
6 *Opus Caroli regis* IV, 16, pp. 528–9. This translation is that of Camille (1985), pp. 33–4.
7 The Iconophile is Theodore the Studite, *Epistle ad Platonem*, PG 99, col. 500. Translation taken from Mango (1972), p. 173. The Iconoclast is the Emperor Constantine V, *Peuseis (Inquiries)*. Text in Hennephof (1969), fragment 142, and Sahas (1986), p. 31. On Theodore and Iconoclasm, see Parry (1989).
8 'You shall not make for yourself a graven image or any likeness of anything that is in heaven above or that is in the earth beneath or that is in the water under the earth; you shall not bow down to them or serve them', Exodus 20:4–5. I have here simplified the arguments of both sides and omitted a great deal of the theology, but for details, see Martin (1930), Barnard (1977) and Sahas (1986). For art and theology, see Ladner (1953); Kitzinger (1954), Cameron (1992), Barber (1993 and 1995), and Cormack (1997).
9 *Horos* of the Iconoclastic Council of 754, Mansi, *Sacrorum conciliorum* 13, col. 208 ff. Translation from Mango (1972), p. 166.
10 Constantine V, *Peuseis*; Hennephof (1969), fragment 159; and Sahas (1986), p. 31. The debates about the nature of Christ, whether he was God, man or both, whether he had one nature, human and divine but divisible, two separate natures, human and divine, or one nature, human and divine and indivisible, were long-standing and divisive in eastern Christianity. Correct Orthodox belief said that Christ had one indivisible nature, human and divine, godhead and humanity fused and inseparable, that the Incarnate Christ was fully human and fully divine at one and the same time. Thus, the Iconoclasts argued, since the divine cannot be portrayed through material means, Christ cannot be portrayed. In portraying Christ, the Iconophiles thus fell into one of two heresies. If they believed that Christ had two natures, that he was both human and divine at the same time, but that these two natures are separable, they can be divided, and only the human nature portrayed, they fell into the Nestorian heresy, condemned in the fifth century. If they believed that Christ was portrayed in both his human and divine natures, this was clearly impossible because it suggested that Christ's divine nature was encompassed by his human nature, since, obviously only his human nature could be portrayed, so they fell into the Arian heresy, which argued that Christ was created by God and therefore possessed human and divine qualities in one divisible nature. See note 8 for references.
11 Theodore the Studite, *Epistle ad Platonem*, PG 99, col. 500; Mango (1972), p. 173. The well-known phrase that 'the honour given to the image is conveyed to its prototype' is used by John of Damascus, borrowing from the fourth-century Church Father, Basil of Caesarea. See John's *De Fide Orthodoxa* 4, 16, PG 94, col. 1158 and Basil, *De Spiritu Sancto* 17, 44, PG 32, col. 149.
12 John of Damascus, *On the Divine Images* I, 16, PG 94, 1245A–B. English translation taken from John of Damascus *On the Divine Images* (1980), p. 23. For John's theology of the icon, see Louth (2002), ch. 7, pp. 193–222.
13 John of Damascus, *On the Divine Images* I, 9, PG 94, 1240C.
14 See, for example, Nilus of Sinai's story of a young man rescued by St Plato, who recognized the saint because he had often seen his portrait on icons, a story retold as part of the Iconoclastic dispute: PG 79, col. 580-1; Mansi, *Sacrorum conciliorum* 13, pp. 32–3; Mango, (1972), p. 40.
15 John of Damascus, *On the Divine Images* I, 17, PG 94, col. 1248C; Theodore the Studite, *Antirrheticus against the Iconoclasts* III, 1.2, PG 99, col. 392A. English translation available in Theodore the Studite (1981). See also Nelson (2000).
16 *Horos* of the Seventh Ecumenical Council (Nicaea II), Mansi, *Sacrorum conciliorum* 13, col. 377E; trans. Sahas (1986), pp. 178–9.

17 *Horos* of the Seventh Ecumenical Council (Nicaea II), Mansi, *Sacrorum conciliorum* 13, col. 232C; trans. Sahas (1986), p. 69.
18 *Horos* of the Seventh Ecumenical Council (Nicaea II), Mansi, *Sacrorum conciliorum* 13, col. 377E; trans. Sahas (1986), p. 179.
19 *Opus Caroli regis* IV, 2 and cited in Chazelle (1986), p. 176 and n. 75.
20 *Opus Caroli regis* III, 23. Also Gero (1973); Freeman (1994), pp. 171–4; Chazelle (1986) and (2001) esp. p. 43. On Gregory's dictum and its reception in the West, see Chazelle (1990), which makes the case that Gregory saw the role of pictures as improving understanding. That pictures were books for the illiterate is a nice idea but one that raises the practical question of whether the illiterate could actually see those pictures in an age without spectacles and electric light.
21 *Opus Caroli regis* II, 8. See Freeman (1994), pp. 165–7.
22 *Opus Caroli regis* III, 13. Trans. from Davis-Weyer (1971), p. 103. On this theme, see also Chazelle (1993), p. 57.
23 Text of Hrabanus Maurus, ed. E. Dümmler, *Carmina* No. 38, *MGH* Poet. II, lines 1–19, p. 196.
24 *Opus Caroli regis* I, 15, p. 170; IV, 16, pp. 528–9; IV, 21,p. 540. Cited and discussed by Freeman (1994) and Chazelle (2001), pp. 43–4.
25 See Wallace-Hadrill (1983), p. 221, who sees this as Theodulf's 'coup de grâce'.
26 'Even if we suppose that an image of the Holy Mother of God ought to be adored, how are we to identify her image or differentiate it from other images? When we see a beautiful woman depicted with a child in her arms, with no inscription provided, how are we to know whether it is Sarah holding Isaac or Rebecca with Jacob …? Or if we consider the fables of the gentiles … how are we to know whether it is Venus with Aeneas or Alcmene with Hercules …? For if one is adored [by mistake] for another that is delusion, and if one is adored that should never have been adored, that is madness.' *Libri Carolini* IV, 21, Freeman, *Opus Caroli regis*. The translation is Freeman's (1994), p. 165.
27 On this theme in a more general context see Chazelle (1993), esp. pp. 55 ff.
28 See the discussion in Cormack (1997), esp. pp. 94–5 and pp. 128–30.
29 It may also have been a concern of the *Libri Carolini*. Auzépy (1997, pp. 292–3) suggests that one of the purposes of the *Libri Carolini* was to expose the written sources used by Nicaea II as fallacious.
30 Anastasios of Sinai, *Hodegos* XII.3, *PG* 89, col. 198. See also the discussion of this passage in Kartsonis (1986), pp. 40–63.
31 Mansi, *Sacrorum conciliorum* 13, cols 184D–185A, 189C for example. Partial translation available in Mango (1972), pp. 153–4.
32 Cameron and Herrin (1984), ch. 47, pp. 124–5. The *Parastaseis* is a problematic text for, as Cameron and Herrin explain, it is not clear exactly when it was written, by whom, or for what purpose. It has been described as an Iconophile text, which sets out to contrast beneficent Christian images with dangerous pagan statues which bring death and destruction to those around them (see Kazhdan 1987). Equally, it could be seen as an Iconoclast text which shows how Christian and pagan images share the same powers and are thus equally idolatrous (see James 1996, p. 16).
33 Leontios de Neapolis (1974), pp. 96–7, and Maguire (1995) pp. 62–3.
34 Meyer, Smith and Kelsey (1999) translate a variety of magical spells which share a formulaic use of words, with repetitions of names and phrases, repeated letters decreasing in number and considered patternings on the written surface, often interwoven with symbols and images.
35 Described in more detail in Maguire (1996), pp. 119–20.
36 The trisagion and 'Lord, save!' are particularly popular incantations. See Russell (1995), esp. pp. 37–42.
37 This is described and pictured in Maguire (1996), p. 123 and fig. 107.
38 Papalexandrou (2001) looks at Byzantine monumental inscriptions in the context of the 'non-rational' uses of writing.
39 Maguire (1994) illustrates this with examples from papyri laid out in various 'ornamental' ways.
40 See for example, Cameron and Herrin (1984), ch. 64, pp. 140–47 with its account of the debate between seven philosophers over the meanings of statues in the Hippodrome.
41 See Clanchy (1979), especially on how legal matters were oral rather than written and on the role of seals as visual images securing a statement.
42 In this context, I wonder how far McKitterick's discussion of the hierarchy of texts in Carolingian culture is also about the magical power of the symbol of the written letter to the viewer who might be unable to recognize the words (McKitterick, 1990, esp. pp. 301–4).
43 Goodman (1968), p. 25 and discussed in Camille (1985), p. 43 and n. 78.
44 On word and image serving parallel functions, see James and Webb (1991). On the medieval imagination and its interaction with spirituality, see the interesting work by de Nie (1987) and (1998).
45 Indeed, as Freeman (1994: p. 171), has suggested, a distinction may lie between 'word' and 'words': Theodulf may believe only in the power of the Word of God. Theodore the Studite declared that an image and its caption could not be separated and that both deserved veneration. *Antirrheticus against the Iconoclasts* I, 14, *PG* 99, cols. 344D–345B.

References

PRIMARY SOURCES AND TRANSLATIONS

Cameron, A. M. and Herrin J. (eds), (1984), *Constantinople in the Early Eighth Century: The Parastaseis syntomoi chronikai*, Leiden: Brill.

Davis-Weyer, C. (1971), *Early Medieval Art 300–1150*, Toronto: University of Toronto Press.

Hennephof, H. P. (1969), *Textus Byzantini ad iconomachiam pertinentes*, Leiden: Brill.

Hrabanus Maurus, *Carmina*, ed. E. Dümmler, *MGH Poet*, II.

John of Damascus, (1980), *On the Divine Images: Three Apologies against those who attack the Divine Images*, trans. D. Anderson, New York: St Vladimir's Seminary Press.

Libri Carolini: A. Freeman (ed.), (1998), *Opus Caroli Regis Contra Synodum (Libri Carolini)*, *MGH, Concilia, Tomus II, Supplement I*, Hannover: Hahnsche.

Leontios de Neapolis (1974), *Vie de Syméon le Fou*, ed. A. J. Festugière, Paris: Librairie Orientaliste Geuthner.

Mango, C. (1972), *Art of the Byzantine Empire 312–1453*, Toronto: Prentice-Hall.

Mansi, J. D. (orig. 1901–27, repr. 1960–61), *Sacrorum conciliorum nova et amplissima collectio*, vols 12 and 13, Paris and Leipzig; repr. Graz: Akademische Druck-u.Verlagsansalt.

Meyer, M. Smith, R. and Kelsey, N. (eds) (1999), *Ancient Christian Magic: Coptic Texts of Ritual Power*, Princeton: Princeton University Press.

Sahas, D. J. (1986), *Icon and Logos: Sources in Eighth Century Iconoclasm*, Toronto: University of Toronto Press.

Theodore the Studite (1981), *On the Holy Icons*, trans. C. P. Roth, New York: St Vladimir's Seminary Press.

SECONDARY SOURCES

Auzépy, M.-F. (1997), 'Francfort et Niceé II', in Berndt, R. (ed.), *Das Frankfurterkonzil von 794*, vol. 1, Mainz: Selbstverlag der Gesellschaft für Mittelrheinische Kirchengeschichte, pp. 279–300.

Barber, C. (1993), 'The body within the frame: a use of word and image in iconoclasm', *Word and Image* **9**, 140–53.

Barber, C. (1995), 'From image into art: art after Byzantine Iconoclasm', *Gesta* **34**, 5–10.

Barnard, L. (1977), 'The theology of images', in Bryer, A. A. M. and Herrin, J. (eds), *Iconoclasm*, Birmingham: University of Birmingham, pp. 7–14.

Brady, G. (1936), 'Faux et fraudes littéraires dans l'antiquité chrétienne', *Revue d'histoire ecclésiastique* **32**, 5–23 and 275–302.

Brown, P. (1973), 'A Dark Age crisis: aspects of the Iconoclastic controversy', *English Historical Review* **88**, 1–34.

Brubaker, L. (1989), 'Perception and conception: art, theory and culture in ninth-century Byzantium', *Word and Image* **5**, 19–32.

Brubaker, L. and Haldon, J. (eds) (2001), *Byzantium in the Iconoclast Era (c680–850)*, Aldershot: Variorum.

Bryer, A. A. M. and Herrin, J. (eds) (1977), *Iconoclasm*, Birmingham: University of Birmingham.

Cameron, A. M. (1992), 'The language of images: the rise of icons and Christian

representation' in Wood, D. (ed.), *The Church and the Arts*, Studies in Church History 28, Oxford: Oxford University Press, pp. 1–42.

Camille, M. (1985), 'Seeing and reading: some implications of medieval literacy and illiteracy', *Art History* **8**, 26–49.

Chazelle, C. M. (1986), 'Matter, spirit and image in the Libri Carolini', *Recherches Augustiniennes* **21**, 163–84.

Chazelle, C. M. (1990), 'Picture books and the illiterate: Pope Gregory's letters to Serenus of Marseilles', *Word and Image* **6**, 138–53.

Chazelle, C. M. (1993), 'Images, Scripture, the Church and the *Libri Carolini*', *Proceedings of the Patristic, Medieval and Renaissance Studies Conference* **16/17**, pp. 53–76.

Chazelle, C. M. (1995), '"Not in painting but in writing": Augustine and the supremacy of the word in the *Libri Carolini*', in English, E. D. (ed.), *Reading and Wisdom: The* De Doctrina *of Augustine in the Middle Ages*, Notre Dame, Ind.: University of Notre Dame Press, pp. 1–22.

Chazelle, C. M. (2001), *The Crucified God in the Carolingian Era: Theology and Art of Christ's Passion*, Cambridge: Cambridge University Press.

Clanchy, M. T. (1979), *From Memory to Written Record: England 1066–1307*, London: Arnold.

Cormack, R. (1997), *Painting the Soul: Icons, Death Masks and Shrouds*, London: Reaktion.

Foucault, M. (1973), *Ceci n'est pas une pipe*, Montpellier, and trans. and ed. J. Harkness, *This is not a pipe*, Berkeley: University of California Press, 1982.

Freeman, A. (1957), 'Theodulf of Orleans and the Libri Carolini', *Speculum* **32**, 663–705.

Freeman, A. (1985), 'Carolingian orthodoxy and the fate of the *Libri Carolini*', *Viator* **16**, 65–108.

Freeman, A. (1994), 'Scripture and images in the *Libri Carolini*', *Testo e immagine nell'altro medievo* **41**, 163–88.

Gero, S. (1973), 'The *Libri Carolini* and the image controversy', *Greek Orthodox Theological Review* **18**, 7–34.

Goodman, K. S. (ed.) (1968), *The Psycholinguistic Nature of the Reading Process*, Detroit: Wayne State University Press.

Haldon, J. F. (1990), *Byzantium in the Seventh Century*, Cambridge: Cambridge University Press.

Herrin, J. (1989), *The Formation of Christendom*, London: Fontana.

James, L. (1996), '"Pray not to fall into temptation and be on your guard": Pagan statues in Christian Constantinople', *Gesta* **35**, 12–20.

James, L. and Webb, R. (1991), '"To understand ultimate things and enter secret places": ekphrasis and art in Byzantium', *Art History* **14**, 1–17.

Kartsonis, A. (1986), *Anastasis: The Making of an Image*, Princeton: Princeton University Press.

Kazhdan, A. P. (1987), Review of Cameron and Herrin (eds), *Parastaseis*, *Byzantinische Zeitschrift* **80**, pp. 400–403.

Kazhdan, A. P. et al. (eds) (1991), *The Oxford Dictionary of Byzantium*, Oxford: Oxford University Press.

Kessler, H. L. (1994), '"Facies bibliothecae revelata": Carolingian art as spiritual seeing', *Testo e immagine nell'alto medioevo* **41**, 533–94; repr. in H. L. Kessler, *Spiritual Seeing*, Pennsylvania: University of Pennsylvania Press, 2000, pp. 149–89 and 239–53.

Kitzinger, E. (1954), 'The cult of images in the age before Iconoclasm', *Dumbarton Oaks Papers* **8**, 83–150.

Ladner, G. B. (1953), 'The concept of the image in the Greek Fathers and the Byzantine Iconoclast controversy', *Dumbarton Oaks Papers* **7**, 1–34.

Louth, A. (2002), *St John Damascene: Tradition and Originality in Byzantine Theology*, Oxford: Oxford University Press.

McCormick, M. (1993), 'Textes, images et iconoclasme dans le cadre des relations entre Byzance et l'Occident Carolingien', *Testo e immagine nell'alto medievo* **41**, 95–162.

McKitterick, R. (1990), 'Text and image in the Carolingian world', in McKitterick, R. (ed.), *The Uses of Literacy in Early Medieval Europe*, Cambridge: Cambridge University Press, pp. 297–318.

Maguire, H. (1994), 'Magic and geometry in Early Christian floor mosaics and textiles', in Hörandner, W., Koder, J. and Kresten, O. (eds), *Andrias: Herbert Hunger zum 80. Geburtstag, Jahrbuch der Österreichischen Byzantinistik* 44, pp. 265–74.

Maguire, H. (1995), 'Magic and the Christian image', in Maguire, H. (ed.), *Byzantine Magic*, Washington: Dumbarton Oaks, pp. 51–72.

Maguire, H. (1996), *The Icons of their Bodies: Saints and their images in Byzantium*, Princeton: Princeton University Press.

Martin, E. J. (1930), *A History of the Iconoclastic Controversy*, London: SPCK.

Nelson, R. S. (2000), 'To say and to see: ekphrasis and vision in Byzantium', in Nelson, R. S. (ed.), *Visuality before and beyond the Renaissance*, Cambridge: Cambridge University Press, pp. 143–68.

de Nie, G. (1987), *Views from a Many-windowed Tower: Studies in the Imagination of Gregory of Tours*, Amsterdam: Rodopi.

de Nie, G. (1998), 'Seeing and believing in the Early Middle Ages: a preliminary investigation', in Heusser, M. et al. (eds) *The Pictured Word*, Word and Image Interactions 2, Amsterdam: Rodopi, pp. 67–76.

Noble, T. F. X. (2001), 'The varying roles of Biblical testimonies in the Carolingian image controversy', in Cohen, E. and de Jong, M. B. (eds), *Medieval Transformations: Texts, Power and Gifts in Context*, Leiden: Brill, pp. 101–19.

Papalexandrou, A. (2001), 'Text in context: eloquent monuments and the Byzantine beholder', *Word and Image* **17**, 259–83.

Parry, K. (1989), 'Theodore Studites and the Patriarch Nicephoros on image-making as a Christian imperative', *Byzantion* **59**, 164–83.

Russell, J. (1995), 'The archaeological context of magic in the early Byzantine period', in Maguire, H. (ed.), *Byzantine Magic*, Washington: Dumbarton Oaks, pp. 35–50.

Speck, P. (1978), *Kaiser Konstantin VI*, vol. 1, Munich: Fink.

Wallace-Hadrill, J. M. (1983), *The Frankish Church*, Oxford: Clarendon Press.

Naming names and shifting identities in ancient Egyptian iconoclasm

Penelope Wilson

Naming names

The study of iconoclasm in Ancient Egypt is beset by problems of definition, especially in the imposition of a 'western' Christian definition on an ancient culture with a different cultural agenda and different world or cosmic view.[1] There are, however, good examples from Egypt of what might be readily recognised as iconoclasm and others that might expand the modern definition. Egyptologists themselves have tried to classify the various aspects of iconic damage and deliberate mutilation in Egypt (Brunner-Traut, 1982), but it seems that any rigid classification might overlook an important area of concern to the Egyptians themselves. In fact there is a complex spectrum of reasons for image and text mutilation in Ancient Egypt that goes beyond the narrow meaning implied by a dictionary definition. There are also varying methods, degrees and techniques of achieving image change or removal, revealing a complex synergy of ideological emphases.

The image of Ancient Egypt is defined for us by its images, whether they are monumental sculptures of kings, reliefs from the tombs of royal officials or even the pictograms and hieroglyphs that comprise the Egyptian writing system. Indeed, the relationship between 'image' and 'text' is a very close one. This triangle of communicative media often functions together to determine and identify each member. It is difficult to separate one particular mode of image destruction from another, although there has been an emphasis by Egyptologists on studying three particular areas of iconoclastic activity in Ancient Egypt (Schulman, 1969–70, pp. 36–7; Björkman, 1971; Der Manuelian, 2000)[2]:

1 Obliteration of names and usurpation of cartouches containing kings' names from inscriptions on tombs and monuments

2 The dismantling of buildings and often the reuse of structures or building materials

3 A full *damnatio memoriae* to efface the memory and existence of persons from contemporary minds and those of posterity by the systematic destruction of their names, likenesses and monuments. The implications this might have for the afterlife of a person constituted a drastic, rather shocking action in the mind of an Ancient Egyptian.

Sometimes different forms of iconoclastic activity can be visited on the same monument or image over a period of time. The lifespan of Egyptian images creates a problem for us in discerning what is ancient iconoclastic activity from the Pharaonic period, as opposed to Christian iconoclasm of what was regarded as pagan imagery in the period after the third century AD, or Islamic and modern attention to the monuments. To some extent this problem can be solved by careful examination of the context of the iconoclastic damage, or by the physical position of the damage. For example, careful removal of textual references must have been undertaken by at least semi-literate Egyptians (Der Manuelian, 2000, pp. 295–6), implying that a contemporary iconoclast did the damage. If a tomb was inhabited by later Egyptians, then they are more likely to have targeted the images, being unable to read the texts, and if the floor level was different due to the build up of rubbish, then the level of the damage might reveal it was done at this later date. If the damage is partly cut into smoke covered images, again this would imply that the damage is later. If there is explicit Christian imagery of the cross cut into images or Arabic graffiti then this can be compared to the image damage for similarity in technique. There is still much work to be done in examining the layered contexts of iconoclasm in Egypt as a whole.

The cases of Hatshepsut and her chief steward Senmut (Dynasty 18, c.1498–1483 BC) and that of Akhenaten and the city of Akhetaten (Tell el-Amarna, Dynasty 18, c.1350–1334 BC) are usually cited to demonstrate the extremes of the process (Schlott, 1989, pp. 211–14; Schulman, 1969–70), but they are examples of complex processes at work, often over long periods of time, executed by different groups of people, perhaps for different underlying reasons. Serious analysis requires a definition specific to the function and relationship of 'image', 'text' and 'building' within the Egyptian conceptual framework, so that the degrees of iconoclasm can be understood.

In broad terms it seems that in an Egyptian monumental context, 'image' and 'text' are essentially to be regarded as inseparable components of the same thing (Posener, 1946, p. 56). Images act as determining pictures for the texts they accompany, especially if they accompany the actions of an individual or record a list of epithets. Text acts as explanatory labels for the scenes depicted on walls and for conferring individual identity on statues

and relief representations. The removal of either, or of both, is therefore essentially the same act – taking away the identifying marks, be they images or textual labels. The difference is that for two dimensional images, statues and names in cartouches, the exciser of such things did not necessarily have to be literate. In this case the damage could be done on a larger scale, whereas more subtle removals of names within texts, where they are not otherwise highlighted, suggests that someone sufficiently literate, probably a scribe or official, had to go through the text and mark up the elements to be removed. In the tomb of Ramose, for example, texts on the east wall were daubed with a purplish wash as a guide for the excisers (Davies, 1941, p. 4, n. 2). This suggests a more careful and deliberate process. On balance it seems that the process of removing the naming hieroglyphs may have had more weight. Ultimately this may derive from the 'magical' power latent in pictures when used as writing.

The most powerful expression of this power is in the suppression or mutilation of 'living' hieroglyphs in the funerary Pyramid and Coffin Texts. In the former case complete human figures used as hieroglyphs are not written in the royal Old Kingdom pyramids, or a complete figure could be replaced by part of a figure,[3] as, for example, where the head and shoulders of a standing man replaced the entire figure. In more extreme cases the human figures could be replaced with single strokes or a sign of something completely different with a similar phonetic sound. Even animal signs are usually changed or mutilated with a knife or spear (Ritner, 1993, pp. 163–7 and fig. 14), while signs in the shape of fish are avoided altogether; bird-signs are, however, usually left intact (Lacau, 1913). Presumably these were not deemed to be so dangerous. This caution, which also seems to have been extended to the burial chambers of private officials, reached an extreme degree in the tomb of Seshem-ib near the Pyramid of Unas at Saqqara and in four tombs at Heliopolis, all of Old Kingdom (Dynasty 5–6) date. In these places human figures were suppressed or cut in two, animal signs were suppressed or mutilated and in the title 'servant of the god', the sign writing god (a flag-pole with flag) was not written. Evidently the scribes working in these tombs were very careful to protect the deceased from the power of the hieroglyphs and what they represented (Lacau, 1926; Kammerzell, 1986).

Similar changes were made much later in the Temple of Esna, where surviving texts date from the Roman period. Here there seems to have been a deliberate and methodical destruction of the faces and hands of certain signs showing people, gods, animals (especially serpents) and birds. These signs had been carefully picked away with a metal tool. 'Fertility' signs such as the belt of Isis, male phalluses, the genitalia of gods and nursing signs had also suffered damage. It is not clear if this was to expunge them or because they were deliberately touched to impart their power to those seeking help

for infertility. The child hieroglyph showing an infant with his finger to his mouth was indeed often not mutilated but rather gouged out, so that powder from the building would be useful in potions or amulets (Sauneron, 1968, pp. xxiv–xxvi).

Magical texts attach a very strong importance to naming names, which is the basis of the story of Isis and the names of Re. The goddess of magic tricks the sun god Re into revealing to her his 'secret' name which makes her the 'Greatest of Magic', wielding ultimate power over the poison of scorpions.[4] The major trials of those who committed crimes against the state in Dynasty 20 do not record the real names of the criminals but give them alternative names which suggest their villainy. For example, in the Harim Conspiracy against Ramesses III the conspirators are listed as 'Re hates him', 'Bad man in Thebes', 'Re blinds him', 'Cut off the ear', 'Penhuy the bad' and 'The Demon', presumably bowdlerizations of the real names such as 'Re loves him', 'The good man in Thebes' and so on (Posener, 1946, pp. 52–3). In magical rituals, execration figures of enemies could be made of wax or clay and the names of the enemy then written or inscribed on the figure. When the image was destroyed by smashing, or burning or burying it, the person concerned would suffer accordingly (Ritner, 1993, pp. 173, 185). Together, then, image and name were the totality of representation, but each was powerful in its own right.

Removing text and image: methods

An inscription from Coptos sets out the ground rules for this procedure. This text from the reign of Intef Nubkheperre in Dynasty 11 describes the punishment for anyone 'harbouring enemies' in the temple at Coptos. In order for the name of the person and his son and heirs to be forgotten: 'Remove his writings from the Temple of Min, from the Treasury, in every scroll likewise', presumably referring to every occurrence of his name (Petrie, 1896, p. 10, pl. VIII, 6–7; cf. Edel, 1970, Abb.1A and pp. 12–13).

This allusion to the removal of names is made explicit by Akhenaten in his Boundary Stela inscription: the inscription:

shall not be obliterated. It shall not be washed out, it shall not be hacked out, it shall not be (white)washed with plaster. It shall not go missing. If it does go missing, if it disappears, or if the tablet on which it is falls down, I shall renew it again as a new thing in this place where it is.

(Murnane and Van Siclen, 1993, text p. 96, trans. p. 103)

The text summarizes the ways in which names were removed and replaced at Tell el-Amarna: either ink inscriptions were washed off, or stone ones were

eroded, chipped out and plastered over so that the plaster could be re-inscribed. Many examples of such types of damage are evident from Egypt, while there is also evidence for the restoration of inscriptions and images.

Removing text and image: rationale

In cases where the images themselves were singled out for mutilation, it is interesting to examine the areas of the images which were actually removed. There is a high proportion of instances where the profile of the face is attacked with the eye(s) of figures usually singled out for removal. It has been suggested that such things were done in tombs because people who lived in the tombs long after the end of the culture which created them felt the need to remove the seeing eyes of the images and any harm which might come from them. This argument was applied specifically to Coptic (Christian) monks who sometimes used Egyptian tombs as cells for prayer and contemplation. The images, particularly of women, may well have disrupted the contemplations of monks enough to bring about their erasure in the tombs.[5] In the case of the tomb of Nakhtmin and his wife dating from Dynasty 18, there is still some uncertainty whether the destruction meted out to the statues of this man and his wife was the result of political iconoclasm at the time of his fall from grace at court or from the religious iconoclasm of the Christians (Helck, 1982, p. 371). A similar argument has been advanced that the removal of the erect phallus of Min and Amen-Re from temples throughout Egypt was done by Christian Egyptians who prudishly disfigured monuments.[6] Though dating of such damage is notoriously difficult, a study of the types of image change can give a broad clue as to 'pagan' or 'Christian' involvement.

In temples which were converted into churches, such as the Temple of Isis at Philae, there can be a clear distortion of the Egyptian imagery. Ankh-signs are turned into crosses, crosses are carved over the faces of goddesses, faces and bodies of gods were chiselled out and in fact the whole axis of worship in the temple was changed from north–south to east–west by establishing an apsidal niche and altar in the east wall of the hypostyle hall of the Temple of Isis (Porter and Moss, 1939, p. 256). In Edfu temple the images of the gods around the inside of the Enclosure wall had their faces systematically removed and limbs attacked and some of the images of Horus Behedety were inscribed with a cross (Figure 6.1) or the word 'Epiphanios'. The latter may be the personal name of the man sent to do this work, or date from the time of the overthrowing of pagan temples in Alexandria by Bishop Epiphanius in the late fourth century AD (Barnard, 1974, pp. 89-90), or it may even represent the conversion of the pagan images into 'Christianized' versions through the use of this powerful epithet.[7]

Such image defacement, however, seems to have been a long standing practice in Egypt. For example, on the Middle Kingdom (Dynasty 13 or later) stela of Senbuy in the Fitzwilliam Museum,[8] parts of the faces of the figures have been damaged with a chisel, and specifically the profile – the nose and mouth. The eyes of Senbuy and his wife have not been attacked. There is possibly some chisel damage to the left hand and foot of Senbuy and to the arms of his son, Re-Seth. The name of the son is a composite of the sun god Re and that of the god Seth and there is also a chisel mark on the Seth sign in his name. The removal of the man's face, however, raises questions about the motives behind such actions. Though nothing is known of the provenance of this stela, it most likely comes from Memphis, the administrative capital of Egypt. Bourriau suggests, tentatively, that the association with Seth may have led to the proscription of the people on it, but it could equally tentatively be related to some personal vendetta, perhaps contemporary with or dating from soon after the death of Senbuy (Bourriau, 1982, pp. 51–5 and fig. 1). The removal of the nose and mouth suggests a deliberate choice in the defacement, for in the afterlife it was believed that the mouth and nose were needed and ritually 'opened' to allow the deceased to partake of food and air in order to maintain his *ka* (living force) in the afterlife. If the chisel marks to the feet and arms are also deliberate then these too would deny the deceased movement in the afterlife. The attention to the son would mean he would be unable to perform the required cults for his parents to sustain their *ka*s. Further, the attention to the image of Senbuy and not his name suggests that whoever did this defacing was illiterate, otherwise Senbuy's name in the main text on the stela almost certainly would have been removed.

The reign of Akhenaten: iconoclasm as a political and economic tool

The most obvious – and most complex – examples of iconoclasm in Egypt occur during the 'Amarna Period' (*c*.1358–1340 BC). King Amenhotep IV changed his name to Akhenaten, therefore changing his divine allegiance, and moved the religious centre of Egypt from Thebes to a brand new city at Akhetaten in Middle Egypt. Akhenaten is often called the 'heretic king', which has passed as an adequate explanation for the destruction of his capital city Akhetaten, the smashing of his statues, the desecration of his tomb and the removal of his early buildings at Karnak and attack on his images there. In a sense, however, he started it all first, for, at some time in his reign, he sent out the chisellers to remove the name of the Theban and state god Amen from the temples at Karnak, Luxor and throughout Egypt (Figure 6.2). Though they even removed the Amen element from the name of Akhenaten's father, Amenhotep, they were not very systematic about it, for

at Deir el-Bahri the name of Amen was chiselled out from the third terrace of the mortuary temple of Hatshepsut quite thoroughly, but not really elsewhere in the building (Hari, 1985, pp. 15–16). It has also been suggested that in fact the aim of the Amen attack was not necessarily to remove this god but simply to exalt the sun god Re, who was much more closely identified with the Aten sun disk, the focus of Akhenaten's cult. This stems from the fact that at the beginning of Dynasty 18, the Thebans had increased the political power of their local god Amen (and of the new Theban dynasty) by allying him with the Heliopolitan god Re, creating a 'new' state deity, 'Amen-Re King of the Gods' with his cult centre at Karnak in Thebes, and with all the economic and political power of a state god. Thus, the name of Amen-Re comprises two parts; by removing the Amen element, the Re element would be left behind. In this way the Atenists may simply have been reverting to the Re cult, so that though there is still a strong political and religious statement here, it does have a positive purpose. For example, in the tomb of Ramose, the name Amen is removed and Re is left (Davies, 1941, pl. VI; Hari, 1985, p. 15). Looking at the excisions of Amen, it is quite clear that it was intended that *all* occurrences of the name Amen were to be removed whether or not they were paired with that of Re. In one example on the architraves of the sun court of Luxor temple built by Amenhotep III, the name of Amen is removed in its own right, by itself and with epithets, within the cartouches of the king and sometimes with the rest of the epithets in the cartouche (Helck, 1957, pp. 1682–1705).

Presumably all the considerable economic benefits of the produce of temple lands and animals were diverted to the Aten cult, possibly under Akhenaten's direct supervision. This, above all, must have made the Amen priesthood bitter, as they lost their livelihoods and power and could see the erasures as the tangible proof every day that it had happened. The close relationship of 'religious', 'political' and 'economic' power in Egypt meant that a change in one aspect changed the balance in all.

Religious subtlety?

A more subtle kind of iconoclasm is the treatment meted out to Re-Harakhty. In the earliest part of the reign of Akhenaten, while he was still Amenhotep IV, the falcon headed Re-Harakhty is shown in offering scenes with the king. Donald Redford contends that Akhenaten removed the figure of the god and then took his sun disk and gave it arms, thus turning the important disk element into the deity; then the disk was placed over the king's head instead of in front of him, thus turning Akhenaten into the focal part of any offering scenes, with the disk operating over his head (Redford, 1976, pp. 53–6;

Aldred, 1991, pls 27–8). At one fell stroke this got rid of the image of the god and promoted the figure of Akhenaten. This is certainly the most subtle form of iconoclasm Akhenaten introduced at Karnak.

There is also an indication that at Thebes itself aspects of the 'old' cult which were of interest to Akhenaten were extremely carefully inspected and altered if necessary. At the back of the temple of Karnak was a small temple to the goddess Maat, the personification of cosmic harmony and one of the concepts which Akhenaten did not abandon.[9] A stela from the temple set up by the priest Merimaat in the reign of Amenhotep III is well preserved in its upper left quarter where there is an image of and the names and epithets of Maat,[10] but the rest of the stela has been erased. It seems that it once contained a symmetrical image and name of 'the king's wife, hand of Atum' (a clear allusion to the post of the priestess of Amen) (Varille, 1943, pl. LXXV and p. 27). There seems little doubt about the effacement being carried out in the reign of Akhenaten, but because it is so efficiently done, it is difficult to see exactly why. If there were other measures taken in Akhenaten's reign, for example changes in the nature of the rituals at Thebes, in costume or iconography, in religious language used, even in types of festival gifts handed out to the population of Thebes, such things would not have survived in the categories of evidence we have. The erasures and effacements may then be the tip of an iceberg of huge proportions, suggesting a real change in Egyptian court-society and earning Akhenaten the epithet nearly a hundred years later of 'kheru' 'the enemy' or 'the overthrower'.[11]

The removal of the name of Amen also had the side effect of negating the existence of an individual in the damage done to a group of western Theban tomb chapels mostly dating from the reigns of Tuthmose III through to Amenhotep IV. The tombs belonged to high ranking officials serving the king at Thebes and consisted of a usually T-shaped tomb chapel mostly cut into the rocky mountain of the western Theban chain, from which a deep shaft descended to a burial chamber. The shaft was blocked and the burial chamber never intended to be entered again, but the chapel would have been open and relatives would have visited it to share funerary meals for the dead at various festivals throughout the year. A study of one of these tombs shows the typical types of damage here.

The tomb of Amenemhet at Thebes

If our interpretations of the various pieces of damage are accurate this tomb by itself provides an almost complete catalogue of methods of iconoclasm in Egypt. Amenemhet was a scribe at Thebes during the reign of Tuthmose III (c.1483–1450 BC) and his tomb chapel was highly decorated with a repertoire

of scenes dealing with the sustenance of Amenemhet in the afterlife and the performance of his cult. Descending vertically from the chapel was a shaft leading to the burial chamber cut into the rock. The chamber was covered in inscriptions from the so-called Book of the Dead and would have been inaccessible to all but the spirits of those buried in the chamber.

The scenes in the chapel have suffered a considerable amount of damage, perpetrated by different people, at different times, for different reasons. The main problem for the tomb chapel seems to have been its accessibility and closeness to Thebes. The bulk of deliberate defacement in the tomb occurred in the reign of Akhenaten. He had closed down the state cult of the god Amen at Thebes and it seems had ordered that the name of Amen be removed wherever it occurred. Unfortunately for Amenemhet his name means 'Amen is foremost' and so his tomb would have certainly demanded attention.

In the Hall and the south and north passages of the tomb, the name of Amenemhet and those of his family members compounded with 'Amen' were removed. The excisions seem to have been fairly systematic but some instances have been missed, particularly those high up on the wall. Presumably, they could not be seen properly from below or were too high to reach. In one instance the excisers have been too zealous and shown their ignorance. The word for 'to die' in Egyptian is written with the same hieroglyphs as those which make up the name 'Amen' but in a slightly different order. Nevertheless, on the south wall of the passage, one sculptor has removed the word, leaving only its determinative behind. Presumably whoever did this was either illiterate and had been given a limestone flake with the requisite signs upon it, or he was being extremely efficient and removing anything which could be construed as writing 'Amen'. Elsewhere, other gods' names are removed such as that of the goddess Mut, the consort of Amen at Thebes, written with a vulture sign. This sign is also used to write the word for 'mother' and so in Amenemhet's list of his ancestors the sign for 'mother' is ruthlessly removed (Davies, 1915, p. 35, n. 6 and see pl. VII Hall south wall, lower register; Figure 6.3). The plural word for 'gods' was also erased consistently by hammer and chisel in the tomb chapel, as the Atenists sought to deny the presence of more than one main god (Davies, 1915, p. 24).

It seems that these particular deities were deliberately targeted. The images and name of Hathor as the goddess of the west (burial place) were left intact and the name of Hathor occurring in the texts for the Festival of Hathor was also left. Other deities, such as Nut, the sky goddess, also survive intact.

Most curiously of all, throughout the tomb the image of the *Sem*-priest is totally expunged. This priest would normally be the designated heir of the deceased (Schmitz, 1984), usually his son who was responsible for performing the funerary cult of his father and maintaining his *ka* in the afterlife. As he has no 'deistic' implications, other than maybe an

identification with Horus, the son of Osiris, the removal of this figure is difficult to attribute to the Atenists unless they had another, more sinister, agenda. Removing the name of Amen from Amen-emhet would have been bad enough in Egyptian terms, denying Amenemhet identity and life in the next world, but taking out the image of the person responsible for maintaining his *ka* is a complete removal of his ability to exist after death. That would have appalled an Egyptian. It is true that the Aten cult of Akhenaten was not strong on the provision of an afterlife for people, so the Atenists could conceivably have been denying this afterlife.[12]

This damage could also be construed as a personal attack on the image of the son of Amenemhet or on Amenemhet and his life after death. If he or his family were disgraced for some reason, this would be the most effective and potent way of dealing with him for eternity. He could have opposed the agents of Akhenaten and made himself unpopular, or there may be now unknowable personal vendettas at work. In other Theban tombs in the same area but with differing dates, however, similar damage can also be seen, suggesting the *Sem*-priest and what he represents in general is the target. The *Sem*-priest is an obvious target as he usually wears a panther or leopard skin over his body and around his shoulders, with the head and claws of the animal hanging free. Some have suggested that the attack is on the pelt itself, which is often shown with its spots rendered stylistically as stars. In such cases the star sign could also be a graph for the word god, though this is a later practice. It is not, however, just the animal skin which is erased but the whole figure of the person, so it does seem like a more directed attack and indeed it occurs consistently throughout the Theban tomb group. In the tomb of Ramose the priestly destruction is also extended to the lector-priest (though this maybe accidental, expecting the *Sem*-priest to be in this position) and in TT181 a figure with the text 'sem' written next to it is erased (Polz, 1997, pp. 45–6, n. 97). Of all the Atenist activities it is the most interesting and most difficult to understand.[13]

Finally, the faces of most of the female figures and of some of the men in the tomb have been removed. The tomb was used by Coptic monks as a cell during the Christian period and, as Nina Davies suggested, this mutilation was done by the monks, either to remove the 'evil eye' or any possible source of temptation (Davies, 1915, p. 24).[14]

The Theban group

The group of tombs in this exercise of erasures and iconoclastic damage during the reign of Akhenaten includes those of the viziers Rekhmire and Ramose, and Kenamun, Amenhotep Sese, Nebamen and Puyemre. The

reasons for their inclusion may be fairly complex and extend from personal vendetta to the accessibility of the tomb chapels and the deliberate sending of a strong political message to all of Thebes from Akhenaten. Above all, the effect of this programme would have been psychological, going out beyond the temple precincts and into a more private world of 'ordinary' people at Thebes. It sent a strong political message to those Amenists at Thebes and supporters of the Amen-led state cults and could be interpreted as an implied threat of what could happen if there was serious opposition to Akhenaten and his regime. The cruelty of this policy is hinted at in the tomb of the Vizier Ramose. He was vizier in the last years of Amenhotep III and during the transition to Amenhotep IV/Akhenaten. As such his tomb demonstrates the stylistic changes in art between the two reigns. It is presumed that he went to the new capital at Akhetaten, leaving his tomb unfinished; Davies (1941, p. 4) suggests that Ramose himself may even have supervised the erasure of the name of Amen from his own tomb. Certainly the care with which the erasures in this tomb are carried out suggests that someone took the time to pick up on every single possible reference to Amen, including the removal of images of geese, for the goose was one of the sacred animals of Amen (Davies, 1941, pl. XVI). The removal of vulture signs is also carried out here, but the sign was carefully picked out from the writing of the word for 'horses' where it has phonetic value (Davies, 1941, pl. VIII). All the erasures were done with a sharp implement which easily took away the delicate raised relief (Davies, 1941, p. 27). In the tomb of Puyemre, the eradication of the signs used to write the word for 'gods' was also extended to similar looking objects being manufactured in a leather working scene (Davies, 1923, vol. I, p. 69 and pl. XXIII).

The tomb of Rekhmire, however, provides something of a problem in adopting only the idea of an Atenist backlash as an explanation for the damage at this time. Rekhmire was the vizier of Egypt during the reigns of Tuthmose III and Amenhotep II and it is quite clear from the patterns of damages that his name and image were subject to erasure during the reign of Amenhotep III and that the Atenists then had their turn later, in Akhenaten's reign. In fact, different methods were used by the effacers: first, the name and image of Rekhmire and Meryet, his wife, were scratched away on the surface of the walls and then indelible red paint was painted over them; then, second, the Atenists removed the name of Amen, Mut, Karnak (the cult centre of Amen), the word 'gods' and the *Sem*-priest by deep excision (Davies, 1943, vol. I, p. 7). It seems that one must allow for the fact that in the close-knit and turbulent world of Egyptian politics, it was also the afterlife, and not just this life, which could be a focus for removal and denial. Schulman has argued that it is necessary to distinguish carefully between *damnatio memoriae* and iconoclasm and that they are indeed different. The former can clearly be seen

in Egypt, particularly if all the monuments and tombs of individuals are examined together (Schulman, 1969–70, pp. 36–7). For the various reasons suggested above, it seems that such divisions may not have been so clear-cut in the Egyptian mind.

Though individuals may have suffered under the Atenist onslaught, the attack on the god Amen does indeed seem to have been a new aspect of royal control. Previously kings highlighted their devotion to one god over another by royal endowments to temples, rather than by trying to remove them completely. The only other comparable example of this divine iconoclasm is that meted out to the god Seth later.

The case of Seth

There is no doubt that the treatment of the god Seth represents a significant shift in Egyptian cultural life, particularly in attitudes towards the 'outside' world(s). Seth was the god of Qubt (Nagada) in Upper Egypt in the Early Dynastic period. He was later regarded as the representative god of Upper Egypt and in terms of the mythic kingdom one of the elements of kingship. In the reign of Peribsen, this comes to the fore when instead of a Horus-falcon being written over the name of the king, both the Seth-animal and Horus-falcon appear together. The true implication of this is uncertain but it seems to be the first real attempt by a king to fashion the mythic unification of Egypt. For some reason, on the monuments of Peribsen the Seth animal was erased (Petrie, 1901, pl. 31), perhaps during the reign of his successor Khasekehmwy whose name change also alludes to a more dualistic power symbolism. What is not clear is whether Seth in his aspect as a god of chaos had become unacceptable to a stable 'unified' kingdom or whether it was simply the political power faction behind the god, maybe local rulers based at Nagada, who were being attacked and rendered powerless. From an Egyptological viewpoint, the removal of the Seth figures has been seen as an indication that Seth was a 'bad' god, but a study of his representations throughout the Old and Middle Kingdom shows that this view is clearly erroneous. Seth was a necessary corrective part of the idea of duality in Egypt and despite the political indiscretions of the Nagada rulers, this regional centre maintained a Seth cult quite happily.

At the end of the Middle Kingdom the Seth story took a twist when one of the other cult centres of Seth in the eastern delta was occupied by a successful group of entrepreneurs and Eastern Desert peoples known as the Hyksos. Their city Avaris had a cult temple to Seth. The Theban kings who eventually imposed a countrywide rule on Egypt found it easy to equate the Hyksos with chaotic forces, including Seth. For this reason the early New Kingdom

material at Thebes is lacking in representations of Seth. The political importance of the process is underlined by the eventual emergence of a ruling house whose origin was the ancient city of Avaris and whose main god was Seth. After their promotion of the Seth cult in Dynasty 20, no new temples to Seth were built and not even existing temples were restored. Te Velde sees this as indicating a loss of interest in the cult of Seth in Egypt, partly due to the loss of Egyptian power in Asia exacerbated by the invasion of the Assyrians in 670 BC, when Memphis and Thebes were burned and plundered. A resulting active hatred for foreigners led to the demonization of Seth, particularly under Saite rule and after (664–525 BC). The Saite kings had already practised the removal of the names of their predecessors, the kings of Dynasty 25, who were Nubian in origin (Yoyotte, 1951), almost to show how truly 'Egyptian' they were. That the anti-Seth campaign may have been deliberate, with temples being pulled down, may be deduced from texts such as the Papyrus Jumilhac where Horus, 'defeated Seth and annihilated his gang. He destroyed his towns and his districts and he scratched out his name in this land, after he had broken his statues in pieces in all the districts' (Vandier, n.d., P. Jumilhac XVII, pp. 10–11 after te Velde, 1967, pp. 146-7). There is also an example of the conversion of a bronze statue of Seth shown as a warrior into the ram-headed god Khnum by the addition of a pair of curled ram's horns and the shortening of Seth's long squared off ears (Legrain, 1894; Koefoed-Petersen, 1950, p. 51, pls 95–7).[15] The general tenor of the texts in the Ptolemaic temple of Edfu is that here Seth is the enemy *par excellence* with a host of derogatory names (te Velde, 1967, pp. 148–50). A number of magical rituals were devised to deal with him including the 'Cursing Seth' spells which were so potent in magical practices that they persisted into the Hellenistic, Roman and Christian periods. This striking change in Egyptian belief resulted in widespread iconoclasm against this once worshipped god that is one of the most noteworthy differences between Egypt prior to the first millennium BC and thereafter.

Whatever happened to Amen during the Amarna period was apparently instigated at the state level and maybe only affected Thebes to any great extent for a short time. Seth, however, became an anti-icon and truly demonic presence at every level of society and never returned to his former level of acceptance.

Iconoclasm at Akhetaten

There are many examples of name erasures, building changes and image changes at Akhetaten itself, but what does this amount to and is it really iconoclasm? There seems in fact to be a complex but consistent use of the

practice, giving the impression that this kind of behaviour is the norm and that it is only 'apparently' sustained at Amarna because the material has been so well 'preserved'[16] and investigated. It is possible that the kind of layered and all-embracing types of name erasures and image manipulation of royal images was a standard Egyptian practice. The reuse and usurpation of statues and buildings of Amenhotep III by the later kings Merenptah and Ramesses II has never been considered a destructive process per se, to annihilate the memory of Amenhotep III, but perhaps was a means of maintaining links with the past and using the power of ancestor kings. At the very least it was good economic sense in the late New Kingdom (Kozloff and Bryan, 1992, pp. 172–5). In the Roman period, political events changed the naming of the images of emperors in the remaining parts of the Temple of Esna, for example, during the Caracalla–Geta struggle around AD 200 (Sauneron, 1952, pp. 114–17).

The Maruaten

Changes in images and names occurred at Akhetaten during the reign of Akhenaten in the small parkland complex called the Maruaten, lying to the south of the main city areas. Variously described as ritual parklands or sun shade pavilions to which the royal family could retire and keep cool while enjoying the gardens and pools around them, they were closely associated with female members of the royal family (Kemp, 1989, p. 285). The Maruaten seems to have been originally built for a woman called Kiya, a secondary queen of Akhenaten. Sometime during his reign, she disappears from view – either dying or falling out of favour. Her name was removed from wherever it had been carved, including the Maruaten, and was replaced there by the name of the eldest daughter of the king, Meritaten, to whom the ownership of the Maruaten fell. Because the building was eventually dismantled so thoroughly, it is difficult to know the extent to which the name Kiya was removed, but her name was certainly mostly replaced wherever it occurred. Similarly, the coffin from Valley of the Kings tomb 55 may have been originally inscribed for Kiya and then reused for the burial of a young man. This might imply that instead of true usurpation, this is a case of the reuse and recycling of objects and monuments so that they can be used by others. In a country where life expectancy, even at court, was short, this seems to be a sensible way in which to utilize the economic output that would have been required to build monuments and provide funerary equipment.

In addition, places like the Maruaten often have an economic component in that they were endowed with lands, necessary for the upkeep of a cult or

the person who owned the building. In this case there might well be legal reasons why it was necessary to assert the name of the owner, with no chance that any of the economic benefits could revert to the *postmortem* cult of a previous owner. That this kind of usurpation was undeniably regarded as the norm can readily be demonstrated from other periods.[17]

The actual mode of the replacement of Kiya's name and figure is sometimes elaborate but the final result may simply have been a visual effect and clearly was never intended to be scrutinized in detail later. For example, on a column drum the name of Kiya was partly effaced, the plumes of her crown were cemented out and she was turned into Meritaten. In other places, the head of the image of Kiya was patched with cement to become Meritaten and then later the head of Meritaten was removed and the whole figure was covered with cement. In 'improving' the name of Kiya various changes could be made: the name of Kiya was replaced by the name of Meritaten, mottoes (given life) or even the name of the King himself.

The case of a limestone block in the Ny Carlsberg Glyptothek, Copenhagen perhaps best exemplifies some of the detective work needed to follow representational histories.[18] The block comes from Hermopolis, across the river from Akhetaten whence many of the stone blocks dismantled at Amarna were taken to build the temple of Thoth. It shows the head of a woman wearing a special wig, called a 'Nubian Wig', and a large round earring, and in front of her face are the hands of the Aten-disk's sun rays. At first glance it is a very beautiful fragment of an elegant woman, but closer inspection reveals that the shape of her head has been altered by recutting to make it more elongated and the inscriptions behind her head are very lightly cut, identifying this woman as 'king's daughter of his body, his beloved ... Meritaten'. Faint traces of an original inscription apparently can be read: 'the wife and [great] beloved of the King of Upper and Lower Egypt, who lives on [Maat]' which is the first part of Kiya's titulary (Arnold, 1996, pp. 106-7). The alteration of the wig would have been carried out with the help of plaster, now lost, to remove the hair on the forehead and top of the head, and push the skull into an egg shape, so that it would have been shown shaven, with a broad side lock of hair.[19] This transforms the usual wig of Kiya into a side lock of a grown princess and royal daughter. The face of the woman was not changed, but close inspection shows that there is damage to the eyes, mouth and nose. While some damage may have been expected in the removal of blocks to another place, this seems to be deliberate mutilation to the sensitive parts of the body: the eyes to deny visual existence and the mouth and nose to prevent eating and breathing. This attack must have taken place before or during dismantling and before reuse at Hermopolis. Examples such as this are common from Akhetaten, but with such changes taking place in a relatively short time,

each block must be examined carefully to follow its brief and turbulent history.

A limestone block now in the Brooklyn Museum and also from Hermopolis, showing a queen kissing a child, has extensive chisel damage to her name and titles. The queen's eyes and nose are effaced and some random chisel blows occur on her head and near her throat. The child is not marked in any way. This has been interpreted as a block showing Nefertiti with her eldest daughter (Aldred, 1991, pl. 36). In this case the desecration could have happened towards the end of the Amarna period or even during the Ramesside period to erase the memory of the queen. The exact interpretation would depend upon the political conditions at the end of the Amarna period and our imperfect understanding of what is left.

The situation has been neatly summarized by Dorothea Arnold as, on the one hand, casual usurpation in response to a real situation (the death of a person), compared with the more deliberate, planned removal of names which happened late on in the reign of Akhenaten. Arnold suggests that, around Year 12, the royal family at Akhetaten suffered a number of serious losses resulting in increasing instability for the king himself: Tiye, the king's mother and Kiya had died, Meketaten, the second daughter, died and erasure of the names of traditional gods became even more usual. Meritaten had replaced Kiya, Nefertiti may have become co-ruler and Thebes started to express dissatisfaction openly (Arnold, 1996, p. 115). The impression is that there was a measure of panic resulting in the king striking out at tangible things he could change – in this case the names of 'old' gods. It happened at the same time between Years 8 and 12 that the Aten was raised up to become the one and only god. The didactic name of the Aten changed: 'Sun ruler of the Horizon' was substituted for 'Re Harakhty' (the chief designation of the sun god at this time) and the focus of Akhenaten's interest moved from the disk itself to the light from it. The plural word for 'gods' (*neteru*) was removed as well as the names of Amen and his consort Mut (Allen, 1996, p. 4). This theory effectively dates the erasures in the Theban tomb chapels to around Year 9 onwards of Akhenaten, and thus at the beginning of his sole reign (if there was a co-regency of about seven years). It is a reasonable enough theory and, as indicated above, suggests that 'iconoclasm' in Egypt may have been an accepted part of religious ideology and practice but that it could be used ultimately as a political and economic weapon.

It is therefore misleading to examine cases of name erasure in isolation from contemporary political and religious events. When those events are imperfectly or only partially understood it is, of course, even more important that we do not jump to conclusions based on modern systems of classification and the need to organize things into familiar categories. In addition, the changing fortunes and relationships of the royal family members may have

been solely responsible for apparently religious changes. The fluctuating political fortunes of the court therefore have direct ramifications for the symbolic world and the two are closely intertwined. There is no simple way to precisely distinguish these dimensions of Egyptian society.

The dissolution of Akhetaten

The dissolution of Akhetaten was begun after Akhenaten's death with stone blocks being taken to Hermopolis to be used in the construction of temples there during the reigns of Seti I, Ramesses II and Seti II – some 40 or 50 years later. Over 1230 *talatat* blocks were recovered from the western tower of the pylon of Ramesses II, many originally from the Maruaten (Roeder and Hanke, 1969, pp. 1-3). The tiny fragments of the remains of the city attest to destruction and the smashing of hard stones – but it is not clear if this was done as a result of vicious and passionate hatred for Akhenaten. It may have been more efficient and expedient to break up the temples in such a fashion. Some of the work may also have been done later in the Roman period, when limestone was burnt and broken to be used to make mortar, and hard stones were carted away for building elsewhere. This was a far more accessible quarry than most in Egypt. *Talatat* blocks at Karnak were used in rebuilding programmes (Ninth and Tenth Pylons of Horemhab) or buried outside the temple – but this kind of thing had happened before. It is difficult to see at Akhetaten whether or not there was systematic destruction of everything associated with the king. It is true that the temple to the Aten, Royal Residence and peripteral shrines were taken down to their foundations and statues smashed to very small pieces but whether this was because they were targeted for political reasons or for stone, or for both reasons is not completely clear.

At Thebes, the tomb of Ramose had been carved in exquisite low raised-relief, so that in the original attacks on Amen it was easy to smooth off the relief so that the object of the attack was simply obliterated. Later, when some of the Amen names were restored, it was easy to recut the hieroglyphs in deep set relief and sometimes to use plaster to restore damaged areas. The effect was not as seamless as the original relief, but it could have been done fairly quickly. Ramose's tomb, however, also contained images of Akhenaten and Nefertiti and these images and names were chipped out along with the names of the Aten. They were just as totally obliterated as Amen had been before, but the impression given is that the obliteration was meant to be visible and obvious (Davies, 1941, pp. 5, 32 and pls XXXIII, LIII).

In this argument, the silences of the Abydos King List are perhaps more eloquent than the damage at Akhetaten itself. This list records the ancestors

of Seti I back to the 'first' legendary king of Egypt, Menes. Periods of uncertain rule are omitted, as are certain individuals who must have been well known but whose rule is not acknowledged. Among these people are Hatshepsut, Akhenaten and Tutankhamen (Kemp, 1989, p. 22 and fig. 4). The evidence suggests that it was the ultra-pious upholders of the new renaissance era, particularly Ramesses II, who unilaterally sought to suppress what had gone before. Part of the reason may have been that Ramesses paid huge dues to the Amen priesthood (Hari, 1985, pp. 17–18). That the family of this king was not from Thebes but from the Eastern Delta which had itself once been a statelet run by 'Asiatic' kings may have encouraged them to seek out worthy credentials to legitimize their own status as kings of Egypt. They did so at the expense of Akhenaten and perhaps made him an example of how 'iconoclasts' were treated in the Egyptian world view and a scapegoat for their own perceived shortcomings.

Usurpation, negation and denying existence in Ancient Egypt

As already noted 'usurpation' of names and even of buildings is not simply 'iconoclasm' as we might recognise it and it could also have a more positive aspect than may hitherto have been recognized. Certainly the Egyptians themselves justified changing names on monuments to serve their own purposes and must have realized that they could not expect the same thing not to happen to them after their demise. There are numerous examples of this process, while the surviving monuments obviously tend to make modern studies focus more on one area than another.

The changes made by the Egyptians to their images and texts make a broadening of the definition of iconoclasm seem necessary. Such changes should be examined on an individual basis and from an Egyptian point of view in so far as it can be recovered. Inevitably, some things will be lost to us such as the precise reasons for personal attacks, though the evidence is clearly there. Even in areas where the overall nature of the iconoclastic attacks seems clear there is still room for further work, particularly in the reasons behind the removal of the *Sem*-priest images in the Atenist changes. It is clear there are positive effects too from negating names and images, in order that later kings may align themselves with the power of their ancestors and give themselves legitimacy of ruling power through contact with the past. It could equally be the easiest way for rulers to signal changes in power and direction and go as far as a full scale removal of royal power where it was deemed politically expedient. In a civilization where totalitarian rule triumphed and was expressed through the medium of buildings and statues, the surest political weapon and one of the most immediately effective

methods of making high ranking officials toe the line seems to have been this iconoclastic response. It transcends the merely religious sphere of belief and re-emphasizes the control of the ruling powers in both this world and the next.

Acknowledgements

First of all, many thanks are due to the editors of this volume, Anne and Jeff, for their persistence and sterling work. I would like to thank Janet Wilton, AWT, Michael Ackroyd and David Rohl for allowing me to give parts of this paper at a public weekend course and for a chance to visit Luxor. Thanks are due also to Roger Dickinson for suggestions and discussions.

Notes

1. *The Shorter Oxford English Dictionary* defines iconoclasm as 'the breaking or destroying of images; esp. images and pictures set up as objects of veneration'. *Shorter OED*, vol. I, Oxford University Press, 1983, p. 1014. The period under consideration covers the Unified Kingdoms of Egypt between 3100 and 30 BC.
2. Previously: partial modification of a name; replacement of the name; suppression of a name (Posener, 1946, p. 56).
3. In the pyramids of Unas, Teti and Pepi I human forms were deliberately suppressed.
4. 'Myth of the Cunning of Isis' in Papyrus Turin (Rossi and Pleyte, 1869–76, pls 131,12–133,14, 77 and 31,1–5; Pritchard, 1969, pp. 12–14).
5. St Anthony famously resisted various demonic temptations including the forms of women (Griggs, 1990, p. 104).
6. This damage has also been attributed to Atenists (cf. Fischer, 1974, p. 11 and Fischer, 1976).
7. Gnostic literature acknowledges multiple forms and likenesses of the divine, perhaps deriving from the multiple ancient forms of gods. See The Apochryphon of John II, 1, 2 (Robinson, 1988, p. 105).
8. E.SS.37 Fitzwilliam Museum, Cambridge, England.
9. One of Akhenaten's epithets was *ankh em maat*, 'Living in/on Maat' and redefined as the 'principles of divine preservation of the world' (Hari, 1985, p. 13).
10. Inventory number 1722.
11. *pa kheru en Akhet-aten*, 'the enemy of Akhetaten' (Gaballa, 1977, p. 25 and text S124, pl. LXIII). *kheru* may derive from *kher* 'to overthrow' and, in the context of Akhenaten, it may be the nearest Egyptian term to our 'heretic' or even 'iconoclast', thus meaning 'one who overthrows (the order)' (contra Wilson, 1997, p. 745; Erman and Grapow, 1957, III 321 (7)–322 (1) and III 321 (3–5).
12. This is the most potent evidence extant for suggesting that Akhenaten's view of this life and the next totally depended on him and was truly 'different' from orthodox Egyptian thinking.
13. A possible occurrence of a *Sem*-priest at Tell el-Amarna itself in the tomb of Tutu is noted (Davies, *c.*1909, p. 10 and pl. XVI), but cannot be verified.
14. In Theban tomb 56 all the female figures were also expunged by an anchorite.
15. Ny Carlsberg Glyptothek AEIN. 614.
16. The city of Akhetaten, known in the modern day as Tell el-Amarna, was abandoned after the reign of Akhenaten. It has been the subject of scientific work since 1898 (Kemp, 1986, pp. 309–19).
17. Fischer (1974, p. 7, nn. 10–13) records reuses of tombs or monuments which led to a change in the inscriptions or representations.
18. Ny Carlsberg Copenhagen AEIN 1776. There are other instances of this kind of change, for example Metropolitan Museum of Art (New York) 1985.328.8.
19. It is clear that iconography (wigs, adornment and regalia), names and epithets were the only way to recognise 'individuals'.

References

Aldred, C. (1991), *Akhenaten King of Egypt*, London: Thames and Hudson.

Allen, J. (1996) 'The religion of Amarna', in Arnold, D., *The Royal Women of Amarna: Images of Beauty from Ancient Egypt*, New York: The Metropolitan Museum of Art, pp. 3–5.

Arnold, D. (1996), *The Royal Women of Amarna: Images of Beauty from Ancient Egypt*, New York: The Metropolitan Museum of Art.

Barnard, L. W. (1974), *The Graeco-Roman and Oriental Background of the Iconoclastic Controversy*, Leiden: E. J. Brill.

Björkman, G. (1971), *Kings at Karnak: A Study of the Treatment of the Monuments of Royal Predecessors in the Early New Kingdom*, Uppsala: University of Uppsala.

Bourriau, J. (1982), 'Three monuments from Memphis in the Fitzwilliam Museum', *Journal of Egyptian Archaeology* **68**, 51–9.

Brunner-Traut, E. (1982), 'Namenstilgung', in Helck, W. and Otto, E. (eds), *Lexikon der Ägyptologie*, Band IV, Wiesbaden: Otto Harrassowitz, pp. 338–41.

Davies, Nina de Garis (1915), with explanatory text by A. H. Gardiner, *The Tomb of Amenemhet (No. 82)*, London: Egypt Exploration Fund.

Davies, Norman de Garis (c.1909), *The Rock Tombs of El Amarna VI Tombs of Parennefer, Tutu and Aÿ*, London: Egypt Exploration Fund.

Davies, Norman de Garis (1923), *The Tomb of Puyemre at Thebes*, 2 vols, New York: Metropolitan Museum of New York.

Davies, Norman de Garis (1941), *The Tomb of the Vizier Ramose*, London: Egypt Exploration Society.

Davies, Norman de Garis (1943), *The Tomb of Rekh-mi-Re at Thebes*, 2 vols, New York: Plantin P.

Der Manuelian, Peter (2000), 'Semi literacy in Egypt: some erasures from the Amarna period', in Teeter, E. and Larson, J. A. (eds), *Gold of Praise: Studies in Honor of Edward F. Wente*, Chicago: University of Chicago Press, pp. 285–98.

Edel, E. (1970), *Die Inschriften am eingang des Grabes Tef-ib, Siut Grab III*, Wiesbaden: Franz Steiner.

Erman, A. and Grapow, H. (1957), *Wörterbuch des ägyptischen Sprache*, Bd. *1–6*, Berlin and Leipzig.

Fischer, H. (1974), 'The mark of a second hand in Ancient Egyptian antiquities', *Metropolitan Museum Journal* **9**, 5–18.

Fischer, H. (1976), 'An early example of Atenist iconoclasm', *Journal of the American Research Center in Egypt* **13**, 131–2.

Gaballa, G. A. (1977), *The Memphite Tomb Chapel of Mose*, Warminster: Aris and Phillips.

Griggs, C. W. (1990), *Early Egyptian Christianity: From its Origins to 451 C.E.*, Leiden: E. J. Brill.

Hari, R. (1985), *New Kingdom Amarna Period*, Leiden: E. J. Brill.

Helck, W. (1957), *Urkunden der 18. Dynastie*, Berlin: Akademie Verlag.

Helck, W. (1982), 'Nechtmin', in Helck, W. and Otto, E. (eds), *Lexikon der Ägyptologie*, Band IV, Wiesbaden: Otto Harrassowitz, pp. 371–2.

Kammerzell, F. (1986), 'Zeichenverstummelung', in Helck, W. and Otto, E. (eds), *Lexikon der Ägyptologie*, Band VI, Wiesbaden: Otto Harrassowitz, pp. 1359–62.

Kemp, B. J. (1989), *Ancient Egypt: Anatomy of a Civilization*, London: Routledge.

Kemp, B. J. (1986), 'Tell el Amarna', in Helck, W. and Otto, E. (eds), *Lexikon der Ägytologie*, Band VI, Wiesbaden: Otto Harrassowitz, pp. 309–16.

Koefoed-Petersen, O. (1950), *Catalogue des statues et statuettes égyptiennes*, Copenhagen: Fondation Ny Carlsberg.

Kozloff, A. and Bryan, B. (1992), *Egypt's Dazzling Sun: Amenhotep III and his World*, Cleveland Museum of Art and Indiana University Press.

Lacau, P. (1913), 'Suppressions et modifications de signes dan les textes funéraires', *Zeitschrift für Ägyptische Sprache* **51**, 1–64.

Lacau, P. (1926), 'Suppression des noms divins dans les textes de la chambre funéraire', *Annales du Service des Antiquités Egyptiennes* **26**, 69–81.

Legrain, G. (1894), 'Une statue du dieu Set', *Recueil de travaux relatifs à la philologie et à l'archéologie égyptiennes et assyriennes* **61**, 167–9.

Murnane, W. J. and Van Siclen III, C. (1993), *The Boundary Stelae of Akhenaten*, London and New York: Kegan Paul International.

Petrie, W. M. F. (1896), *Koptos*, London: B. Quaritch.

Petrie, W. M. F. (1901), *The Royal Tombs of the First Dynasty II*, London: Egypt Exploration Fund.

Polz, D. (1997), *Das Grab des Hui und des Kel TT54*, Mainz am Rhein: Philip von Zabern.

Porter, B. and Moss, R. (1939), *Topographical Bibliography of Ancient Egyptian Hieroglyphic Texts, Reliefs and Paintings VI Upper Egypt: Chief Temples*, Oxford: Clarendon Press.

Posener, G. (1946), 'Les criminels débaptistés et les morts sans noms', *Révue d'Égyptologie* **5**, 51–6.

Pritchard, J. B. (ed.) (1969), *Ancient Near Eastern Texts*, 3rd edn and supplement, Princeton: Princeton University Press.

Redford, D. (1976), 'The sun-disc in Akhenaten's program: its worship and antecedents', *Journal of the American Research Center in Egypt* **13**, 47–61 and pls IV–XII.

Robinson, J. M. (ed.) (1988), *The Nag Hammadi Library*, San Francisco: Harper & Row.

Roeder, G. and Hanke, R. (1969), *Amarna-Reliefs aus Hermopolis*, Hildesheim: Gebrüder Gerstenberg.

Ritner, R. (1993), *The Mechanics of Ancient Egyptian Magical Practice*, Chicago: University of Chicago Press.

Rossi, F. and Pleyte, W. (1869–76), *Papyrus de Turin*, Leiden: E. J. Brill.

Sauneron, S. (1952), 'Les quelles impériales vues à travers les scènes du temple d'Esné', *Bulletin de l'Institut Français d'archéologie Orientale* **51**, 111–121.

Sauneron, S. (1968), *Le Temple d'Esna: Esna III*, Cairo: Institut Français d'archéologie Orientale.

Schlott, A. (1989), *Schrift und Schreiber im Alten Ägypten*, Munich: C. H. Beck.

Schmitz, B. (1984), 'Sem(priester)', in Helck, W. and Otto, E. (eds), *Lexikon der Ägyptologie*, Band V, Wiesbaden: Otto Harrassowitz, pp. 833–6.

Schulman, A. (1969–70), 'Some remarks on the alleged "fall" of Senmut', *Journal of the American Research Center in Egypt* **8**, 29–48.

te Velde, H. (1967), *Seth, God of Confusion*, Leiden: E. J. Brill.

Varille, A. (1943), *Karnak I*, Cairo: IFAO.

Vandier, J. (n.d.), *Le Papyrus Jumilhac*, Paris: CNRS.

Wilson, P. (1997), *A Ptolemaic Lexikon*, Leuven: Peeters.

Yoyotte, J. (1951), 'Le martelage des noms royaux éthiopiens par Psammétique II', *Révue d'égyptologie* **8**, 215–39.

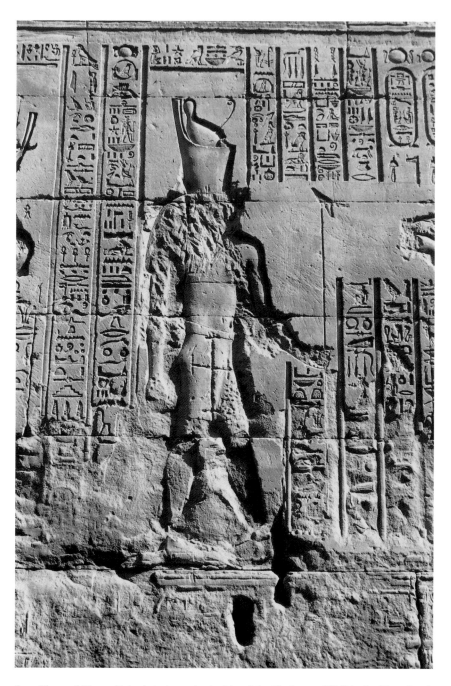

6.1 The god Horus Behedety from the inside of the Enclosure Wall in the Temple of Edfu

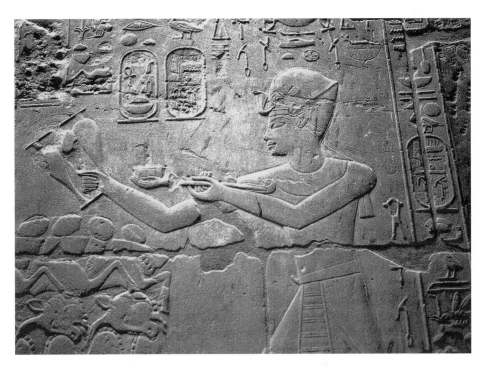

6.2 King Amenhotep III from the Temple of Luxor

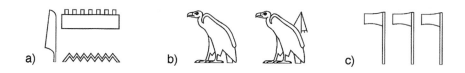

a)

b)

c)

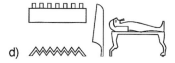

d)

6.3 a) Hieroglyphs for the name of the god 'Amen'
 b) Two varient vulture hieroglyphs used to write the name of the goddess
 'Mut'
 c) The hieroglyphs used to write the plural word for 'gods'
 d) The word for 'to die' 'm-n-i', composed of the same hieroglyphs used for
 the name of 'Amen' except for the last sign

Supplanting the devotional image after Netherlandish iconoclasm

Mia M. Mochizuki

In 1566 a wave of iconoclastic attacks began to sweep through the Northern Netherlands, forever changing the cultural landscape of everything in its path.[1] After peace was established and all offending Catholic paintings and sculpture were removed from the churches, the problem arose of how to decorate appropriated churches for Dutch Reformed Protestant services. One solution was monumental text paintings, images of the Word writ large that functioned as didactic decoration on panels, columns and walls. It was the start of a vibrant, long-lasting form of church decoration that first began to appear in the early decades following iconoclasm and still continues to decorate and be produced for Dutch Reformed churches today, just over four centuries to date. While late medieval Catholic altarpieces utilized a naturalism of renowned clarity to stimulate a worshipper's passionate devotion, these new Dutch Reformed text paintings fundamentally subverted this ideal with a novel visual vocabulary aimed at engaging the viewer in a very different way.

In recent years major scholarly contributions have substantively enriched our understanding of iconoclasm, providing a more textured and nuanced vision of its causes, as well as compelling explanations for the actual process of image breaking in the Habsburg Netherlands.[2] But scant attention has been given to the decoration of essentially Calvinist Netherlandish churches after iconoclasm, the transformation of major sites of worship after religious change.[3] Instead the vague assumption that churches were simply emptied of all art and whitewashed has largely prevailed. The belief that there was nothing in the churches of note led to a concentration of art historical research on the impact of religious reformation on art outside of churches (Veldman, 1995, 1996a and b). If post-iconoclasm church interiors in the Netherlands were examined at all, they were the interiors of Lutheran or hidden Catholic churches (van Eck, 1991 and 1994; Haeger, 1987; Schillemans, 1992). But the interiors of Dutch Reformed churches provide important evidence of the

material consequences of iconoclasm. Moreover, Reformed text paintings were an integral part of Dutch Golden Age visual culture. Yet previously when text in Dutch paintings was explored, interest focused mainly on the appearance of words in seventeenth-century genre scenes and their relationship to cartography and emblem books (Alpers, 1983, pp. 169–221, passim; de Jongh, 1976; Schulze, 1993). So far the most public religious art of this era – the bright, sometimes gaudily coloured, oversized text panels that filled Dutch Reformed churches after iconoclasm – has largely been overlooked. However, these paintings were an extension of the same trends in society that led to the many images of ladies writing, reading and receiving letters, without which any discussion of word and image, literacy or the visual presentation of knowledge during this period remains incomplete.

Following C. A. van Swigchem's pioneering surveys of early modern Dutch Reformed churches, this essay will examine in more detail a sampling of Dutch Reformed text paintings (Van Swigchem 1987 and 1988; Van Swigchem, Brouwer and Van Os, 1984). Although I often refer to the objects as 'text panels' or 'text paintings' as the most literal approximation of *tekstborden*, their purpose is perhaps better encapsulated when they are described as 'paintings of the Word' or 'Word-paintings', since most of them revolve around the Reformed conception of the importance of the Word for the service and the decoration of God's House. Although other texts were used, texts that range from rhetorician-style poetry to memorials to lists of servants of the church, these verbal paintings grew out of the ideals of a specific text, the Bible, as a form of independent ornamentation and it is this text, the Word, that came to dominate and govern the workings of this genre. Text paintings in Reformed churches can be divided into types, such as biblical, memorial and guild paintings. The discrete group of Northern Netherlandish *Ten Commandments* text paintings, which may be considered a subsection of biblical text paintings, will serve in this essay as an introduction to this diverse corpus of material. These paintings of the Law show how artists employed by the Reformed Church reconfigured a subject already current in early sixteenth-century paintings to accommodate Calvin's ideas and thereby produce, quite literally, a fresh formal language for painting. The installation of *Ten Commandments* paintings at specific focal points in Reformed churches then illustrates how new functions were assigned to essentially Calvinist church decoration, signalling the final step in the subversion of the late medieval Catholic devotional image in the public spaces of the Dutch Republic.

Ten Commandments images before iconoclasm

Long before iconoclasm was even a remote possibility in the Netherlands, a panel attributed to the Master of the Magdalena Legend, *c*.1515–25, and currently in the Koninklijk Museum voor Schone Kunsten, Antwerp, depicted a painting within the painting of one of the earliest known examples of a Northern *Ten Commandments* painting (Figure 7.1).[4] The scene shows not only a classic domestic interior, but a home of a special family, the Holy Family, whose model of domestic harmony includes a small house altar in the back left corner of the room. The chest supports two candlesticks and a large panel with a full length portrait of Moses, who displays the stone tablets of the Ten Commandments. The tablets are small, hand-held versions, their writing is not legible and the focus is on the figure of Moses. Not much is known about the decoration or use of home altars in this period, but the Antwerp panel indicates that *Ten Commandments* paintings existed in the Netherlands before iconoclasm and utilized a figural or representational formal language, regardless of the source of inspiration (Veldman, 1995, pp. 230-31). The panel further provides one example of how this subject was depicted in the first quarter of the sixteenth century. Archival records also testify to the existence of early *Ten Commandments* paintings in the Netherlands, even if they are no longer preserved. For example, among the abundant painted decorations in the St Bavo or Great Church in Haarlem before iconoclasm, a *Ten Commandments* panel was recorded already in 1538 as hanging across from the pulpit of the still Catholic church.[5] No other details concerning this painting are known; it was merely mentioned in the course of a discussion on how to protect the pulpit during the construction of vaulting in the nave.

Ten Commandments paintings before iconoclasm were mainly concerned with the figure of Moses and this was also borne out in prints. The earliest graphic work of *Moses with the Ten Commandments* in the Netherlands is a woodcut by the Amsterdammer Cornelis Anthonisz. *c*.1545.[6] Even more than in the Antwerp panel, the figure of Moses, here accompanied by Aaron, receives primacy of place by virtue of his size and the absence of any accompanying text. A later painted Southern Netherlandish *Ten Commandments c*.1560, currently housed in the Museum Catharijneconvent, Utrecht, may be considered a direct artistic descendant of the Antwerp example and provides a sense of how these images looked on the eve of iconoclasm.[7] As in the Antwerp painting, Moses presents the inscribed stones to the viewer, but over the course of the sixteenth century the tablets increased in size, the text became legible and the Ten Commandments themselves usurped the main role, while Moses was consigned to a diminished presence.

These paintings show that although *Ten Commandments* paintings in

churches flourished in the first century (*c.*1566–1672) after the permanent switch to the Dutch Reformed service and many associate the genre specifically with Dutch Calvinists, it is not entirely accurate to think of these panels as an exclusively Protestant phenomenon, since the subject of the Ten Commandments had already begun to appear during the Catholic period, albeit usually represented in figural form. For both Catholics and Protestants Moses was seen as the lawmaker of Israel, the mediator of the Law and the leader in the Old Testament who preceded the coming of Christ (Van Swigchem, Brouwer and Van Os, 1984, pp. 279–81).[8] During the Catholic period this thematic pairing often led to the installation of statues of Moses and Christ together on choir screens, such as those added to the Upper Church, or *Bovenkerk*, in Kampen in 1550. Christ was viewed as the salvation in the New Testament and the one who delivered the promise of the Law to believers. If the Gospel was regarded as the promise of the New Testament, the Ten Commandments was seen as the summary of the Old Testament. Together they told the story of how God made himself known to his people and testified to the importance of recognition in the Christian tradition (Van Swigchem, Brouwer and Van Os, 1984, p. 175). Still further, Veldman has shown that throughout the sixteenth century Old Testament stories were popular not only as general exhortations to lead a moral life, but as exempla of the Ten Commandments, much in line with the Liesveldt Bible's presentation of the Old Testament as the basis for ethical lessons in the conduct of everyday life.[9] Pieter Bruegel the Elder's allegorical representation of *Faith* from the *Seven Virtues Series*, 1559, shows Faith pointing to the Scriptures and wearing the tablets of the Ten Commandments almost like an elaborate hat.[10] Even more so than the Holy Family in the Antwerp panel, the personification of Faith literally lives under and according to the Law of the Lord. Yet despite the shared interest in the Ten Commandments and its ramifications for belief, particularly as a model for daily life, it is safe to assume that well through the mid-sixteenth century most representations of this subject still relied upon figural imagery to express the story and text had yet to assume the authority it would gain in Reformed churches.[11]

The presence of *Ten Commandments* paintings in Catholic churches at least forty years prior to the first outburst of trouble in 1566 is noteworthy because it frames the broader question of how early reformation art began in the Netherlands. Certainly Netherlanders were aware of the theology behind the reformations in Germany and Switzerland in the 1520s, but the early *Ten Commandments* paintings, both in churches and homes, suggest that some of the religious ideas that would come to fruition in later decades had already begun to germinate in the visual vernacular much earlier than previously believed. This was possibly through knowledge of German artists, like Lucas Cranach the Elder, who prominently inserted Ten Commandments tablets in

his *Law and Gospel* paintings first produced in the 1520s.[12] Alternately the paintings might be viewed simply as a direct outgrowth of emerging ideas, a pictorial counterpoint to the contemporary argument for reform then still being discussed within the Catholic Church. After all these early Netherlandish *Ten Commandments* paintings occurred at roughly the same time that Erasmus of Rotterdam posited the textual tradition for just such a role as part of a return to what he considered the purified theology of the early church (Eire, 1986, p. 28). He wrote that true Christians should only execute portraits of God's mind that venerate the Holy Spirit, instead of constructing figural images and statues (Eire, 1986, p. 39). The writings, or *litterae*, were the best 'picture' of God and he stressed the textual and scriptural dimension of incarnation; the Word was not enfleshed but written. The Ten Commandments was the optimal subject by which to present God's image through his writings and return to the basic tenets for leading a good Christian life. Much like the consequences of his other ideas for religious reform, the Erasmian ideal of capturing a verbal portrait of God through the representation of his ideas in place of his physiognomy would plant the seeds for supplanting the late medieval Catholic devotional image and would be of critical importance for church decoration after iconoclasm. The fact that these early *Ten Commandments* paintings, what may be considered 'proto-reformation' art, decorated the walls and columns of still Catholic Netherlandish church interiors for some decades without comment or revolt places these images squarely within the complexity of sixteenth-century religious culture.

Calvin's contribution

When iconoclasm did come to the Netherlands, it was largely inspired by the theology of John Calvin.[13] Calvin's contributions to reformation theology allowed Netherlandish artists to draw upon aspects of earlier, local pictorial traditions and adapt them for the decoration of Reformed churches, providing a doctrinal basis for the appropriation of visual power in post-iconoclasm Netherlandish churches.

Since Calvin wrote that the use of images in the church was acceptable so long as the custom was not abused, decorative painting in churches flourished after iconoclasm.[14] But the representation of divine figures, saints or intercessors was not to be tolerated. According to Calvin figural portraits of God and Christ inverted divine order, blasphemously representing the creator in man's terms. Calvin particularly objected to the *counterfeytsel* or portrait of God, stating, 'it is to be observed that the thing forbidden is *likeness* [to God], whether sculptured or otherwise', and it is 'unlawful to

make any corporeal representation of God' (italics in original; Calvin, 1989, pp. 94, 100). The prohibition against giving God human likeness, a visual blasphemy, was repeated unequivocally and often in his writings. Calvin explicitly equated figural representation of God with idolatry: 'Only let us recollect that God is insulted, not only when his worship is transferred to idols, but when we try to represent him by an outward similitude' (1996, vol. 1, p. 109). By extension, since the human form of Christ neglected to adequately represent his divine side, this longstanding justification for human representation was deemed inappropriate for the new church decoration. Therefore, he wrote, 'the only things which ought to be painted or sculpted, are things which can be presented to the human eye; the majesty of God, which is far beyond the reach of any eye, must not be dishonored by unbecoming representations' (Calvin, 1989, p. 100).

Human representation of the divine was fundamentally irreconcilable with Calvin's belief of 'finitum non est capax infiniti', which understood the spirit of God as infinite, his eternal glory impossible to confine within finite objects, such as the human figure (Eire, 1986, p. 197). The glory of God was best respected as invisible, although it was conceded that God did make rare appearances in the Old Testament in the form of clouds, smoke and fire, but these were all manifestations impossible to confine within set boundaries (Sommer, 1985, pp. 70, 74, 79). Following these ideals figural representations of God should be replaced by a visual language that would deliberately indicate only part of his presence. The ideal of a reflective, synecdochic beauty, rather than a mimetic one, played a key role in the aesthetics of the Reformed church interior, utilizing an alternate model of beauty no longer measured by the painter's virtuoso ability to fool the human eye with a painted simulacrum of the world.[15] Further, Michalski has convincingly argued that the refutation of the 'real presence' in the Eucharist was a central issue in the image debate (1993, pp. 169–80). For Calvinists this was particularly true. The rejection of the physical transubstantiation of the bread and wine into Christ's body and blood was underscored in the aesthetic rejection of figural devotional art. If the presence of Christ in the bread and wine of the Last Supper was only symbolic, rather than literal, the non-figural representation of Christ could indicate the partial presence of Christ, rather than his actual contained Spirit, steering clear of idolatrous worship.

Therefore after figural images were removed from Northern Netherlandish churches, the central question became: how should religious personages be represented without recourse to the human figure? In a remarkably creative manipulation and extension of earlier iconographic conventions in traditional Catholic art, artists replaced the figural physical portraits of God with his Word as an acceptably abstract way of visualizing God. Thus the tablets that were initially held by Moses as a supplementary

attribute, as in the Antwerp panel, expanded to encompass the entire pictorial space often to the total exclusion of Moses. Calvin directed attention to this biblical model when he wrote in a sermon on 2 Samuel:

Notice that there was absolutely no idol or representation of God in it [the Ark of the Covenant], because that would have served to hold the people in superstition; rather, the Law was enclosed in the box. This shows us that God declares himself only in his Word. So when we want to have a living image of him, we must not forge idols of stone or wood or any other material, but we must know him in his Word.

(1992, p. 233)

Through Calvin's writings the Ten Commandments, and by extension other excerpts from the Bible, became the new visual paradigm for representing God's presence. However minimalist and stark these images may be, Calvin warned, 'We must not abuse this simplicity of the Word of God by disdaining it' (1992, p. 235). These ideas were the justification for the substitution of divine figural imagery with text. Calvin's ban on figural imagery of God and his endorsement of the Word were the two most important prerequisites for the decoration of Dutch Reformed church interiors.

Dutch Reformed *Ten Commandments* paintings

The importance of the Ten Commandments was already acknowledged in the Catholic Habsburg Netherlands by the mid-sixteenth century. It only took Calvin's emphasis on the Word to lead to the next logical step: a new formal language whose coin of communication, a truly local vernacular, relied upon a verbal, rather than a figural, vocabulary.

Examples of textual *Ten Commandments* paintings fill post-iconoclasm Reformed churches. A panel by Willem Kruyper in St Steven's Church in Nijmegen presents two pale tablets covered with the Ten Commandments in black writing that occupy three-quarters of the pictorial space in a simple vertical composition (Figure 7.2). The tablets are enclosed in a marble-columned portico and supported on a table with a gilt egg and dart border. Below is a framed excerpt of passages from Matthew. Unlike the Antwerp panel, nary a figure is to be found. The gilded year of completion, 1602, is painted as if carved into the spanner of the table. It completes the play throughout the image of painting versus carved relief and provides an example of a *trompe l'oeil* device, a hallmark of the Dutch Golden Age, applied to non-figural text painting. Images like this underscore the growing importance of architectural ornamentation and the decorative arts at this time. This painting surprises the modern viewer with its bright porcelain colours of roses, ice blues and pastel yellows, a palette more often associated with eighteenth-century Austria than the puritanical black ground and gold

script of the seventeenth-century Dutch Reformed Church. Commissioned by the city of Nijmegen on 7 October 1601 for 153 guilders, a not inconsiderable sum at the start of the seventeenth century, this painting was clearly intended by contemporaries as a significant and independent piece of decoration, marking its distance from the form and cost of architectural inscriptions.[16]

Another example, this time from Harlingen, shows an artist's move outdoors, where he has replaced Kruyper's architectural framing with light-filled airy clouds around two tablets that dominate the pictorial space to the elimination of almost everything but the sky at the top, maintaining an unrelenting focus on the Law. The Hebrew tetragrammaton is substituted for a figural representation of God as the wise man on the throne, much like in the 1535 renovation to Lucas van Leyden's *Last Judgment Triptych, c.*1526–27, which had hung in St Peter's Church in Leiden before iconoclasm and is now in the Stedelijk Museum 'De Lakenhal', Leiden (Freedberg, 1986). The Old Testament name for God in Hebrew, always set in clouds, became an increasingly common model for the textual depiction of God after iconoclasm, the most direct replacement of figure for text.[17] The clouds here reflect the Calvinist belief that the glory of God could not be contained within finite objects. This experimentation with limitless boundaries indicates the way essentially spatial Calvinist metaphors were applied within a painting to show partial divine presence in the human realm. Clouds, fire and other amorphous expressions functioned like the mathematical symbol for infinity, '∞', does today, marking placement with potential and recognizing the limits of accuracy. In the appropriation and extension of spatial metaphors text paintings generally followed more in the representational trail of architectural abstractions, like Gothic number symbolism, than in the footsteps of their painted panel predecessors. And like the Nijmegen painting, the Harlingen panel features lively colours, and both would have originally been placed on a choir screen in the same way a similar early seventeenth-century *Ten Commandments* is preserved on the choir screen of St Peter's Church in Leiden (Figure 7.3).

These few examples only hint at the range of styles Reformed *Ten Commandments* paintings could assume. But what each shared was a solid belief in text as the sole vocabulary of the picture plane at the expense of figural representation. The Bible provided the new pictorial language, text, that was authoritative enough to become canonical and flexible enough to assume many forms. This was the moment when word became image and when text assumed the status of independent subject, much like the emergence of landscape or still-life genres from earlier narrative religious painting. The text of prayers that had been incorporated into devotional images, as illustrated in the Master of Saint-Jean-de-Luze's *Portrait of Hugues*

de Rabutin, Seigneur d'Epiry (?), *c*.1470, in the Musée des Beaux-Arts, Dijon, were expunged as models of worship and church decoration. In this portrait three golden lines of script spiral from the hands of Hugues de Rabutin as he worships a statue of Mary and the Christ Child.[18] But in Reformed text paintings words grew to absorb the entirety of the picture plane. Now words arranged in prayer were no longer merely instruments to reach the divine, but had become independent objects, objects in the sense that they could now be defined as images intended for visual consumption with clear attention to their aesthetic qualities, although in keeping with Calvin's emphases, not necessarily with physical or sensual beauty as a primary goal. Paintings of the Word were texts that became ornaments, texts whose scale and presentation moved their verbal content from the portable, individual world of private devotion to a fixed, didactic decoration in a public forum. The Word was made paint and transformed into an object to be viewed. That these paintings of the Word should indeed be considered a significant form of visual material may be seen from their large numbers, formal qualities, installation and the value with which contemporaries imbued them.

Other Protestant examples of *Ten Commandments* paintings include two from the Reformed Church in Edam, which suggest a particular importance placed on the Law in this city. In a horizontal *Ten Commandments* panel, *c*.1590–1610, two rounded tablets dominate the height of the painting, presenting the Ten Commandments in legible form in the centre of the image (Figure 7.4). But where the Harlingen panel excluded most indications of its environment, the artist of the Edam panel seemed to lavish attention on an almost surreal surrounding landscape. The tablets are balanced on a stone ledge and flanked by two smaller panels on columns. Delicate pink ribbons on the columns flutter in the wind. What is so startling about the Edam picture is the way the tablets of the Law have acquired the naturalistic attributes of conventional representational painting – colour, shadows and setting – but now present the world stage without human habitation. A pastoral landscape and cloudy sky fill the distance, providing a non-threatening, non-idolatrous link to the natural world, a reference perhaps to the second master text, the so-called 'Second Bible' of Nature, in which God's presence revealed itself as much as in the Scriptures (Van Berkel, 2001, p. 137). Above, separate from the main scene, runs a newspaper-like banner from Exodus, which states that God said all these words (*'Godt sprack alle dese Woorden. Exodi XX.'*). The heading underscores the veracity and validity of the painting's message, emphasizing direct authority from on high while recreating a sense of the active performance of rhetorical address, much like a sermon.

Despite the fact that Calvin scornfully disdained the superstition and magic surrounding Catholic sacred images and relics, he did allow for the

supra-human creation of the Ten Commandments, which he described as, 'the two tables which he had written with his own power, without human help' (Calvin, 1992, p. 234).[19] Ornamental frames and sub-divisions consistently called attention to this fact, that the *Ten Commandments* paintings were representations, rather than the original version made by God on Mt Horeb. This was indicated in two ways. First, the external frame emphasized the rectangular shape of the painting (Figures 7.2–7.4). That the rounded tablets of the Commandments were placed in a rectangular frame or format underscored the presence of the human hand in the process of making what was always intended to be viewed as a reproduction of the original. Indeed the framing devices for Word-paintings often recalled the architectural metaphor of a house for God's Word and they used the same ornamental vocabulary seen in contemporary buildings and architectural treatises. Calvinist belief dictated a new role for artifice in the church where indubitably man-made objects would now be preferred over those that claimed divine craftsmanship (*acheiropoeitos*), the latter providing the model for objects of less vaunted authorship that strove for an illusion so complete that marks of a human author were largely erased.[20] For Reformed churches the divine would no longer be represented in man's form, although the role of images as artificial creations made by man would be conscientiously underscored. Naturalistic sirens were thus silenced, while human agency was still recognized.

A second way the proxy status of *Ten Commandments* paintings was reinforced was through internal subdivisions, or formal delineations, that emphatically reminded viewers, should they become too attached to the image, that even God's own original tablets were a recording of his ideas, which were first and foremost a spoken message. 'God spoke all these words' the headings of *Ten Commandments* paintings consistently claim (Figures 7.2–7.4). It was the third-person record of a narrator, rather than the first-person voice of a 'living' frame in the earlier Northern tradition. Frames like those for Jan van Eyck's paintings, which announced the artist's unique authorship, 'Johannes van Eyck made and completed me in the year 1439', became a voice far too reminiscent of 'living idols' just removed.[21] The citations accompanying the claim that 'God spoke all these words', usually Exodus 20:1 or Deuteronomy 5:4–5, showed that the narrator relied upon the most authoritative source of all, sketching a labyrinthine route of radiating echoes back to God's mind. As large quotation marks, these internal frames imbued text with the rhetorical power of announcement, the crystallized words of a permanent preacher hovering weightlessly in space without any of the potential perils of figural sculpture. In these somewhat contradictory ways *Ten Commandments* paintings functioned as forceful arguments both for and against the materiality of images, much like the use of *trompe l'oeil* in the

Nijmegen example. By acknowledging their insistence on the recognition of artifice at the same time that tangible signs were undermined by a spoken message, text paintings were truly products of the ambiguity of the early Reformed Church's position on material form.

In the nave of the same Edam church the Ten Commandments was also painted directly on the wall in the last quarter of the sixteenth century, a technique that perhaps in this case can at least partly be attributed to a pervasive ambivalence to tangible form. This wall painting has been preserved and a reconstructed version added to the church in a recent renovation. The same heading as seen in the more modestly sized panel is visible, but the scale and utter simplicity give the viewer a totally different impression. Arranged in two neat columns of black print with red initial letters on the white wall, the effect of the colour scheme and format is one of a page of the Bible magnified and projected on the wall of the church, the power of the printed page writ large. The pictorial model of the flat surface of a book page, rather than the perspectival recession of a window onto another world, was yet another way to undermine potential idolatry through the negation of a believable three-dimensional material presence. What remains here is the monumentality of its expression, the most clear example of the sheer might of the visual expression of the Word. It is the visual presentation, the scale in this case, of the text towering over the audience that gave the *Ten Commandments* the same power as the exegesis of the Word flowing from the pulpit near by, arguably even more powerful as a permanent fixture.

The *Ten Commandments* images above represent only a small sampling of the genre and although they often differ radically in form from city to city, they nevertheless testify to the need to hone and revise our conception of specifically what Netherlandish iconoclasm was rejecting. The paintings confirm a rejection of images that drew upon sensory response, the hallmark of the late medieval devotional image, as described in Freedberg's *The Power of Images* (1989). Instead text paintings invoked reflection on the tenets of belief and stimulated the viewers' intellect, rather than empathetic sensory responses alone. The verbal paintings did not blur visions and reality, asking viewers to almost smell the incense or myrrh, almost hear the cacophony of the temple, or almost touch the straw of the manger. Human sensory experience and proportions, the common basis for apprehension, measure and representation of the world since ancient times, were no longer appropriate for the Reformed Church audience. The limits of similitude and resemblance for the representation of the divine had been reached. What had started as a debate over transubstantiation resulted in the permanent rejection of an artistic paradigm for the decoration of God's House that had been in practice for long, although sporadically interrupted, periods since

Christianity was first established in the Netherlands over a millennium earlier. But as these examples equally testify, iconoclasm was not so much a blanket rejection of visual power outright, but rather a call for the reconfiguration of late medieval Christian modes of communication between the human and the divine (Eire, 1990, p. 53). It is true that verbal expression was empowered at the cost of earlier pictorial or representational dominance, but certainly not to its exclusion, as is seen in the continued use of pictorial tools and even Calvin's support for the correct use of visual imagery. Sensory response was replaced, but tools like colour, composition and scale, not to mention representational landscape and still-life motifs, harnessed the power of the visual to proclaim the raw energies of the Word. It is even debatable whether these pictorial tools were in a sense more heavily relied upon in the absence of figural imagery now that they were no longer yoked in service to illusion.

Installation

If the appearance of Reformed *Ten Commandments* paintings testified to an innovative formal language, their installation in appropriated Catholic churches only further underscored their commitment to new didactic and decorative roles. By blurring the division of former liturgical zones and reaching new audiences, the function of the late medieval Catholic devotional image was decisively supplanted.

The choir screen, the boundary between the old and new centres of appropriated churches, frequently functioned as an early site for the display of the new belief within the church interior.[22] After the turbulence of iconoclastic attacks in Haarlem, a *Ten Commandments* text panel replaced the Catholic sculpted Calvary scene and large crucifix on the upper beam of the choir screen in the Great Church. In the same place at different times, the Catholic sculpted group and the Reformed *Ten Commandments* panel would have framed the entrance to the choir where now only the support structure for a missing nineteenth-century substitution is visible (Van Swigchem, Brouwer and Van Os, 1984, p. 33). If Catholics usually decorated the space above the choir screen with a crucifix and understood their salvation to be aided by good works and donations to the church, the Dutch Reformed raised *Ten Commandments* panels at this location, attributing their chance of salvation to the grace of God, strong faith and, most importantly, adherence to the Law on earth. The case of the Reformed Church at Weesp provides a comparable example to the transformation that occurred in Haarlem. The Weesp church had a choir screen from *c.*1530, only about fifteen years younger than the magnificent one in Haarlem, in which statues originally

stood.[23] After iconoclasm the statues in Weesp were replaced by panels painted with text on both sides, the Ten Commandments on the front and the Beatitudes from Matthew 5:3–12 on the reverse. The pedestals now supported text paintings in lieu of statues, not only substituting text for figure, but also two-dimensional painting for the more lifelike presence of three-dimensional sculpture, sending a distinctive message with the new decoration of the choir screen.

Pieter Jansz. Saenredam's painting of the *Choir and Southern Choir Ambulatory Seen from the Christmas Chapel in the St. Bavo Church in Haarlem*, 1636, in the Collection Frits Lugt, Institut Néerlandais, Paris, provides some sense of the effect of a new *Ten Commandments* panel straddling the border between nave and choir (Figure 7.5). In Saenredam's painting an elaborately carved frame surrounds a black panel with text painted in a light on dark formula, notably without the figures of Moses. The whole structure functions to magnify the entrance to the choir, which was now more accessible to the public. Saenredam's depiction of the scale of the *Ten Commandments* is consistent with Rem's assertion that the panel was, rather dramatically, approximately the same height as the choir screen itself, the panel competing with the screen's importance through its size and its literal and symbolic surmounting of it (Rem, 1987, p. 21).[24] In large churches, which were often the appropriated main church of a major city, a *Ten Commandments* painting was frequently given this central location on the choir screen, while in modest churches these panels often maintained the pre-iconoclasm connection with the pulpit that was already seen in Haarlem in 1538. But the installation of *Ten Commandments* paintings either above the pulpit or atop the choir screen were governing principles, not rules set in stone, so some churches, like the Reformed Church in Edam, adapted these ideas to their own taste, placing a *Ten Commandments* panel on the choir screen and an additional monumental image of the Law on the wall above the pulpit. However, the twin foci of choir screen and pulpit for installation, or the choice between imprinting the old liturgical centre, the choir, with a new identity or emphatically marking the new core of the service, the pulpit, were no accident. After Reformed appropriation, the nave was dominated by the pulpit and baptismal enclosure, where the Word was preached and baptisms were celebrated. The choir, now relegated to a secondary space in a nave-centred service, was used for the celebration of the Last Supper and marriage ceremonies.[25]

Like many *Ten Commandments* panels, the missing post-iconoclasm Haarlem *Ten Commandments* panel above the choir screen would have been part of a more extensive programme to appropriate the former centre of the Catholic mass under a Reformed stamp. As the viewer approached the choir screen, the Haarlem *Ten Commandments* would have been flanked by two panels with summarized excerpts from the Gospels of Matthew, Luke and

John on the northern and southern pillars which marked the ends of the choir screen. These texts recorded the Beatitudes from the Sermon on the Mount on the viewer's left and admonitions to love thy neighbour on the viewer's right, foreshadowing the benefits to be accrued from living a life according to the Law of the Lord, themes that also were partnered in the Weesp panels. Other common thematic pairings with the Ten Commandments were the Apostles' Creed and the canonical Lord's Prayer, as is known from the Reformed Church in Leur. In this small church three panels painted with text hang on the wall around the pulpit, the *Apostles' Creed* to the left, the *Lord's Prayer* above, and the *Ten Commandments* to the right, the core Reformed triumvirate of 'belief, commandment and prayer' (*geloof, gebod en gebed*) almost embedded into the fabric of the building.[26] In Haarlem the *Ten Commandments* panel would have marked the entrance to the space of the monumental *Last Supper/Siege of Haarlem* structure, the Reformed solution to a Catholic high altarpiece, a striking culmination to the central east–west axis of the Great Church. An oblique view of the Haarlem arrangement in the second half of the seventeenth century is visible in J. A. Berckheyde's *Interior of the St. Bavo Church*, which is now in the Mittelrhein-Museum, Koblenz. With the doors to the choir open, the Last Supper/Siege of Haarlem structure was framed within the portal by the *Ten Commandments* panel above. The major liturgical focus of the Catholic church, the choir, would then be subsumed, reconfigured and marked as Reformed space. Text paintings, having distinguished themselves from the supplementary role of architectural inscriptions to become independent artifacts, were nevertheless still defined by the spaces they decorated, a truly locative form of painting.

Text paintings not only assumed a revised use of images, but also two new audiences: the Dutch Reformed community and the public at large, irrespective of creed. The fresh visual opportunities afforded to the average member of the Dutch Reformed Church were most clearly seen in the redecoration of the choir. Where previously mostly Catholic clergy could regularly enjoy the figural imagery of the choir, now many Dutch Reformed churches used their choirs for the memorial of the Last Supper to which all confessing congregants were invited when it was celebrated four to five times each year. These new viewers were members of the Reformed Church who submitted to the spiritual jurisdiction of their local consistory, and who, thanks to a high literacy rate in the Netherlands, were largely able to read the texts that were no longer written in Latin, but in Dutch. The text paintings visible from within the choir, such as *Last Supper* panels, the *Apostles' Creed* and the *Lord's Prayer*, would then be seen by the entire professing community, not just the spiritual leaders of the church. Outside the choir people of all faiths were encouraged to make the interior of the church part of their daily lives, one reason why *Ten Commandments* paintings were always visible from

the nave, and churches often left their doors open between services to provide space for a wide range of activities, not the least of which was simply strolling. In the nave, transepts and ambulatories, seventeenth-century viewers could stretch their legs, admire the beauty of the architecture and meditate on the meanings of these excerpts from the Bible, frozen in space for contemplation at any time. Due to the position of the Reformed Church as a minority religion among others, particularly in North and South Holland, appropriated main churches of cities were also often centres for the community regardless of religious affiliation (Woltjer, 1994, pp. 17–18).[27] Believers could then reflect on the tenets of Dutch Reformed theology in the company of Roman Catholic, Lutheran, Mennonite and Jewish residents, all of whom passed through the church in the course of the day. The audience for the Ten Commandments was now a broad public bound by a common interest in local society and religious traditions that shared a common biblical basis (Schutte, 1992, p. 37).

The installation of the *Ten Commandments* panels and their new intended audience underscored a radical new vision of painting as decorative instruction – to articulate faith and reiterate biblical tutelage – rather than to recreate passionate devotion and stimulate idolatry. These paintings were meant to be seen, read and understood. This may be deduced by the often large scale of the text paintings, their central placement, their choice of Dutch language, their use of explicit citations, and the clear calligraphic hand in which they were written. In practice this meant that by passing under the *Ten Commandments* panel, the viewer left the predominantly preaching and meditative areas of the church and entered the realm of the Last Supper. The Word of the Lord was announced at the pulpit, the Law of the Lord for daily life, the Ten Commandments, was submitted to and passed under at the transom of the choir, and the Last Supper commemorated the radiation of the truth of the Word. The *Ten Commandments* panel was the glue between the announcement of the Gospel and its memorial. After partaking in the Last Supper, the congregant would then recite the Apostles' Creed or Lord's Prayer, the canonical texts of faith most likely on the reverse of the *Ten Commandments* panel, en route to exiting the choir. Installation was not only important in terms of imprinting old and new spaces with a Reformed identity and drawing the attention of new viewers, but also the prime indication of decorative functions replacing devotional ones, the final shift away from the paradigm provided by the late medieval devotional image and the peculiarities of the visual power it invoked. If the late medieval Catholic ideal of devotional art was modelled on visions where the spiritual became incarnate, Dutch Reformed church decoration followed the paradigm of Moses and the burning bush, where the eternalness of the divine was only partially indicated through spatial metaphors and special locations.

The viewer's movement through the church was no longer an empathetic reenactment of Christ's last journey to the cross, the denouement of the story, but now paralleled the climbing of Mt Horeb to perceive a fleeting glimpse of God's majesty through the Word with all the hope of a fresh beginning under God's Law in the new Jerusalem of the young Dutch Republic.

Altarpieces and statues were often damaged or destroyed during iconoclasm, and in the period that followed the resulting church decoration, if recognized as existing at all, was commonly viewed as of little consequence. Yet iconoclasm can be seen as a catalyst for the complete overhaul of a specifically Netherlandish devotional art from whose formal compositions astonishingly creative and intellectually beautiful solutions were wrought in accordance with a new theology. This was no less than the momentous shift from visual to verbal images, sensual to intellectual art and the newfound pre-eminence of language, above the plastic arts, as the medium of the imagination (Eire, 1986, p. 41). It was not the divorce of art from religion, as is often believed, but a profound revitalization and redefinition of religious art, to express a new concept of divine presence predicated on human and divine boundaries over figural efficacy. By leavening the regional tradition of early Netherlandish painting with the ideas of Erasmus and Calvin, artists working for the Dutch Reformed Church produced a national decoration for churches, as illustrated by *Ten Commandments* text paintings, that was in equal parts typically Netherlandish and distinctively Reformed. Text paintings were both more and less radical than they may initially appear – more radical in their insistence on the total elimination of the human figure from pictorial space, but less extreme in their building on themes already long present in religious culture. With Dutch Reformed text paintings, the form, location, audience and function of the late medieval devotional image was decisively overthrown. Word replaced figure, nave superseded choir, public access prefaced private entitlement, didactic lessons trumped devotion and the Word as a legible object silenced the netherworld of visions. When the fervour of iconoclasm had cooled in the Northern Netherlands a radically different church interior emerged in its wake.

Notes

1 Iconoclasm erupted in the Netherlands in 1566, but attacks continued sporadically well through 1581. This essay is based upon parts of my unpublished Ph.D. dissertation, 'The reformation of devotional art and the Great Church in Haarlem', Yale University, 2001.
2 Baxandall, (1980); Besançon (2000); Belting (1994); Bredekamp (1975); Eire (1986) Eire (1990); Filedt Kok, (1986); Freedberg (1988 and 1989); Gamboni (1997); Koerner (1993); Michalski (1993); Moxey (1976–77 and 1989); Warnke (1977); Wood (1993).

3 Although iconoclasm actually consisted of multiple attacks at different times and places and was part of a complex reform movement, for the purpose of this essay 'iconoclasm' is used, rather than 'reformation' or 'revolt', to underscore the systemic mechanism of image destruction. By the 'first century after iconoclasm' I mean roughly from 1566, the outbreak of iconoclastic attacks, to 1672, the date generally used to mark the beginning of the decline of the Dutch Golden Age, when the Amsterdam Stock Exchange crashed and Louis XIV invaded the Netherlands.

4 This panel may have originally hung on a column of a late medieval church. I would like to thank Prof. dr. Ilja M. Veldman for bringing the painting to my attention. For a more complete overview of Netherlandish *Ten Commandments* images from 1351 through the seventeenth century, see Veldman (1995), p. 230, passim. For more details on this painting, see Vandamme (1988), p. 498.

5 Archiefdienst voor Kennemerland, Haarlem, Church Masters's Accounts 1538, [n.pag.]; Allan (1874–88), p. 382; Graaf (1876), p. 100.

6 'Anthonisz.' is a common abbreviation for 'Anthoniszoon'. Cornelis Anthonisz., *Moses and Aaron with the Ten Commandments*, c.1545, woodcut (Armstrong, 1990, p. 105; Veldman, 1996b, p. 56).

7 South Netherlandish Master, *Moses with the Ten Commandments*, oil on panel, c.1570, Utrecht, Museum Catharijneconvent. For a reproduction of the painting and more detailed information, see Dirkse and Zijp (1986), pp. 145–7. The text of this *Ten Commandments* panel generally agrees with that of the Vorsterman Bible, which was published in 1533.

8 However, one difference between the Catholics and Protestants was that before the reformation the Ten Commandments was held up as a model by which believers could recognize and understand their sins during the sacrament of confession. It should also be noted that within the range of early reformed religions different versions of the Ten Commandments were used. Calvinist theologians tended to split the first commandment into two and combine the ninth and tenth. Luther and Melanchthon reversed the ninth and tenth commandments (Veldman, 1995, pp. 216–17, passim; Veldman, 1996b, p. 54).

9 The Liesveldt Bible was published c.1526–42 and was one of many versions of the Bible printed in the sixteenth century before a standard translation authorized by the States General, the *Statenvertaling*, appeared in 1637 (Veldman, 1995, p. 236).

10 Pieter Bruegel the Elder, *Fides* (Faith) from the *Seven Virtues Series*, pen in brown ink on paper, 1559 Amsterdam, Rijksmuseum. An engraved version also exists. The text at the bottom of the image reads: '*Fides maxime a nobis conseruanda est praecipue in religionem, quia deus prior et potentior est quam homo*' (Above all we must keep faith, particularly in respect to religion, for God comes before all, and is mightier than man). For reproductions of both the drawing and the engraving, see Orenstein (2001), pp. 178–9. Tromp-Teicher (1993) believes this representation of Faith with the tablets of the Law on her head, replacing the more standard church building, was Brueghel's iconographic innovation.

11 Other subjects, such as the Last Judgment, were also popular with both Catholics and Protestants, while stories relating to the suffering and death of Christ are almost never seen in Dutch Reformed churches (Steensma, 1975, p. 11).

12 Lucas Cranach the Elder, *The Law and the Gospel*, panel, 1529, Gotha, Schlossmuseum. For a colour reproduction of this image and more detailed information, see Schuttwolf (1994), pp. 20, 21, 35.

13 Iconoclasm in the Netherlands largely followed the theology of John Calvin, but a number of other reformers, both within and outside the Catholic Church, such as Erasmus, Luther, Zwingli and Menno Simons, were also influential. Furthermore, each reformer's ideas were given a distinctive local interpretation. For the purpose of this essay Erasmus and Calvin will be discussed as the formative influences on Dutch Reformed church decoration.

14 For the most recent discussions of Calvin's views on idolatry, see Eire (1986), pp. 195–233, passim; Michalski (1993), pp. 59–74, passim; and Sommer (1985).

15 By 'simulacrum', I particularly mean in the Platonic sense of a false likeness, phantasm or semblance. Camille (1996) has discussed the history of this word in relation to the making of likenesses (*eikons*) and its repercussions for art history as a history of the progress of the technical mastery of mimesis.

16 More than a half-century earlier in 1546 an established master like Maerten van Heemskerck received 150 guilders from the Wool Weavers' or Drapers' Guild for painting the wings for their altarpiece in the St Bavo or Great Church in Haarlem. In addition to the gilding of the frames, the payment included essentially three scenes: the *Annunciation* covering the outside of both wings and the *Adoration of the Magi* and *Birth of Christ* on the inside of the left and right wings respectively. This would mean roughly 50 guilders per major scene in the middle of the sixteenth century. Even allowing for inflation by 1601, the amount of 153 guilders paid for Kruyper's *Ten Commandments* panel would then represent quite an expensive commission for a single work, particularly one by a lesser known artist.

17 This replacement was particularly popular in print culture. The earliest use of the tetragrammaton in graphic work is seen in a Mennonite pamphlet, a woodcut called *The Witness of Christ* from 1529 by Hans Weiditz (Berlin, Kupferstichkabinett). This only predates *Moses and Aaron with the Ten*

Commandments by just over a decade. Both were part of the burgeoning 'crypto-reformation' visual world of the first half of the sixteenth century. See Krücke, (1959), pp. 81–3, passim; Muller (1994), pp. 336–9; Veldman (1996a), pp. 302–4. The States General's translation of the Bible, 1637, also depicts God in the form of a tetragrammaton (Van Swigchem, Brouwer and Van Os, 1984, pp. 22–3).

18 Master of Saint-Jean-de-Luze, *Portrait of Hugues de Rabutin, Seigneur d'Epiry* (?), oil on panel, *c.*1470, Dijon, Musée des Beaux-Arts. This panel was originally half of a diptych, the other half of which features de Rabutin's wife in prayer before a statue of St John the Evangelist, although without text. For reproductions of both images, see Borchert (2002), pp. 67, 254.

19 Exodus 31:18; Deuteronomy 10:4–5.

20 For more on the *acheiropoeitos* image, or those images made without human hands, in the context of works by Albrecht Dürer and Hans Baldung, see Koerner (1993), pp. 80–126, 139–59, 411–48.

21 'JOH[ANN]ES DE EYCK ME FECIT + [COM]PLEVIT AN[N]O 1439.' One example is Jan van Eyck, *Virgin and Child by the Fountain*, oil on panel, 1439, Antwerp, Museum voor Schone Kunsten. A reproduction may be seen in Borchert (2002), pp. 184, 235.

22 Interestingly choir screens were not often torn down in the Northern Netherlands after iconoclasm, as occurred elsewhere.

23 The identities of the statues are not provided (Van Swigchem, Brouwer and Van Os, 1984, pp. 30–31).

24 Rem also has suggested that the Haarlem *Ten Commandments* panel, like a contemporaneous surviving example in the St Lawrence Church in Rotterdam, would have taken the text of Exodus 20:1–17 as its source (Rem, 1996 p. 176).

25 These were general tendencies, certainly with exceptions, and were never intended to be strictly enforced to the point of exclusive use (Snoep, 1985, p. 173; Van Swigchem, Brouwer and Van Os, 1984, p. 4).

26 The *Ten Commandments* panel was executed in 1616, the *Apostles' Creed* and *Lord's Prayer* panels in the 1640s and the present-day arrangement around the pulpit was installed in 1714, although it is believed to reflect an earlier arrangement (Van Swigchem, 1984, p. 277, 281). These thematic links were also reflected in the small Reformed Church at Rijswijk, where a seventeenth-century *Ten Commandments* panel was erected directly on top of the pulpit, separating the nave and choir, with the texts of the Apostles' Creed and the Lord's Prayer on the choir-side of the panel.

27 Spaans has concluded that in Haarlem in 1620 only about half of the population showed a strict confessional allegiance and the breakdown of this religious half of the population was roughly 20 per cent Reformed, 14 per cent Mennonite, 12.5 per cent Catholic, 1 per cent Lutheran and 1 per cent Walloon Reformed (1989, pp. 104–5, 299).

References

Allan, Francis (1874–88), *Geschiedenis en beschrijving van Haarlem van de vroegste tijden tot op onze dagen*, vol. 3, Haarlem: Van Brederode.

Alpers, Svetlana (1983), *The Art of Describing: Dutch Art in the Seventeenth Century*, Chicago: University of Chicago Press.

Armstrong, Christine Megan (1990), *The Moralizing Prints of Cornelis Anthonisz*, Princeton: Princeton University Press.

Baxandall, Michael (1980), *The Limewood Sculptors of Renaissance Germany*, New Haven: Yale University Press.

Belting, Hans (1994), *Likeness and Presence: A History of the Image before the Era of Art*, trans. E. Jephcott, Chicago: University of Chicago Press.

Berkel, Klaas van (2001), 'Vermeer and the representation of science', in Franits, Wayne E. (ed.), *The Cambridge Companion to Vermeer*, Cambridge: Cambridge University Press, pp. 131–9.

Besançon, Alain (2000), *The Forbidden Image: An Intellectual History of Iconoclasm*, trans. J. M. Todd, Chicago: University of Chicago Press.

Borchert, Till-Holger (ed.) (2002), *The Age of Van Eyck: The Mediterranean World and Early Netherlandish Painting 1430–1530*, exh. cat., Bruges: Groeningemuseum.

Bredekamp, Horst (1975), *Kunst als Medium sozialer Konflikte. Bilderkämpfe von d. Spätantike bis z. Hussitenrevolution*, Frankfurt am Main: Suhrkamp.

Calvin, John (1989), *Institutes of the Christian Religion*, trans. Henry Beveridge, repr. edn, Grand Rapids: William B. Eerdmans .

Calvin, John (1992), *Sermons on 2 Samuel Chapters 1–13*, trans. Douglas Kelly, Edinburgh: The Banner of Truth Trust.

Calvin, John (1996), *Commentaries on the Last Four Books of Moses*, trans. C. W. Bingham, repr. edn, 2 vols, Grand Rapids: Baker Book House.

Camille, Michael (1996), 'Simulacrum', in Nelson, Robert S. and Schiff, Richard (eds), *Critical Terms in Art History*, Chicago: University of Chicago Press, pp. 47–57.

Dirkse, P. P. W. M. and Zijp, R. P. (eds) (1986), *Ketters en papen onder Filips II*, exh. cat., Utrecht: Museum Het Catharijneconvent.

Eck, X. van (1991), 'De decoratie van de Lutherse kerk te Gouda in de zeventiende eeuw', *Oud Holland* **105**, 167–84.

Eck, X. van (1994), *Kunst, twist en devotie. Goudse katholieke schuilkerken 1572–1795*, Delft, Eburon.

Eire, Carlos M. N. (1986), *War Against the Idols: The Reformation of Worship from Erasmus to Calvin*, Cambridge: Cambridge University Press.

Eire, Carlos M. N. (1990), 'The Reformation critique of the image', in Scribner, Bob and Warnke, Martin (eds), *Bilder und Bildersturm im Spätmittelatler und in der frühen Neuzeit*, Wolfenbütteler Forschungen 46, Wiesbaden: Harrassowitz, pp. 51–68.

Filedt Kok, J. P., Halsema-Kubes, W. and Kloek, W. Th. (eds) (1986), *Kunst voor de Beeldenstorm: Noordnederlandse kunst 1525–1580*, exh. cat., 2 vols, Amsterdam: Rijksmuseum.

Freedberg, David (1986), 'De kunst en de beeldenstorm, 1525–1580. De Noordelijke Nederlanden', in Filedt Kok, J. P., Halsema-Kubes, W. and Kloek, W. Th. (eds), *Kunst voor de Beeldenstorm: Noordnederlandse kunst 1525–1580*, exh. cat., vol. 1, Amsterdam, Rijksmuseum, pp. 52–3.

Freedberg, David (1988), *Iconoclasm and Painting in the Netherlands, 1566–1609*, Ph.D. diss., Oxford University, 1972, New York: Garland.

Freedberg, David (1989), *The Power of Images: Studies in the History and Theory of Response*, Chicago: University of Chicago Press.

Gamboni, Dario (1997), *The Destruction of Art: Iconoclasm and Vandalism since the French Revolution*, New Haven: Yale University Press.

Graaf, Jacob Johannes (1876), 'Plaatsbeschrijving der S. Bavo-kerk te Haarlem', *Bijdragen voor de geschiedenis van het Bisdom Haarlem* **4**, pp. 1–121.

Haeger, Barbara (1987), 'Barent Fabritius' three paintings of parables of the Lutheran Church in Leiden', *Oud Holland* 101, 95–114.

Jongh, Eddy de (1976), *Tot lering en vermaak. Betekenissen van Hollandse genrevoorstellingen uit de zeventiende eeuw*, exh. cat., Amsterdam: Rijksmuseum.

Koerner, Joseph Leo (1993), *The Moment of Self-Portraiture in German Renaissance Art*, Chicago: University of Chicago Press.

Krücke, Adolf (1959), 'Der Protestantismus und die bildliche Darstellung Gottes', *Zeitschrift für Kunstwissenschaft* **13**, 59–90.

Michalski, Sergiusz (1993), *The Reformation of the Visual Arts: The Protestant Image Question in Western and Eastern Europe*, London: Routledge.

Moxey, Keith P. F. (1976–77), 'Image criticism in the Netherlands before Iconoclasm of 1566', *Nederlandsch Archief voor Kerkgeschiedenis*, n.s. **57**, 148–62.

Moxey, Keith P. F. (1989), *Peasants, Wives and Warriors: Popular Imagery in the Reformation*, Chicago: University of Chicago Press.

Muller, Franck (1994), 'Les premières apparitions du tétragramme dans l'art allemand et néerlandais des débuts de la réforme', *Bibliothèque d'Humanisme et Renaissance* **56**, 327–46.

Orenstein, Nadine M. (2001), *Pieter Bruegel the Elder: Drawings and Prints*, exh. cat., New York: The Metropolitan Museum of Art.

Rem, Paul H. (1987), 'De koorhekbekroning in de Haarlemse St. Bavo na de Reformatie', *Bulletin van de Stichting Oude Hollandse Kerken* **24**, Spring, 20–24.

Rem, Paul H. (1996), 'De protestantse inrichting van de Laurenskerk. De opstellen van de kerkmeubelen vanaf 1572', in Lieburg, F. A., Okkema, J. C. and Schmitz, H. (eds), *De Laurens in het midden. Uit de geschiedenis van de Grote Kerk van Rotterdam*, Rotterdam: Stichting Grote of Sint-Laurenskerk, pp. 170–85.

Schillemans, R. (1992), 'Schilderijen in Noordnederlandse katholieke kerken uit de eerste helft van de zeventiende eeuw', *De zeventiende eeuw* **8**, 41–52.

Schulze, Sabine (ed.) (1993), *Leselust. Niederländische Malerei von Rembrandt bis Vermeer*, exh. cat., Frankfurt: Schirn Kunsthalle.

Schutte, G. J. (1992), 'De publieke kerk en de cultuur: theocratie van calvinistische stempel?', *De zeventiende eeuw* **8**, 33–9.

Schuttwolf, Allmuth (ed.) (1994), *Gotteswort und Menschenbild. Werke von Cranach und seinen Zeitgenossen*, exh. cat., vol. 1, Gotha: Schlossmuseum.

Snoep, D. P. (1985), 'Liever woord dan beeld', in Boer, J. N. de, Delleman, Th. A., Phaff, H. E., Snoep, D. P., Steur, A. G. van der and Temminck, J. J. (eds), *De Bavo te boek*, Haarlem: Joh. Enschedé en Zonen, pp. 174–5.

Sommer, Elisabeth (1985), 'Of idols and images: Calvin and Luther on religious art', *Essays in History* **29**, 67–82.

Spaans, Joke (1989), *Haarlem na de Reformatie. Stedelijke cultuur en kerkelijk leven, 1577–1620*, Hollandse Historische Reeks 11, The Hague: Smits.

Steensma, Regnerus (1975), *Verbeeld Vertrouwen. De mens tussen kruishout en doodskop*, Baarn: Bosch & Keuning.

Swigchem, C. A. van (1987), 'Kerkborden en kolomschilderingen in de St. Bavo te Haarlem, 1580–1585', *Bulletin van het Rijksmuseum* **35**, 211–23.

Swigchem, C. A. van (1988), *'Een goed regiment': Het burgelijke element in het vroege gereformeerde kerkinterieur*, The Hague: SDU.

Swigchem, C. A. van, Brouwer, T. and Os, W. van (1984), *Een huis voor het Woord*, The Hague: Staatsuitgeverij.

Tromp-Teicher, Bertha (1993), 'The *Fides* of Pieter Bruegel the Elder: a closer look at the tablets of the Law', *Dutch Jewish History* **3**, 227–38.

Vandamme, Erik (ed.) (1988), *Catalogus schilderkunst oude meesters*, Antwerp: Koninklijk Museum voor Schone Kunsten.

Veldman, Ilja M. (1995), 'The Old Testament as a moral code: Old Testament stories as exempla of the Ten Commandments', *Simiolus* **23**, 215–39.

Veldman, Ilja M. (1996a), 'Calvinisme en de beeldende kunst in de zeventiende eeuw', in Bruggeman, M. (ed.), *Mensen van de nieuwe tijd: een liber amicorum voor A.Th. van Deursen*, Amsterdam: Bakker, pp. 297–306.

Veldman, Ilja M. (1996b), 'Die religiösen Bilder des Hermann tom Ring und seine Beziehung zur niederländischen Kunst', in Lorenz, A. (ed.), *Die Maler tom Ring*, exh. cat., vol. 1, Münster: Westfälischen Landesmuseum für Kunst und Kulturgeschichte Münster, pp. 49–76.

Warnke, Martin (ed.) (1977), *Bildersturm. Die Zerstörung des Kunstwerks*, Frankfurt am Main: Syndikat.

Woltjer, J. J. (1994), 'De plaats van de calvinisten in de Nederlandse samenleving', *De zeventiende eeuw* **10**, 2–23.

Wood, Christopher S. (1993), *Albrecht Altdorfer and the Origins of Landscape*, Chicago: University of Chicago Press.

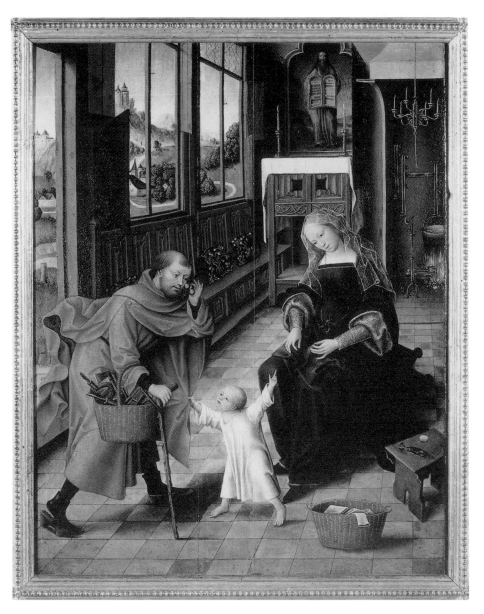

7.1 Master of the Magdalena Legend, *Holy Family*, c.1515–25

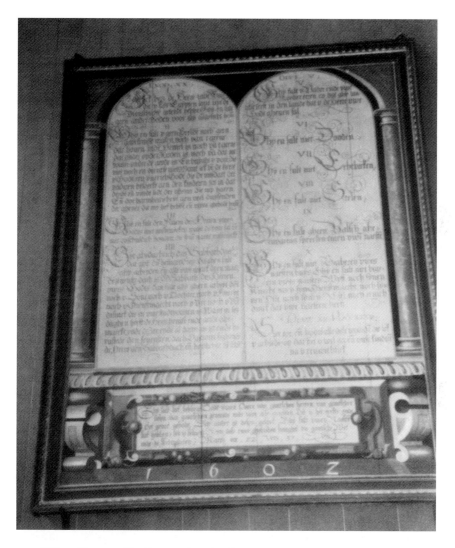

7.2 Willem Kruyper, *Ten Commandments*, 1602

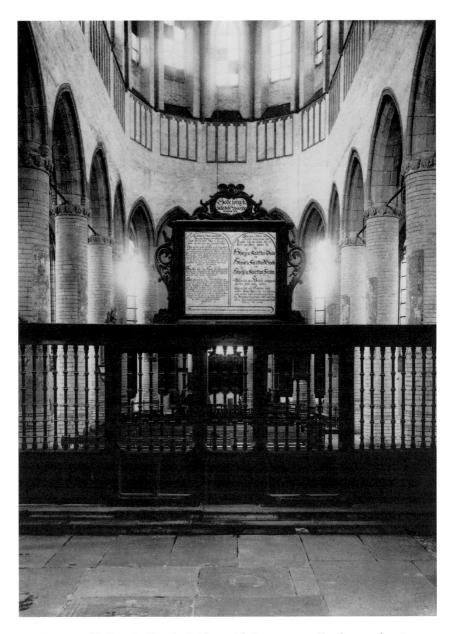

7.3 Interior of St Peter's Church, Leiden, with Anonymous, *Ten Commandments*, seventeenth century

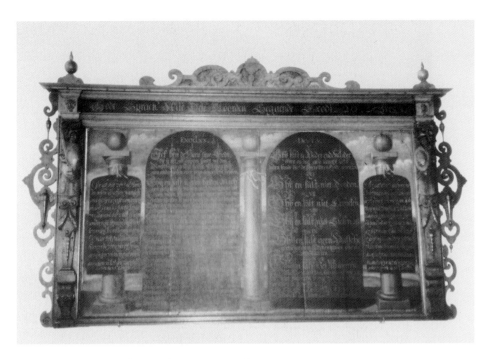

7.4 Anonymous, *Ten Commandments*, c.1590–1610

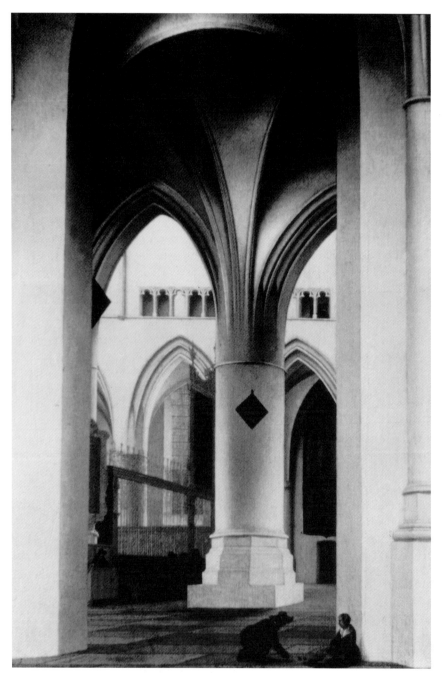

7.5 Pieter Jansz. Saenredam, *Choir and Southern Choir Ambulatory Seen from the Christmas Chapel in the St. Bavo Church, Haarlem,* 1636

8

Preservation and destruction, oblivion and memory[1]

Dario Gamboni

In 1794, the French moralist Joseph Joubert proposed to consider oblivion in a positive light, as necessary to the arts and sciences as memory itself. He expressed their solidarity and the function of selection fulfilled by oblivion in formulas that seem to aim at providing the caption of an allegory or the motto of an emblem: 'The sieve of oblivion. Or the sifter of oblivion. / Or: Memory and oblivion are the mother and the father of the Muses. Real knowledge is made up of these two things. Or: She holds a sieve in her hand. This sieve is called oblivion' (Joubert, 1966, p. 21).[2] It is probably not by chance that Joubert expressed these thoughts at a time when the material and artistic culture of the Ancien Régime had gone through the 'sieve' of 'revolutionary vandalism' and was being selected to constitute the 'national heritage'.[3] Iconoclasm could be understood as an instrument and a physical expression of oblivion in this active and selective sense. Indeed, it was used to represent the political transformations under way, for instance in the lower right corner of a print by J.-S. Duplessis entitled *The French Revolution*, published in 1792, where one sees Father Time breaking with a hammer the symbols of 'feudalism', including a broken column, coats of arms and crowns (Herding and Reichardt, 1989, fig. 123, pp. 92–3).

Attributing to Time itself the violent accomplishment of the *fin du règne féodal* naturalized the Revolution and reconciled the political and historical sense of the term revolution (end of a cycle and profound transformation of a social order) with its astronomical and mechanical sense (cyclical movement and periodical return of a body to a point in its orbit). In the frontispiece to his collection of prints after Roman antiques published in 1638 (Figure 8.1), François Perrier had shown Time attacking statuary, represented by the Torso Belvedere, not with a hammer but with his teeth. This image corresponded to the myth of Chronos eating his children and, more immediately, to the classical metaphor of *tempus edax rerum*, 'Time the

devourer of all things' (Ovid, *Metamorphoses* XV, 234). The degradation and ultimate disappearance of material and artistic productions are here defined as natural and irreversible processes; between Time's feet and his scythe, the self-devouring serpent of Eternity plays with its winding body around a lying column fragment so as to complicate and break the full circle of its cyclical revolution. But Perrier's prints are meant to help the remains of Antiquity 'escape from the jealous tooth of Time' in some measure. The reproductive artist thus assumes the function also claimed by historiography, that of saving the works of art and – when they are known – their authors from oblivion. At the end of the index of names in Carlo Malvasia's *Felsina pittrice: vite dei pittori bolognesi* (Bologna, 1678), the emblem combining the painter's brush and the historian's pen in a laurel wreath is accompanied by the motto *sic nomina vivunt* (so do names live [further]). And on the frontispiece to J. B. Descamps's *La vie des peintres flamands, allemands et hollandois...* (Paris, 1753), a genius discovers the portraits of the great men to hang them in the 'temple of Memory' while another one shows their works to the personification of Painting, who adds praise of them to the narration of the artists' lives.

Iconoclasm had already been used as a metaphor of oblivion in an active, positive sense by theoreticians of the 'art of memory'. In 1611, Schenkelius (Lambert Schenckel) recommended memorizing a discourse by imagining a room with pictures on the walls corresponding to the various ideas to be successively expressed; in order to free the room to devise a new discourse, one should imagine furious men entering it and breaking the pictures by throwing them on the ground and out of the door (Stoichita, 1993, pp. 137–8). Victor Stoichita relates this simile to the iconoclasm of the Reformation and, more directly, to the Flemish paintings of picture collections which include scenes of iconoclasm. Frances Yates has pointed to another link by suggesting that the reform of the art of memory advocated in the sixteenth century by Ramus (Pierre de la Ramée), which consisted of replacing 'the emotionally exciting memory image' with 'the abstract order of dialectical analysis', owed part of its success in Protestant countries to the fact that 'it provided a kind of inner iconoclasm, corresponding to the outer iconoclasm' (Yates, 1966, pp. 34–35, 277–8).

These pictorial and rhetorical equivalences between oblivion and abolition on the one hand and, on the other hand, intentional or unintentional degradation and destruction are predicated upon a double equation between material disappearance and oblivion, material preservation and memory. This equation, which remains generally taken for granted, seems to be based on a causal (rather than only figurative) relationship in so far as the material existence of an object meant to be seen appears to be also a condition of its being and remaining present in the consciousness of viewers. But it is an

equation that calls for serious qualifications, which this essay intends to briefly examine. One can even consider that it expresses an overvaluation of material preservation, which has been contradicted in some of its aspects by the very development of modern art.

First, it must be recalled that material existence is a necessary but not a sufficient condition of visibility. Works of art can be and indeed are often 'buried' in all kinds of store-rooms, bank safes or secret collections where they are accessible to no one or to very few. For everybody else, in such cases, occultation differs from destruction only in its reversibility – a crucial difference, needless to say, in the long run. But even access is not enough, for visibility and invisibility are not inherent and stable properties but the multiple and changing expressions of relationships with viewers. In his *Rediscoveries in Art*, Francis Haskell mentioned the fact that 'the frescoes of Piero della Francesca, the altarpieces of Rogier van der Weyden were seen – and ignored – for centuries' (1980, p. 157). Replacing centuries with decades, one could say as much about many paintings in churches and public buildings of the nineteenth century and of the first half of the twentieth. In a provocative essay entitled 'Behaviours without belief and works of art without spectators' (1988), the French historian of Roman Antiquity Paul Veyne objected against the unrestricted use of iconographical analysis that just as there are rites performed without awareness or comprehension of their intended signification, there are works that are never examined by any one in all their details and were never meant to be. More radically, the Austrian novelist Robert Musil had written in 1927 that paradoxically most remarkable feature of monuments is that one does not notice them, that they are 'impregnated against attention' and 'withdraw from our senses' in an almost active way (1981, pp, 506–9).

'Public space' is understandably the ideal place for works to cease being seen without ceasing to exist. Perception here is ruled by habit, subjected to an inflation of stimuli and generally oriented by non-aesthetic pursuits. When the organizers of the exhibition *Skulptur Projekte 1987* invited artists to intervene in the public space of Münster (Westphalia), the Swiss Rémy Zaugg declared that it was already filled with too many objects. Instead of adding yet another one of his own, he proposed to rescue from oblivion two bronze statues that had been erected in 1912 to mark an entry into the town but had since been removed from their original site and banished to an unfavourable location. Zaugg, who considered that they were thus degraded to the level of trash, attempted to turn them into sculpture again by restoring as far as possible their original conditions of perception (see Bussmann and König, 1987, pp. 262–70; Schmidt, 1993, pp. 104–71). As we have seen, however, standing on a pedestal in a square does not prevent works from slipping into invisibility, and neither does hanging on a museum wall. In a museum, this

metaphorical movement tends to be materialized, made official and enforced by the relegation into a storeroom. One need only think here of all the works of the nineteenth and twentieth centuries in public collections which have been, at one moment or another, excluded from the Modernist canon. In a series of works shown at the Venice Biennale in 1993, the Australian artist Jenny Watson pointedly attributed such a fate to an iconographic rather than stylistic cause when she commented on the depiction of a lying nude woman, entitled *Pleasure*, with the inscription 'This painting is in the process of becoming important', while *Domestication* (Figure 8.2), showing a woman cleaning on her knees, was labelled 'This painting is in the process of being relegated to a back room' (see *La Biennale di Venezia*, 1993, vol. 1, pp. 88–9).

Moveable or not, exhibited in the public space or in public buildings, artefacts considered as a part of cultural heritage enjoy a legal protection. A decrease in visibility and value can nevertheless provoke their material degradation and even their elimination, for technical reasons but also, and more profoundly, because it corresponds to an absence of the interest justifying the continuous investments (in time and skill as well as money) necessary to preservation. Of course, the same phenomenon is influenced by factors such as the materials used for the works, the physical conditions of their storage, and the conceptions and practices of the people in charge of their preservation. The effects of such a devaluation or disqualification are at their most destructive when the objects in question are fragile and belong to a category that comes to lose the very status of work of art. It then needs a 'rediscovery' to draw attention to their existence (past or present) and to their degradation. A good example of this is provided by sculptures of the nineteenth century and of the first half of the twentieth, especially by plasters (original plasters as well as plaster casts), which have been neglected and destroyed in great quantities. In cases of this kind, there is indeed a correspondence between destruction and oblivion, but oblivion comes first: rather than following destruction, it precedes and provokes it; or, to put it another way, destruction does not lead to oblivion but derives from it.

The situation is different when the destruction of an artwork does not result from its presence being too weak but on the contrary too strong – in other words, when the necessary or fortuitous combination of its properties with characteristics of the viewers and of the context (spatial, social or historical) make it appear as a 'scandal' that 'offends the eye', to quote phrases that have been in use at least from the Reformation to the present time (see Christin, 1991; Poulot, 1995; Gamboni, 1997). Negative reactions, especially when they are collective, increase the work's visibility. When an open conflict arises and the elimination requested by one party meets with the resistance of another one, then the stakes involved in the controversy can make the litigious object lastingly memorable even if it disappears materially.

What is remembered is not only the object, but all that has attached itself to it in the course of the fight for and against it and all that this fight has brought to light. This may go well beyond the specifics of the case, to the point of symbolizing a general problem, transformation or epoch.

This was the case, for instance, with two works respectively dismantled in 1989 and 1992, Richard Serra's *Tilted Arc* and Nicolai Tomski's *Lenin monument*. The former has become famous as an example of the difficulties encountered by 'public art' and modern sculpture in the public space, the latter as a symbol of 'Socialist Realism' and of the fall of the Communist regimes. The parallelism I point out in their fate is not meant to suggest any intrinsic kinship between the two, but it may well imply that despite the opposite relationship of these two works to artistic autonomy, their removal expressed a general crisis of monumental values. The cases are too complex to be dealt with here at length (see Weyergraf-Serra and Buskirk, 1991; Elfert, 1992; Gamboni, 1997, pp. 79–85, 155–64; Senie, 2002). Suffice it to say that *Tilted Arc* was commissioned by the American General Services Administration for Federal Plaza in Manhattan, where it was installed in 1981, while the *Lenin monument* had been commissioned by the East German government for Leninplatz in East Berlin and inaugurated in 1970. Serra's work was removed by the same federal office that had commissioned it, but under changed political circumstances (the Reagan government and administration) and on the basis of opposition voiced by users of the site. There arose so much controversy and resistance, however, that the dismantling had to take place at night, on 15 March 1989. The removal of Tomski's statue was decided by the Senate of the City of Berlin. It was equally surrounded by polemics, proved technically difficult, and lasted from November 1991 until its completion on 8 February 1992. One can consider it as a belated result of the collapse of the East German state and a more direct result of the re-unification of German politics. In both cases, the removal was officially meant to be provisional but has proved so far to equate to destruction, due to material damage caused by the dismantling, to the still unfavourable political context, and in Serra's case to the artist's insistence on the 'site-specificity' of his work. In both cases, the destructive outcome of the controversy has been commented upon continuously, in situ and beyond, by verbal and by visual means (for instance posters, sprayed inscriptions and stencil silhouettes of the *Lenin monument* on its empty plinth).

One cannot attribute the posthumous fame and endurance of *Tilted Arc* and of Tomski's *Lenin monument* to their 'destruction' or removal alone. But in the historical process including their production and their reception, the moment of their material disappearance corresponded to an important and lasting expansion rather than to a weakening of their indirect presence. The same can be said of works of sculpture and architecture recently targeted in

the course of internal or international conflicts, such as the Old Bridge of Mostar in Bosnia, the giant statues of Buddha in Bamiyan, Afghanistan, or the Twin Towers of the World Trade Center in New York. In such cases, awareness of the absence and suffering over the associated wounds and losses can even lead to reconstructions, currently effected in Mostar and envisioned in Bamiyan (see Gamboni, 2001; Bailey, 2002; 'Target Architecture', 2002). This is by no means an automatic phenomenon, however. There are works that have caused scandal and have been destroyed, but were forgotten all the same. A case in point is Gustave Courbet's anticlerical painting, *Return from the Conference*. It was refused in 1863 at the Salon and even at the Salon des Refusés, and was bought by a Catholic who destroyed it at the beginning of the twentieth century. As Shigemi Inaga has pointed out, this did not prevent it from failing to gain any position worth mentioning in the history of art (1996 [1989]).

Destruction, therefore, does not suffice – any more than does preservation – to guarantee permanence. But it can contribute to it, and this is enough to challenge the equation between destruction and oblivion and to justify a theoretical distinction between memory and material survival. One could object that the kind of 'mental preservation' that can be fostered by material elimination is bought with an impoverishment and fossilization of a work that tends to be reduced to the abstraction in the name of which it is remembered. Indeed, the loss of the material object diminishes the possibilities of confrontation, reinterpretation and even modification which a preserved work is capable of offering or suffering. But the extent of such an impoverishment depends on the distance which, in each case, separates the lost original from the traces it has left; and the history of preserved works shows that they are anything but safe from reductive and immobilizing interpretations. It can also happen that works withdrawn from perception gain in the process a semantic and expressive openness or suggestivity comparable to that of some unrealized projects and immaterial creations.

A central issue in this respect is that of the visual traces or surrogates of lost works. In the age of mechanical – and now digital – reproduction, works of art may or (rather) may not have lost their 'aura', but they certainly have augmented their means of indirect existence and survival (see Benjamin, 1969; Heinich, 1983). This process had actually started well before the advent of photography, as François Perrier's print (Figure 8.1) reminds us, and I have mentioned that it was also the self-appointed task of the history of art to contribute to it with verbal descriptions and comments. It must be observed in passing that the message of Perrier's frontispiece is ambiguous because the fragmentary form in which it shows us the Torso Belvedere, about to be further devoured by Father Time, is the one in which this statue had so

impressed its viewers from the time of its discovery in the early fifteenth century that it became the very symbol of the art of sculpture.[4]

But the advancement of the means of reproduction has done more than duplicate originals and allow painting, for instance as Odilon Redon recognized in 1876, to compete with the 'power of multiplication' of literature and obtain 'a new security assured in time' (Redon, 1961, p. 55). It has also freed artists from the obligation of surviving through the material substance of their works. Reflecting upon the problems involved in the continuing expansion of 'cultural heritage', David Lowenthal (1989; 1993) has emphasized the contradictions of material preservation and proposed, as alternatives to it, the preservation of fragments, of processes and of representations, which is traditionally practised in the cultures of China and Japan (see also Ryckmans, 1989). His critique of the cult of heritage can be compared with a recent comment on *Tilted Arc* by David Antin, who stated that it should be possible to destroy works of public art in a ritual fashion that would honour their creator and concluded:

one of the great things about artworks that go away is they remain in your mind. And you can use them. They can become part of other artworks. While if they clutter up the space, you eventually have insufficient space to put up anything else. So from my point of view removal is a greater problem than preservation.

(1992, p. 260)

Antin's notion of a finite space that can be 'cluttered up' and must be emptied to make room for something new is a physical equivalent of Schenkelius' image of the mental space of memory, which must be violently freed from its pictures to make room for the preparation of a new discourse. The competition between preserved works and works to come that it suggests may refer implicitly to the fight for artistic recognition within what Pierre Bourdieu called the 'artistic field' (also a spatial metaphor) and to the avant-garde ideology of the 'clean slate'. Indeed, Antin's wish for a ritual and respectful destruction of extant works of public art evokes Robert Rauschenberg's *Erased de Kooning Drawing, 1953* (San Francisco Museum of Modern Art), which – among other things – gave a ritual expression to the conflict of artistic generations and turned the work it obliterated into a monument to its own destruction. There has been in recent years an increasing tendency on the part of artists or would-be artists to claim as art unauthorized modifications of works by others exhibited in museums or galleries (see Kastner, 1997; Gamboni, 1998). And one notices a logically related tendency, within the academic discussion of iconoclasm, to question the opposition between creation and destruction and consider that later transformations, including violent ones, can be part of the continued existence of images and works of art.[6] When it comes to actual physical

interventions, this tendency raises major ethical as well as legal issues. To what extent does the claim to 'free' a work from the museum or to 'expose' its commodification by interfering with its material integrity, as suggested by Tony Shafrazi about Picasso's *Guernica* in 1974 and by Alexander Brener about Malevich's Suprematism (*White Cross on Grey Background*) in 1997, paradoxically fall prey to the fetishization of material preservation, in so far as it finds it necessary to appropriate the original (rather than a surrogate) and to impose itself upon all future viewers?

Taking advantage of the liberation provided by means of reproduction, an important part of the art of the twentieth century has in fact endeavoured to challenge the will to last and to organize transience from its inception. In this respect, it represents a treasure-trove of experiments that may be more ambivalent but is at least as rich as that of traditional Far Eastern civilizations. An early example is Marcel Duchamp's *Unhappy Readymade* realized in 1919 in Paris by his sister Suzanne and his brother-in-law Jean Crotti after the instructions he had sent from Buenos Aires as a wedding gift. While most other Readymades were thrown away and replaced when needed, the *Unhappy Readymade* was a kind of 'performance' *ante litteram* and implied the destruction of its material element, a geometry book attached to a balcony so that the wind would blow through its pages. It survived by means of a photograph, modified by Duchamp and included in his 1941 *Boîte-en-valise*, and of Suzanne's painting *Le Readymade malheureux de Marcel* (1920, private collection) (Naumann, 1982, p. 13). Auto-destructive works found their greatest development in the 1960s and a climax was already reached on 17 March 1960 with Jean Tinguely's *Homage to New York*, a memorable and well-remembered 'mechanical happening' organized in the garden of the Museum of Modern Art (see Hultén, 1967, pp. 126 ff.; Hoffmann, 1995).

While the materials of Tinguely's *Homage* and of most analogous works were not preserved, those of later constructions/destructions have often obtained an ambiguous status, hesitating between that of document, surrogate, relic, fragment and even full-fledged artwork. In 1993, Jean-Pierre Raynaud decided to demolish his house of La Celle-Saint-Cloud, a *Gesamtkunstwerk* that had been open to the public from 1971 to 1988, and exhibited the pieces for sale in 976 surgical containers presented at the CAPC in Bordeaux (Figure 8.3). Commenting on this gesture in the French journal *Architecture d'Aujourd'hui*, François Chaslin made of the destruction an instrument of memory: 'Raynaud pushed his radical logic to the end, wiping the slab clear so as to build in our memories, for a long time, this immaterial mausoleum' (1993, pp. 55–6).[7] The demolition of a house, which may seem to radicalize indeed Schenkelius' emptying of a room, thus leads to the erection of a mental monument of its own. To the extent that it deals with the memory

of sensorial experiences and replaces their material source with mental images, it is indeed on the side of inner iconophily rather than iconoclasm (see Yates, 1966; Latour and Weibel, 2002).

The German preservationist Gabi Dolff-Bonekämper has recently proposed to add to the catalogue of monumental values defined in 1903 by Alois Riegl a *Streitwert*, a 'conflict value' corresponding to the monuments' capacity to provoke controversies and debates (Dolff-Bonekämper, 2003).[8] Conceptualizing this capacity as a positive and active virtue helps shift the attention from the monuments (and more generally the works of art) as material objects to their function and potential as *Bedeutungsträger* and *Bedeutungsstifter*, bearers and creators of meaning. I have already mentioned that, in a similar way, re-examining the relations between preservation and destruction, oblivion and memory can help relativize material preservation and take advantage of the alternative models offered by other cultures and by the (in this respect still implicit) tradition of modern and contemporary art. The fact that physically extant works can nevertheless cease to 'live' is well known and has been expressed in many ways. Museums have from the start been criticized as 'cemeteries', for instance by Joubert's compatriot and contemporary Quatremère de Quincy, who denounced them as 'demolition studios' where only matter had been transported, not feelings, ideas or relationships (Quatremàre de Quincy, 1989 [1815]; Haskell, 1983). Confronted at the beginning of the twentieth century with the Chinese attitude toward art, time and matter, the French physician and poet Victor Segalen advocated the acceptance of 'the ages in their successive fall' and reversed Ovid and Perrier by praising 'time in its voracity'; more recently, the sinologist Pierre Ryckmans joined in this praise by writing that in China 'continuity is not ensured by the immobilism of inanimate objects; it is achieved through the fluidity of successive generations' (Segalen, 1995 [1914]; Ryckmans, 1989).

However, objects are 'inanimate' – as far as we are concerned – only when they are not involved in some interaction with humans. Their 'death' is never definitive, and the moment when they may or will reawaken from their sleep cannot always be predicted. Nowadays, the heritage industry is continuously searching for untapped resources, and the hold of event-based exhibitions on visitors' priorities leads museums to try and lure them into their permanent collections by having contemporary artists 'resuscitate' dormant displays by means of temporary interventions. It has already been hinted that (would-be) artists' iconoclastic assaults on works of art are sometimes intended (or claimed to be intended) as ways to 'save' the works in question from their museum embalming. The growing tendency to accept or discuss such claims speaks of a conception of artistic agency that is increasingly collective and open to temporal change (see, for example, Gell, 1998, esp. pp. 62–5). While it can be problematic in such extreme cases, this evolution seems to me to be

as a whole positive. I have argued elsewhere that elimination and preservation are really two sides of the same coin. It would be better to recognize this fact and explicitly to plan both together – to the extent that they can be planned – in the interest of memory and debate rather than of material preservation for its own sake.

Notes

1 A first version of this paper was published in French in Wessel Reinink and Jeroen Stumpel (eds), *Memory & Oblivion: Proceedings of the XXIXth International Congress of the History of Art held in Amsterdam, 1–7 September 1996*, Dordrecht: Kluwer Academic, 1999, pp. 897–903.
2 'Le tamis de l'oubli. Ou le crible de l'oubli. / Ou: La mémoire et l'oubli sont la mère et le père des muses. Le vrai scavoir est composé de ces deux choses. Ou: elle tient dans sa main un crible. Ce crible est appelé l'oubli.'
3 See especially Poulot (1995). The idea that the 'art of forgetting' is as important as the 'art of remembering' had already been put forth by Cicero in his *De oratore* (II, xliv, 299–300); see Stoichita (1993), p. 137.
4 Michelangelo reportedly refused to complete it; see Le Normand-Romain (1990).
5 'Imaginez les musées reproduits ainsi [i.e. by photography]. L'esprit se refuse à calculer l'importance que prendrait soudain la peinture ainsi placée sur le terrain de la puissance littéraire (puissance de multiplication) et de sa sécurité nouvelle assurée dans le temps.'
6 See the contribution by Finbarr Barry Flood in the present volume and Flood (2003).
7 'Raynaud est allé au bout de sa logique, avec son implacable radicalité, faisant table rase pour coucher dans nos mémoires, et pour longtemps, ce mausolée immatériel.'
8 See also my observation on 'stumbling-statues' in 'Statues d'achoppement', in *La statuaire publique au XIXe siècle*, Paris: Monum, forthcoming.

References

Antin, David (1992), 'Fine furs', in Mitchell, W. J. T. (ed.), *Art and the Public Sphere*, Chicago and London: University of Chicago Press, pp. 249–61.

Bailey, Martin (2002), 'Bamiyan Buddhas may be rebuilt', *The Art Newspaper* **13** (123), March, 1–4.

Benjamin, Walter (1969), 'The work of art in the age of mechanical reproduction', in Arendt, Hannah (ed.), *Illuminations*, New York: Schocken Books, pp. 217–25.

Bussmann, Klaus and König, Kasper (eds) (1987), *Skulptur Projekte in Münster 1987*, exh. cat. (Westfälisches Landesmuseum für Kunst und Kulturgeschichte, Münster), Cologne: DuMont.

Chaslin, François (1993), 'Les mille chutes de la maison Raynaud', *Architecture d'Aujourd'hui* **288**, 55–6.

Christin, Olivier (1991), *Une révolution symbolique. L'iconoclasme huguenot et la reconstruction catholique*, Paris: Minuit.

Dolff-Bonekämper, Gabi (2003), 'Lieux de mémoire et lieux de discorde: la valeur conflictuelle des monuments', in Recht, Roland (ed.), *Victor Hugo et le débat patrimonial*, Paris: Somogy/Institut national du patrimonie, pp. 121–44.

Elfert, Eberhard (1992), 'Die politischen Denkmäler der DDR im ehemaligen Ost-Berlin und unser Lenin', in *Demontage ... revolutionärer oder restaurativer Bildersturm? Texte und Bilder*, Berlin: Karin Kramer, pp. 53–8.

Flood, Finbarr Barry, with Strother, Z. S. (2003), 'Between creation and destruction: the

aesthetics of "iconoclasm"', for the 91st Annual Conference of the College Art Association, New York, 19–22 February.

Gamboni, D. (1997), *The Destruction of Art: Iconoclasm and Vandalism Since the French Revolution*, London and New Haven: Reaktion Books/Yale University Press.

Gamboni, D. (1998), 'The abolition of art: labels, distinctions and history', in Dallal, Alberto (ed.), *La Abolición del arte*, Mexico: Universidad Nacional Autónoma de México, Instituto de Investigaciones Estéticas, pp. 17–39.

Gamboni, D. (2001), 'World heritage: shield or target?', *Conservation: The Getty Conservation Institute Newsletter* **16** (2), 5–11.

Gell, Alfred (1998), *Art and Agency: An Anthropological Theory*, Oxford: Clarendon Press.

Haskell, Francis (1980), *Rediscoveries in Art: Some Aspects of Taste, Fashion and Collecting in England and France*, London: Phaidon.

Haskell, Francis (1983), 'Les musées et leurs ennemis', *Actes de la recherche en sciences sociales* **49**, September, 103–6.

Heinich, Nathalie (1983), 'L'aura de Walter Benjamin. Note sur "l'ouvre d'art à l'ère de sa reproductibilité technique"', *Actes de la recherche en sciences sociales* **49**, September, 106–9.

Herding, Klaus and Reichardt, Rolf (1989) *Die Bildpublizistik der Französischen Revolution*, Frankfurt am Main: Suhrkamp.

Hoffmann, Justin (1995), *Destruktionskunst: Der Mythos der Zerstörung in der Kunst der frühen sechziger Jahre*, Munich: Silke Schreiber.

Hultén, K. G. Pontus (1967), *Jean Tinguely 'Méta'*, Paris: Horay.

Inaga, Shigemi (1996), 'Retour de la conférence: une ouvre perdue de Gustave Courbet et sa position (manquée) dans l'histoire de l'art', *Les amis de Gustave Courbet*, 94–5, 30–43 (first published 1989).

Joubert, Joseph (1966), *Pensées*, ed. Georges Poulet, Paris: Union Générale d'Editions.

Kastner, Jeffrey (1997), 'Art attack', *ARTnews* **96**, October, 154–6.

La Biennale di Venezia. XLV Esposizione Internazionale d'Arte (1993), Punti cardinali dell'arte, exh. cat., vol. 1, Venice: Marsilio.

Latour, Bruno and Weibel, Peter (eds) (2002), *Iconoclash: Beyond the Image Wars in Science, Religion and Art*, exh. cat. (Zentrum für Kunst und Medientechnologie, Karlsruhe), Cambridge, Mass. and London: MIT Press.

Le Normand-Romain, Antoinette (1990), 'Torse du Belvédère', in *Le corps en morceaux*, exh. cat. (Musée d'Orsay, Paris; Schirn Kunsthalle, Frankfurt am Main), Paris: Réunion des Musées Nationaux, pp. 99–115.

Lowenthal, David (1989), 'Material preservation and its alternatives', *Perspecta: The Yale Architectural Journal*, **25**, 67–77.

Lowenthal, D. (1993), 'Memory and oblivion', *Museum Management and Curatorship* **12**, 171–82.

Musil, Robert (1981), 'Denkmale', in *Gesammelte Werke*, vol. 7, Reinbeck bei Hamburg: Rowohlt.

Naumann, Francis M. (1982), 'Affectueusement, Marcel: ten letters from Marcel Duchamp to Suzanne Duchamp and Jean Crotti', *Archives of American Art Journal* **22** (4), 2–19.

Poulot, Dominique (1995) 'Revolutionary "vandalism" and the birth of the museum: the effects of a representation of modern cultural terror', in Pearce, Susan (ed.), *Art in Museums*, New Research in Museum Studies 5, London and Atlantic Highlands, NJ: Athlone, pp. 192–214.

Quatremère de Quincy (1989), *Considérations morales sur la destination des ouvrages de l'art*, in Quatremère de Quincy, Considérations morales sur la destination des ouvrages de l'art suivi de Lettres sur l'enlèvement des ouvrages de l'art antique à Athènes et à Rome, Paris: Fayard, pp. 47–8 (first published Paris, 1815).

Redon, Odilon (1961 [1922]), *A soi-même. Journal (1867–1915). Notes sur la vie, l'art et les artistes*, Paris: Corti.

Ryckmans, Pierre (1989), 'The Chinese attitude toward the past', in Lavin, Irving (ed.), *World Art: Themes of Unity in Diversity*, Acts of the XXVIth International Congress of the History of Art, University Park and London: Pennsylvania State University Press, vol. 3, pp. 809–12.

Schmidt, Eva (ed.) (1993), *Rémy Zaugg. Vom Bild zur Welt*, Cologne: Walther König.

Segalen, Victor (1995), 'Aux dix mille années', in Segalen, Victor, *Oeuvres complètes*, ed. Henry Bouillier, Paris: Robert Laffont, vol. 2, pp. 52–3 (first published in Stèles, Paris, 1914).

Senie, Harriet F. (2002), *The 'Tilted Arc' Controversy: Dangerous Precedent?*, Minneapolis and London: University of Minnesota Press.

Stoichita, Victor (1993), *L'instauration du tableau. Métapeinture à l'aube des Temps modernes*, Paris: Méridiens Klincksieck.

'Target Architecture: The Role of Old Buildings in the Management of Global Conflict', (2002), papers of the conference held at Columbia University, New York, 23 February.

Veyne, Paul (1988), 'Conduites sans croyance et ouvres d'art sans spectateurs', *Diogène* 143, July–September, 3–22.

Weyergraf-Serra, Clara and Buskirk, Martha (1991), *The Destruction of 'Tilted Arc': Documents*, Cambridge, Mass. and London: MIT Press.

Yates, Frances A. (1966), *The Art of Memory*, Chicago and London: University of Chicago Press/Routledge and Kegan Paul.

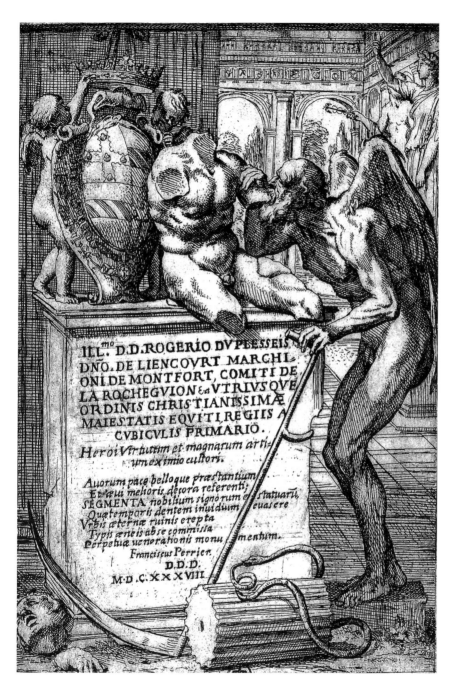

8.1 François Perrier, frontispiece of *Segmenta nobilium et statuarii*, 23.6 × 15.5 cm, engraving, 1638

8.2 Jenny Watson, *Domestication*, 80 × 147 cm and 50.5 × 40.5 cm, oil on taffeta and polymer paint on synthetic material, 1992, private collection

8.3 Jean-Pierre Raynaud, *The House*, temporary installation, 1993, CAPC, Bordeaux

Select Bibliography

Aldred, C. (1991), *Akhenaten King of Egypt*, London: Thames and Hudson.

Auzépy, Marie-France (1990), "La destruction de l'icône du Christ de la Chalcé par Léon III: Propagande or réalité?" *Byzantion* 60, 445–92

Bahrani, Zainab (1995), 'Assault and abduction: the fate of the royal image in the ancient Near East', *Art History*, **18** (3), September, 363–82.

Bantjes, Adrian A. (1994), 'Burning Saints, Molding Minds: Iconoclasm, Civic Ritual, and the Failed Cultural Revolution', in Beezley, William H., Cheryl English Martin, and William E. French (eds.), *Rituals of Rule, Rituals of Resistance: Public Celebrations and Popular Culture in Mexico*, Wilmington, Delaware: Scholarly Resources Books, pp. 261–84.

Bantjes, Adrian A. (1997), 'Iconoclasm and Idolatry in Revolutionary Mexico: The De-Christianization Campaigns, 1929-1940', *Mexican Studies/Estudios Mexicanos* **13** (1), pp. 87–120.

Barber, Charles (1993), 'The body within the frame: a use of word and image in iconoclasm', *Word and Image*, **9**,140–53.

Barber, Charles (1995), 'From image into art: art after Byzantine Iconoclasm', *Gesta*, 34, 5–10.

Barber, Charles (2002), *On the Limits of Representation in Byzantine Iconoclasm*, Princeton and Oxford: Princeton University Press.

Barnard, L.W. (1974), *The Graeco-Roman and Oriental Background of the Iconoclastic Controversy*, Leiden: E.J. Brill.

Belting, Hans (1990), *Bild und Kult. Eine Geschichte des Bildes vor dem Zeitalter der Kunst*, München, pp. 331–347. Tr. E. Jephcott (1994) *Likeness and Presence. A History of the Image before the Era of Art*. Chicago: University of Chicago Press.

Benjamin, Walter (1969), 'The Work of Art in the Age of Mechanical Reproduction', in Hannah Arendt (ed.), *Illuminations*, New York: Schocken Books, pp. 217–25.

Björkman, G. (1971), *Kings at Karnak: a study of the treatment of the monuments of royal predecessors in the early New Kingdom*, Uppsala: University of Uppsala.

Brading, D. A. (2001), *Mexican Phoenix. Our Lady of Guadalupe: Image and Tradition Across Five Centuries*, Cambridge: Cambridge University Press.

Bredekamp, Horst (1975), *Kunst als Medium sozialer Konflikte. Bilderkämpfe von der Spätantike bis zur Hussitenrevolution*, Frankfurt: Suhrkamp.

Brown, P. (1973), 'A Dark Age crisis: aspects of the Iconoclastic controversy', *English Historical Review*, **88**, 1–34.

Bryer, A.A.M. and Herrin J. (eds), (1977), *Iconoclasm*, Birmingham: University of Birmingham.

Calvin, John (1989), *Institutes of the Christian Religion*, tr. Henry Beveridge, rep. edn., Grand Rapids: William B. Eerdmans Publishing Company.

Christian Jr., William A (1989), *Person and God in a Spanish Valley*, Princeton: Princeton University Press.

Christin, Olivier (1991), *Une révolution symbolique. L'iconoclasme huguenot et la reconstruction catholique*, Paris: Minuit.

Clay, Richard, 'Iconoclasm, vandalism or sign transformation during the French Revolution' in Boldrick, Stacy and Richard Clay (eds.), *Iconoclasm: contested objects, contested terms*, Aldershot, UK: Ashgate, forthcoming, 2006.

Cordess, Christopher and Maja Turcan (1993), 'Art Vandalism,' *British Journal of Criminology* **33**, 95–102.

Der Manuelian, Peter (2000), 'Semi Literacy in Egypt. Some Erasures from the Amarna Period', in ed. E. Teeter and J.A. Larson, *Gold of Praise. Studies in Honor of Edward F. Wente*, University of Chicago Press, pp. 285–298.

Dierkens, Alain (1984), 'Superstitions, christianisme et paganisme à la fin de l'époque mérovingienne. A propos de l'Indiculus superstitionum et paganiarum' in: Hervé Hasquin (ed.) *Magie, sorcellerie, parapsychologie*, Brussels, pp. 9–26.

Dupeux, Cécile, Peter Jezler, and Jean Wirth (2000), *Bildersturm: Wahnsinn oder Gottes Wille?*, Munich: Fink.

Eire, Carlos M.N. (1986), *War Against the Idols. The Reformation of Worship from Erasmus to Calvin*, Cambridge: Cambridge University Press.

Filedt Kok, J.P., W. Halsema-Kubes and W.Th. Kloek (eds) (1986), *Kunst voor de Beeldenstorm: Noordnederlandse kunst 1525–1580*, exh. cat., 2 vols, Amsterdam: Rijksmuseum.

Fine, Steven (2000), 'Iconoclasm and the art of the late-ancient Palestinian synagogues', in Levine, Lee I. and Weiss, Zeev (eds), *From Dura to Sepphoris: Studies in Jewish Art and Society in Late Antiquity*, Portsmouth, Rhode Island.

Fischer, H. (1976), 'An Early Example of Atenist Iconoclasm', *Journal of the American Research Center in Egypt* **13**, pp.131–132.

Flood, Finbarr Barry (2002), 'Beyond Cult and Culture: Bamiyan, Islamic Iconoclasm, and the Museum,' *Art Bulletin* **84** , 641–59.

Flood, Finbarr Barry (forthcoming), *Circulating Cultures: Artifacts, Elites and Medieval Hindu-Muslim Encounters*.

Flood, Finbarr, Barry (2004), 'Signs of Violence: Colonial Ethnographies and Indo-Islamic Monuments', *Australia and New Zealand Journal of Art*, **5**, December, 2004.

Forsyth, Ilene Haering (1972), *Throne of Wisdom: Wood Sculptures of the Madonna in Romanesque France*, Princeton: Princeton University Press.

Freedberg, David (1988), *Iconoclasm and Painting in the Netherlands, 1566–1609*, Ph.D. diss., Oxford University, 1972, New York: Garland.

Freedberg, David (1989), *The Power of Images. Studies in the History and Theory of Response*, Chicago: University of Chicago Press.

Gamboni, D. (1998), 'The Abolition of Art: Labels, Distinctions and History', in Dallal, Alberto (ed.), *La Abolición del arte*, Mexico: Universidad Nacional Autónoma de México, Instituto de Investigaciones Estéticas, pp. 17–39.

Gamboni, Dario (1997), *The Destruction of Art. Iconoclasm and Vandalism since the French Revolution*, New Haven: Yale University Press.

Gero, S. (1973), 'The *Libri Carolini* and the image controversy', *Greek Orthodox Theological Review*, **18**, 7–34.

Goel, Sita Ram (1993), *Hindu Temples: What Happened to Them? The Islamic Evidence*, vol. 2, second enlarged edn, New Delhi: Voice of India.

Greenhalgh, Michael (1989), *The Survival of Roman Antiquities in the Middle Ages*, London: Duckworth.

Gruzinski, Serge (1993), *The Conquest of Mexico. The Incorporation of Indian Societies into the Western World, 16th-18th Centuries*, Cambridge: Polity Press.

Gutmann, Joseph, ed. (1977), *The Image and the Word: Confrontations in Judaism, Christianity, and Islam*, Missoula, Montana: Scholars Press for the American Academy of Religion.

Hari, R. (1985), *New Kingdom Amarna Period*, Leiden: E.J. Brill.

Herrin, Judith (2002), *Women in Purple*, Princeton: Princeton University Press.

Himmelmann, Nikolaus (1986), 'Antike Götter im Mittelalter', in: *Trierer Winckelmannsprogramme 7*, Mainz: Zabern.

Hoeps, Reinhard (1999), *Aus dem Schatten des Goldenen Kalbes – Skulptur in theologischer Perspektive*, Paderborn.

Hoffmann, Justin (1995), *Destruktionskunst: Der Mythos der Zerstörung in der Kunst der frühen sechziger Jahre*, Munich: Silke Schreiber.

Ingham, John M. (1986), *Mary, Michael, and Lucifer: Folk Catholicism in Central Mexico*, Austin: University of Texas Press.

Kastner, Jeffrey (1997), 'Art Attack', *ARTnews*, **96**, October, 154–156

Keller, Harald (1952), Zur Entstehung der sakralen Vollskulptur in der ottonischen Zeit', in: Kurt Bauch (ed.), *Festschrift Hans Jantzen*, Berlin, pp. 71–90.

Kitzinger, E. (1954), 'The cult of images in the age before Iconoclasm', *Dumbarton Oaks Papers*, **8**, pp. 83–150.

Knight, Alan (1986), *The Mexican Revolution*, 2 vols., Cambridge: Cambridge University Press.

Knoegel-Anrich, Elsmarie (1992), *Schriftquellen zur Kunstgeschichte der Merowingerzeit*, Hildesheim/Zürich/New York: Olms (Reprint of the edition of Darmstadt 1932).

Koerner, Joseph Leo (1993), *The Moment of Self-Portraiture in German Renaissance Art*, Chicago: University of Chicago Press.

Koerner, Joseph Leo (2004), *The Reformation of the Image*, Chicago: University of Chicago Press.

Lacau, P. (1926), 'Suppression des noms divins dans les textes de la chambre funéraire', *Annales du Service des Antiquités Egyptiennes* **26**, pp. 69–81.

Lacau, P. (1913), 'Suppressions et modifications de signes dan les textes funéraires', *Zeitschrift für Ägyptische Sprache* **51**, pp. 1–64.

Ladner, G.B. (1953), 'The concept of the image in the Greek Fathers and the Byzantine Iconoclast controversy', *Dumbarton Oaks Papers*, **7**, pp. 1–34.

Latour, Bruno and Peter Weibel (eds) (2002), *Iconoclash: Beyond the Image Wars in Science, Religion and Art*, exhibition catalogue (Zentrum für Kunst und Medientechnologie, Karlsruhe), Cambridge, MA and London: MIT Press.

Louth, A. (2002), *St John Damascene. Tradition and originality in Byzantine theology*, Oxford: Oxford University Press.

Martin, E.J. (1930), *A History of the Iconoclastic controversy*, London: SPCK.

Meyer, Jean (1985), *La cristiada*, 3 vols, Mexico: Siglo XXI.

Michalski, Sergiusz (1993), *The Reformation of the Visual Arts. The Protestant Image Question in Western and Eastern Europe*, London: Routledge.

Ozouf, Mona (1988), *Festivals and the French Revolution*, Cambridge, Mass.: Harvard University Press.

Parry, K. (1989), 'Theodore Studites and the Patriarch Nicephoros on image-making as a Christian imperative', *Byzantion*, **59**, 164–83.

Poulot, Dominique (1995) 'Revolutionary "Vandalism" and the Birth of the Museum: The Effects of a Representation of Modern Cultural Terror', in Pearce, Susan(ed.), *Art in Museums* (New Research in Museum Studies, 5), London and Atlantic Highlands, NJ: Athlone, pp. 192–214.

Schmitt, Jean-Claude (1987), 'L'Occident, Nicée II et les images du VIIIe au XIIIe siècle', in: Nicée II, 787–1987. Douze siècles d'images religieuses. *Actes du Colloque international Nicée II tenu au Collège de France*, F. Boesflug and N. Lossky (eds), Paris

Spraggon, Julie (2003), *Puritan Iconoclasm during the English Civil War*, Rochester, New York: Boydell.

Stewart, Peter (1999), 'The Destruction of Statues in Late Antiquity', in Miles, Richard (ed.), *Constructing Identities in Late Antiquity*, London: Routledge, pp. 159–89.

Swigchem, C.A. van, T. Brouwer and W. van Os (1984), *Een huis voor het Woord*, The Hague: Staatsuitgeverij.

Vasiliev, A.A. (1956), 'The iconoclastic edict of the caliph Yazid II, A.D. 721', *Dumbarton Oaks Papers*, 9–10, 23–47.

Veldman, Ilja M. (1996a), 'Calvinisme en de beeldende kunst in de zeventiende eeuw', in Bruggeman, M. (ed.), *Mensen van de nieuwe tijd: een liber amicorum voor A.Th. van Deursen*, Amsterdam: Bakker, pp. 297–306.

Veyne, Paul (1988), 'Conduites sans croyance et ouvres d'art sans spectateurs', *Diogène*, 143, July-September, 3–22.

Weyergraf-Serra, Clara and Martha Buskirk (1991), *The Destruction of 'Tilted Arc': Documents*, Cambridge, MA and London: MIT Press.

Wrigley, Richard (1993), 'Breaking the Code: Interpreting French Revolutionary Iconoclasm', in Yarrington, Alison, and Everest, Kelvin (eds), *Reflections of Revolution, Images of Romanticism*, New York & London: Routledge, pp. 182–95.

Yitzhak, Hen (2002), 'Paganism and Superstition in the time of Gregory of Tours: Une question mal posée?', in Kathleen Mitchell and Ian Wood (eds), *The World of Gregory of Tours*, Leiden: Brill, pp. 229–240.

Index

Note: page references in italics indicate illustrations.